CALIFORNIA DESERT

Best wishes!

Kerry Drager

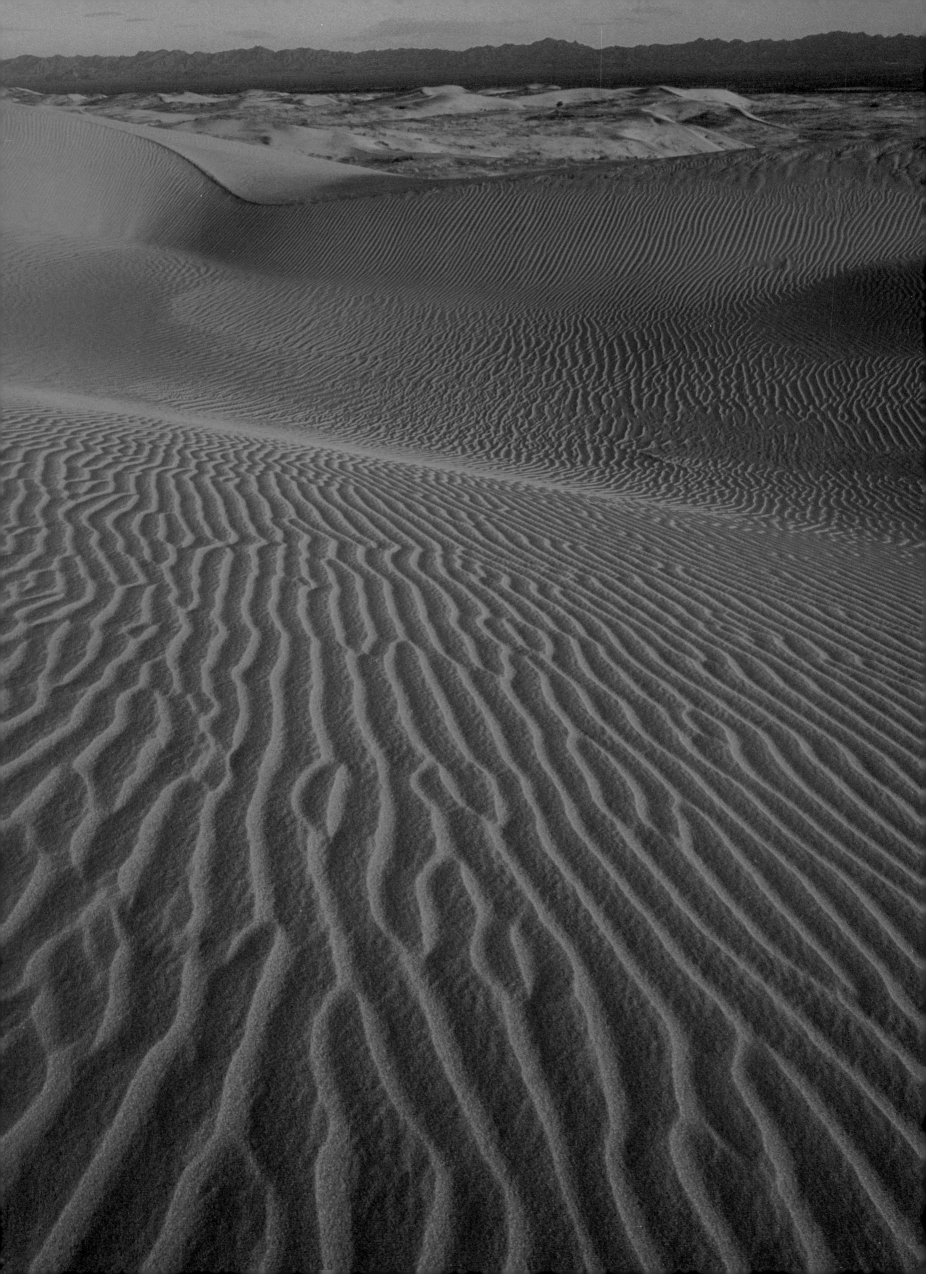

CALIFORNIA DESERT

PHOTOGRAPHY BY KERRY DRAGER

TEXT BY SANDRA L. KEITH

GRAPHIC ARTS CENTER PUBLISHING™

International Standard Book Number 1-55868-096-9
Library of Congress catalog number 93-70512
© MCMXCIII by Graphic Arts Center Publishing Company
P.O. Box 10306 • Portland, Oregon 97210 • 503/226-2402
No part of this book may be reproduced by any
means without the permission of the publisher.
President • Charles M. Hopkins
Editor-in-Chief • Douglas A. Pfeiffer
Managing Editor • Jean Andrews
Designer • Robert Reynolds
Production Manager • Richard L. Owsiany
Typographer • Harrison Typesetting, Inc.
Cartographer • Ortelius Design
Color Separations • Agency Litho
Printing • Shepard Poorman
Binding • Lincoln & Allen
Printed in the United States of America

To my wife and my parents

KERRY DRAGER

◄ ◄ Imperial Sand Dunes, or Algodones Dunes, stretch more than forty miles on the eastern edge of Imperial Valley's agricultural area. California's biggest sandbox starred in the movies, *Lawrence of Arabia* and *Star Wars*.

CALIFORNIA DESERT

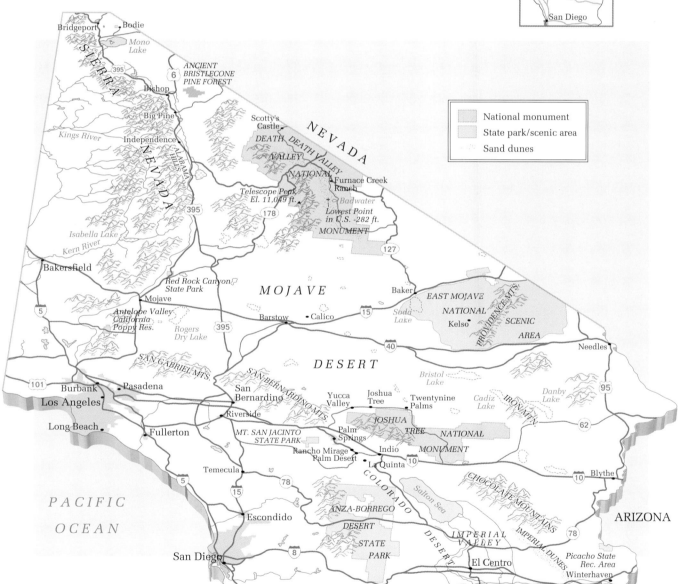

SACRAMENTO

San Francisco

Fresno

Los Angeles

San Diego

Bridgeport • Bodie

Mono Lake

SIERRA

ANCIENT
BRISTLECONE
PINE FOREST

6

Bishop

Big Pine

Kings River

Independence

NEVADA

ALABAMA HILLS

395

Scotty's Castle

NEVADA

DEATH *DEATH VALLEY*
VALLEY

NATIONAL

Furnace Creek
Ranch

Telescope Peak
El. 11,049 ft.

+ *Badwater*
Lowest Point
in U.S. -282 ft.

178

MONUMENT

127

395

Isabella Lake

Kern River

Bakersfield

Red Rock Canyon
State Park

MOJAVE

Baker

EAST MOJAVE

NATIONAL

Mojave

Antelope Valley
California
Poppy Res.

*Rogers
Dry Lake*

395

Barstow • Calico

*Soda
Lake*

15

Kelso

PROVIDENCE MTS.

SCENIC

AREA

Needles

40

SAN GABRIEL MTS.

DESERT

*Bristol
Lake*

Burbank • Pasadena

SAN BERNARDINO MTS.

San
Bernardino

Yucca
Valley

Joshua
Tree

Twentynine
Palms

*Cadiz
Lake*

*Danby
Lake*

IRON MTN.

95

Los Angeles

Riverside

JOSHUA

TREE *NATIONAL*

62

Long Beach

Fullerton

*MT. SAN JACINTO
STATE PARK*

Palm
Springs

Rancho Mirage
Palm Desert

Indio

MONUMENT

La Quinta

10

Blythe

10

Temecula

78

COLORADO

*Salton
Sea*

*CHOCOLATE
MOUNTAINS*

PACIFIC

5

15

DESERT

78

OCEAN

Escondido

ANZA-BORREGO

*IMPERIAL
VALLEY*

IMPERIAL DUNES

ARIZONA

DESERT

DESERT

STATE

Picacho State
Rec. Area

San Diego

8

PARK

El Centro

Winterhaven

	National monument
	State park/scenic area
	Sand dunes

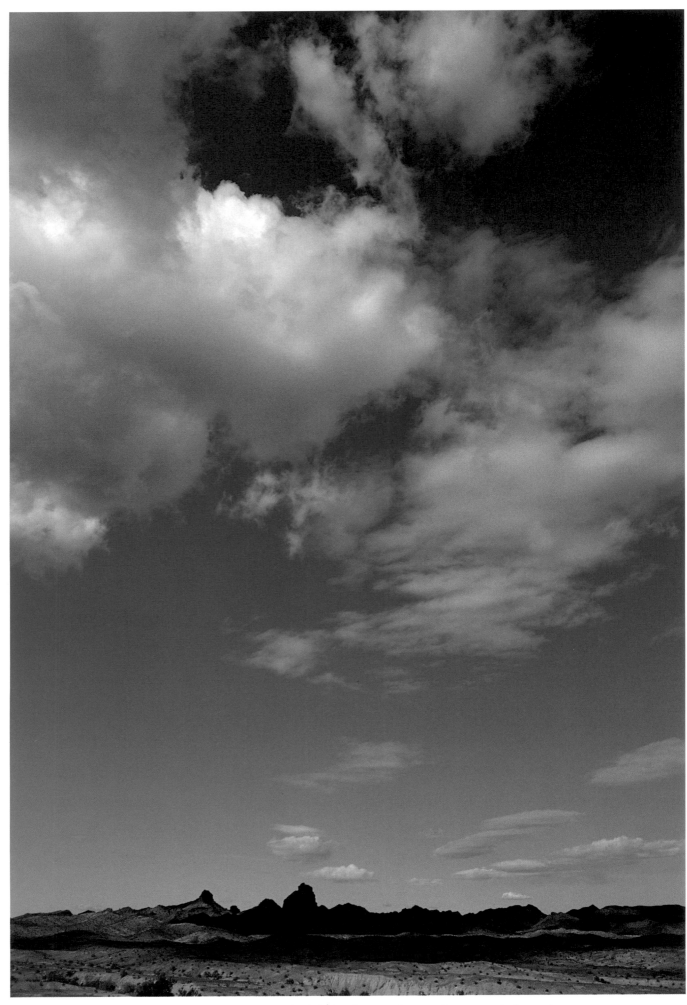

▲ Stark, low-desert scenery highlights the Picacho area between Blythe and Winterhaven in the desert's southeastern corner. A short distance away, the Colorado River marks the boundary between California and Arizona.

WELCOME . . . to the California desert, a land of space enough and quiet aplenty. This is a rumpled, wrinkled country where dry arroyos bump up against hidden oases and moonscape flats are edged by snow-capped mountain ranges; where dun-hued badlands shade a solitude of wildflowers and corrugated buttes hide narrow slot canyons; where spiny plants put forth blooms as delicate as butterfly wings and animals thrive though no rain falls; where oddly shaped plants have even odder names and every erosive wind uncovers seashells deposited during a watery past.

Early explorers named it "The Land of Clear Light." And so it is. Mountains a hundred miles away often seem within walking distance—a deception discovered too late by those who have become stranded and set out on foot. In its entirety, the California desert covers approximately 25.5 million acres that roll northward from the Mexican border to just above Bishop and west from the Colorado River and Nevada border to the slopes of the Laguna, San Jacinto, San Bernardino, San Gabriel, and Sierra Nevada mountains. Within those confines are the geographic provinces known as the Colorado, Mojave, and Great Basin deserts.

Whatever its name, one fact is certain: almost none of it is flat. The small slice of Great Basin Desert that slips over Nevada's borders into California is fronted by the Sierra Nevada with its 14,494-foot-high Mount Whitney, the tallest peak in the contiguous United States. The Mojave ranges from 282 feet below sea level to 6,000 feet above sea level. The Colorado, California's subdivision of the sprawling Sonoran Desert, claims elevations from barely below sea level to just slightly above it.

In their entirety, the California deserts' varied topography sports everything from sand dunes to bighorn sheep, palm trees to tule elk, salt flats to volcanic jumbles, and shardlike creekbeds to rolling rivers. Stretched like pleats along the deserts' creosote-stubbled length are range after range of barefaced mountains with names like Calico, Warner, Grapevine, Inyo, Funeral, Chocolate, Amargosa, and Panamint; and separating the ranges are low-lying valleys like Imperial, Coachella, Death, and Owens.

Salted throughout the deserts' vast array of hills and valleys are hundreds of old mines and ghost towns. Winter snows, desert twisters, and all manner of gnawing rodents have taken their toll, causing roofs to sag and walls to follow close behind. Over time, the desert has reclaimed much of its territory, and today places· like Providence, Skidoo, Leadfield, Cerro Gordo, and Panamint City are true ghosts. Some have fared better and today claim a historical niche as partial ghosts—places like Ballarat and Goldstone and Ludlow. At least one died and came back to life: Calico.

The Calico Mountains lie just northeast of Barstow, and during their heyday, the mountains' five mines produced between thirteen and twenty million in silver and another nine million in borax. The boomtown called Calico was born in 1881 and claimed five saloons, three restaurants, assorted stores and hotels, boardinghouses, assay offices, and a school. By 1907, with the mines played out, the town died and gradually fell into disrepair. In 1951, Walter Knott,

who had himself worked in the mines in 1910, purchased what was left of the old boomtown and turned it into a tourist attraction. Some of the original buildings still stand: Lil's Saloon, Town Office, Lucy Lane's House, the R & D Company store, and the General Store.

Few of Bodie's original buildings remain, but enough are left to get a feel for boomtown life. Situated in the Bodie Hills north of Mono Lake, the weathered, wooden buildings sprawl across the desert landscape in an unexplainable mishmash. Whatever its appearance, Bodie is a true ghost town, a feeble shadow of its 1879 to 1880 heyday when its population exploded from twenty to ten thousand.

Gold—lots of it—lay under the hills, and it was not long before word got out. By the time the place was booming, Bodie claimed forty-seven saloons, ten faro tables, two banks, five stores, four fire companies, and a daily newspaper. Shootings were an almost daily occurrence, resulting in Bodie gaining a reputation as the "wickedest town in the West." Whatever its degree of wickedness, Bodie was one of California's richest gold strikes, and while the boom

Sunrise, Mount San Jacinto and Palm Springs

lasted, some thirty companies produced four hundred thousand dollars in bullion per month for a total production of ninety to one hundred million dollars.

By 1881, with the boom beginning to fade, Bodie's population dropped to less than three thousand; by 1887, it was around fifteen hundred; and by 1921, thirty people called Bodie home. In the end, only one family stayed on. It is to their credit that enough of Bodie remained to hand over to the California State Park System in 1962. Now, the Bodie State Historic Park is preserved in "arrested decay," and until the desert takes back every last wooden board and beam, Bodie will remain part of our common heritage.

California's desert is a paradox. It seems a wasteland, yet is mineral rich. It appears tough, yet is so fragile scars may never heal. It looks forsaken, yet is home to thousands of plants and animals. It appears as colorful as a camouflage jacket, yet is a kaleidoscope of subtle hues. It seems a no-man's-land, yet its immense reaches are punctuated by enough luxury resorts, guest ranches, ghost towns, and recreational facilities to suit anyone's taste. Somehow, it deserves a better name than "cactus country."

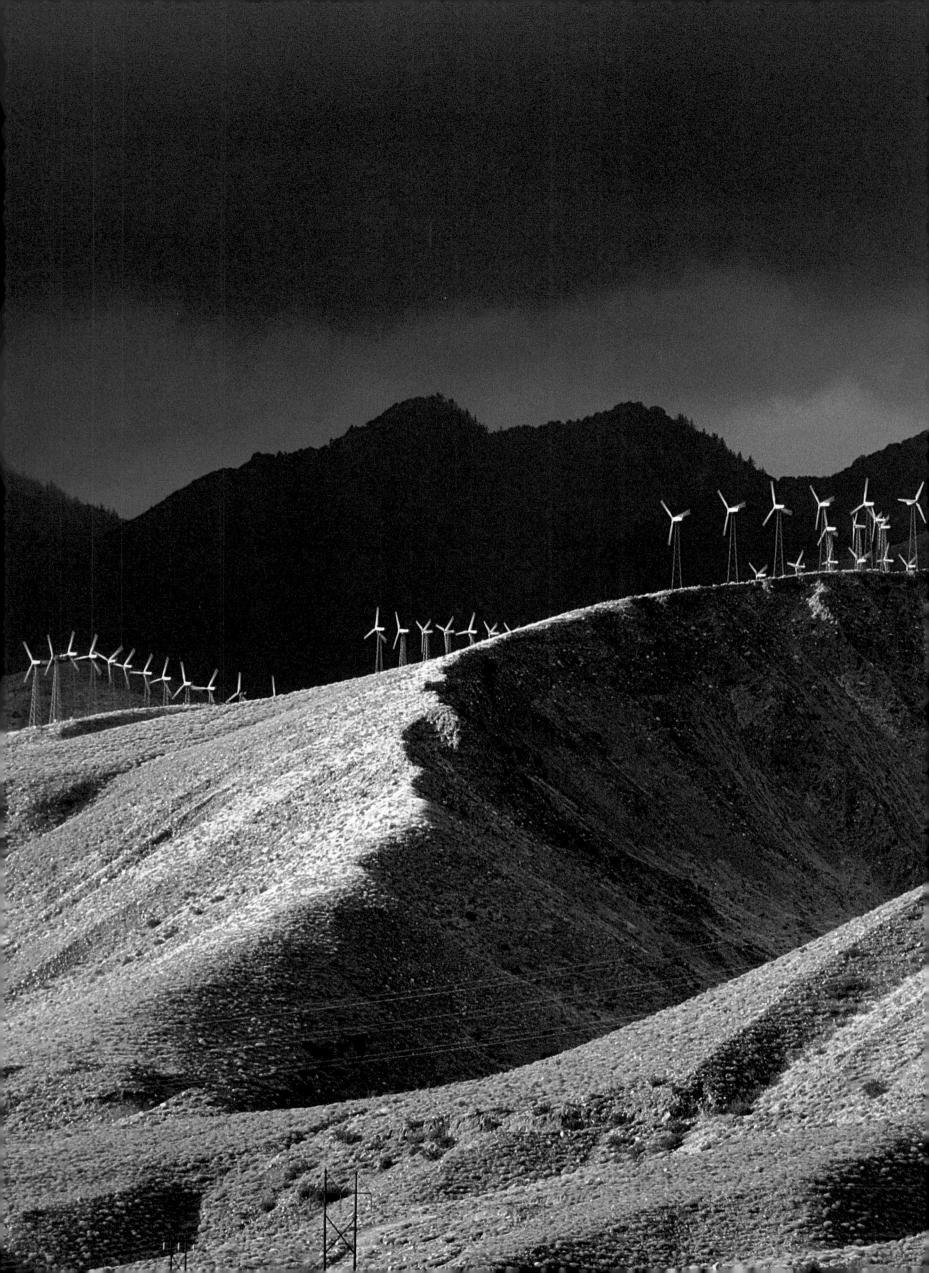

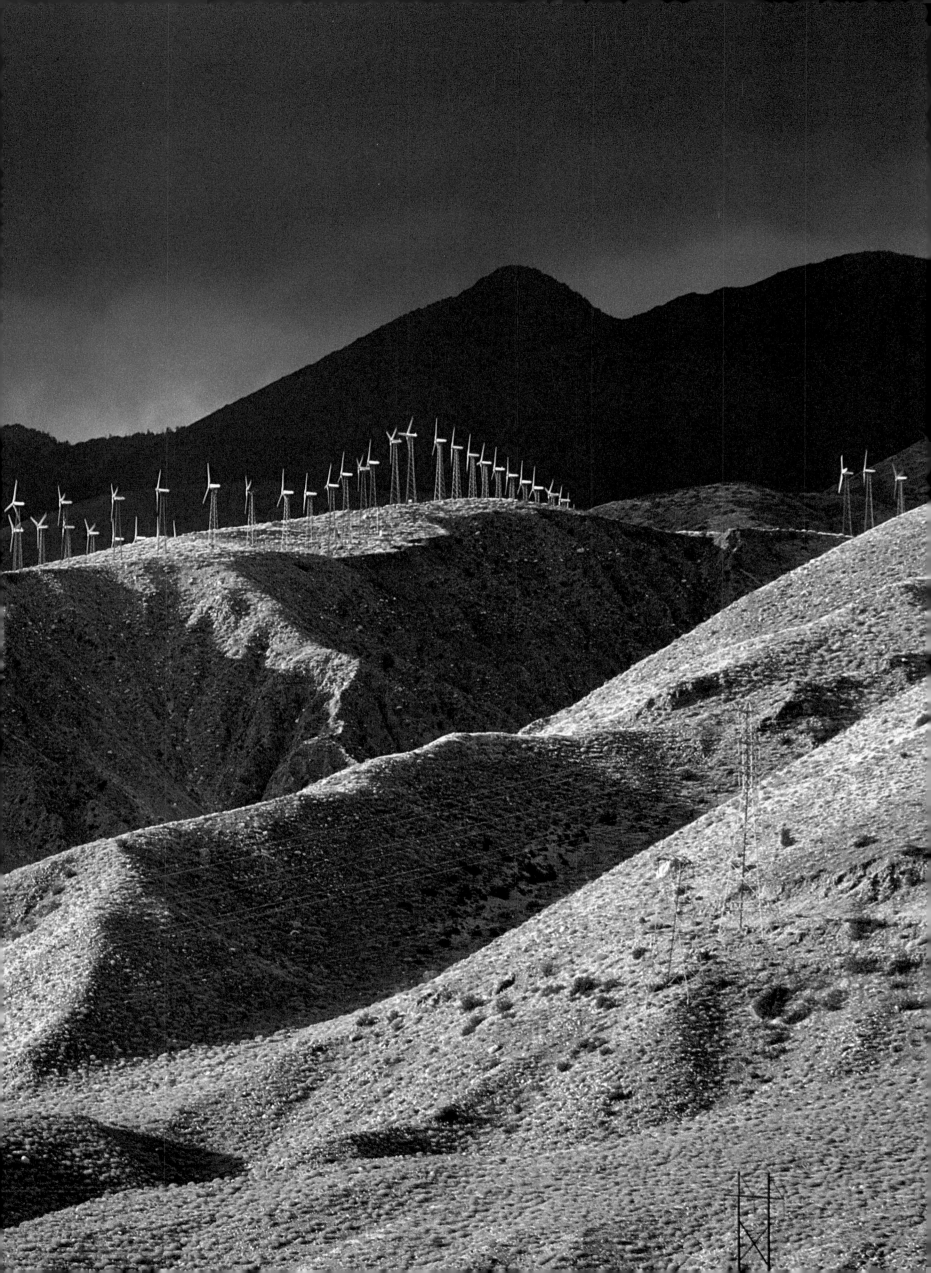

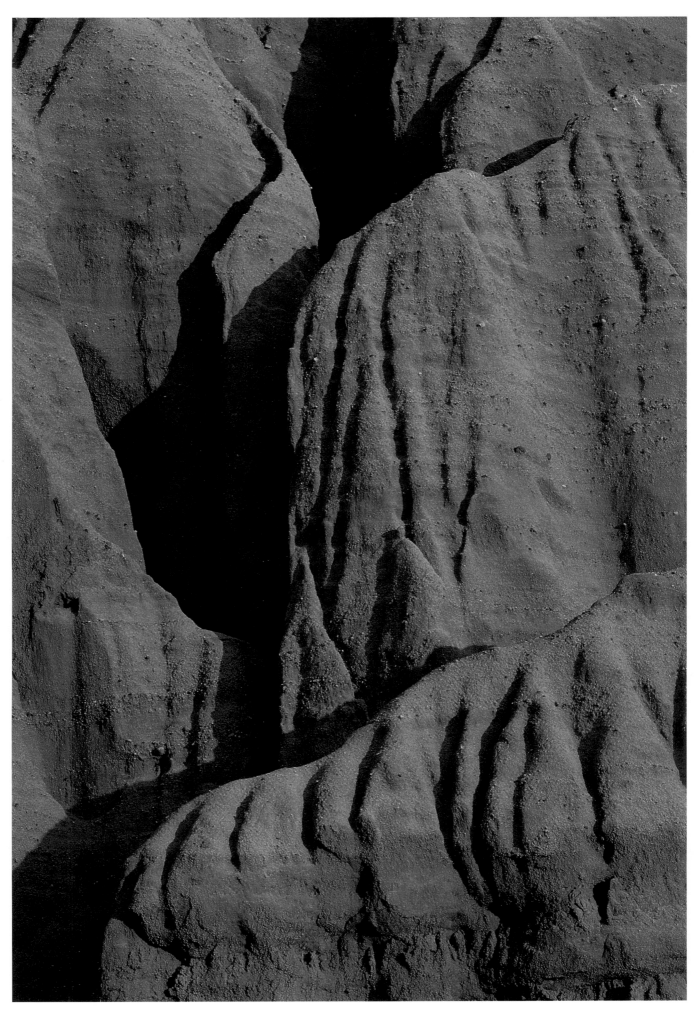

◄ ◄ Giant wind turbines provide electricity northwest of Palm Springs.
▲ Red Rock Canyon State Park evokes a scene from Utah's color country.
▶ Near Barstow, Calico, a ghost town turned tourist town, is a popular spot.

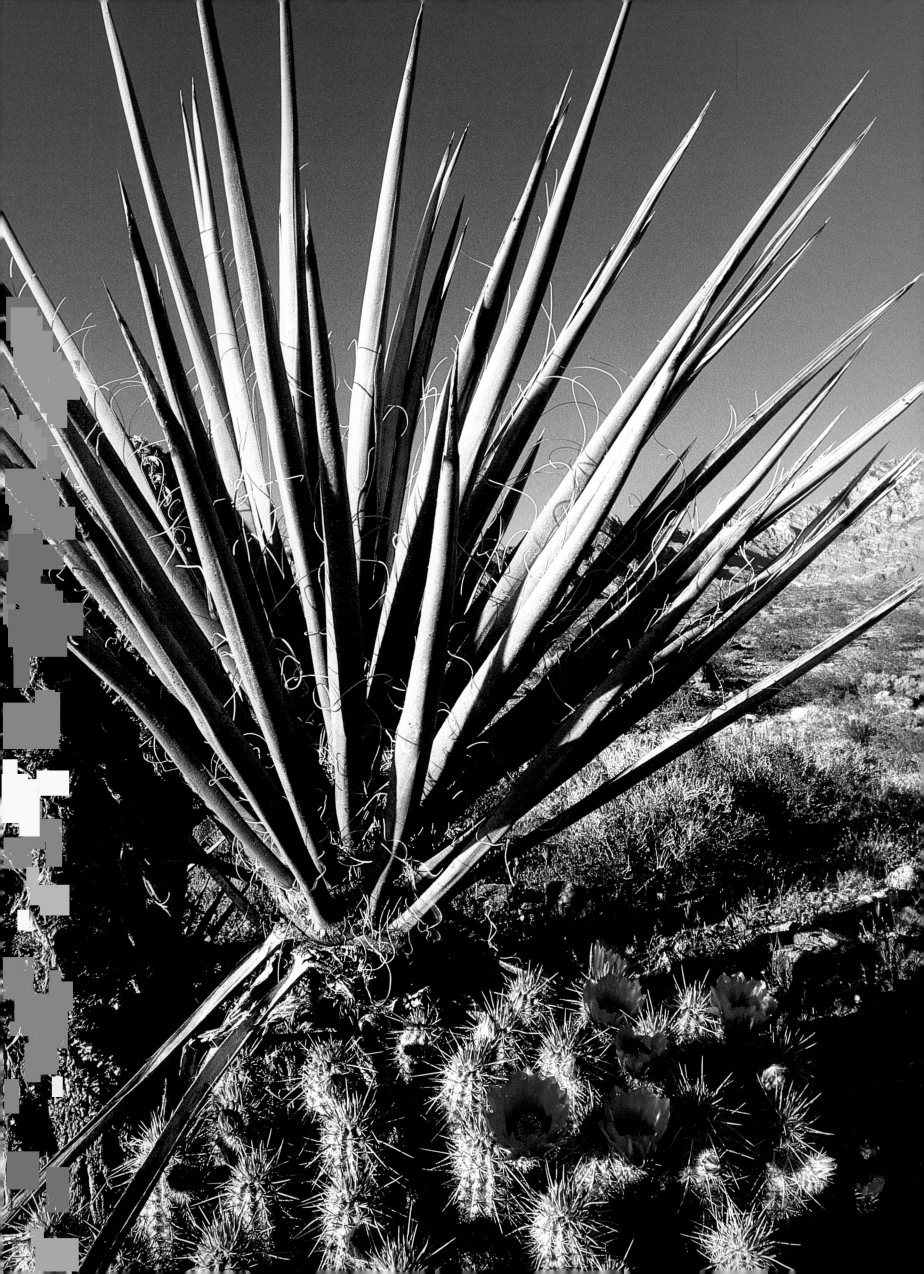

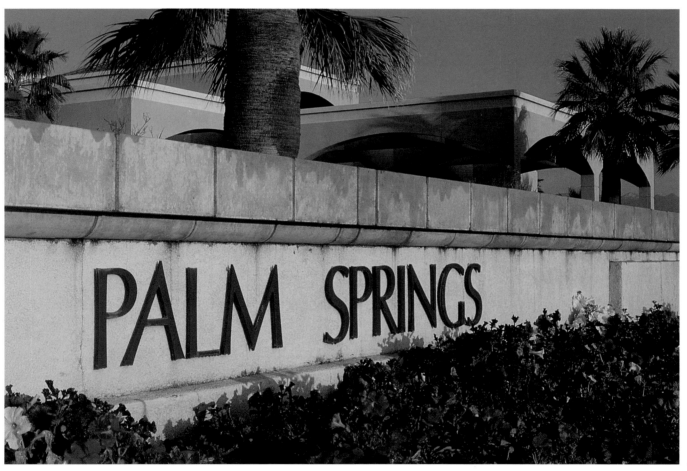

◄ Mojave yucca and blooming hedgehog cactus enhance the lower slopes of the Providence Mountains in the East Mojave National Scenic Area. The East Mojave boasts a surprisingly diverse lineup of canyons, mesas, dunes, caves, old Army "forts," and historic Indian and explorer routes.
▲ Flowers and palms are two Coachella Valley landscaping staples found at the Palm Springs Convention Center. The complex opened in 1988 and hosts conventions, as well as special events and consumer shows.

▲ The Coachella Valley claims more than three hundred hotels ranging from modest bungalows to European-style bed-and-breakfasts to luxury resorts, including Marriott's Rancho Las Palmas Resort in Rancho Mirage.

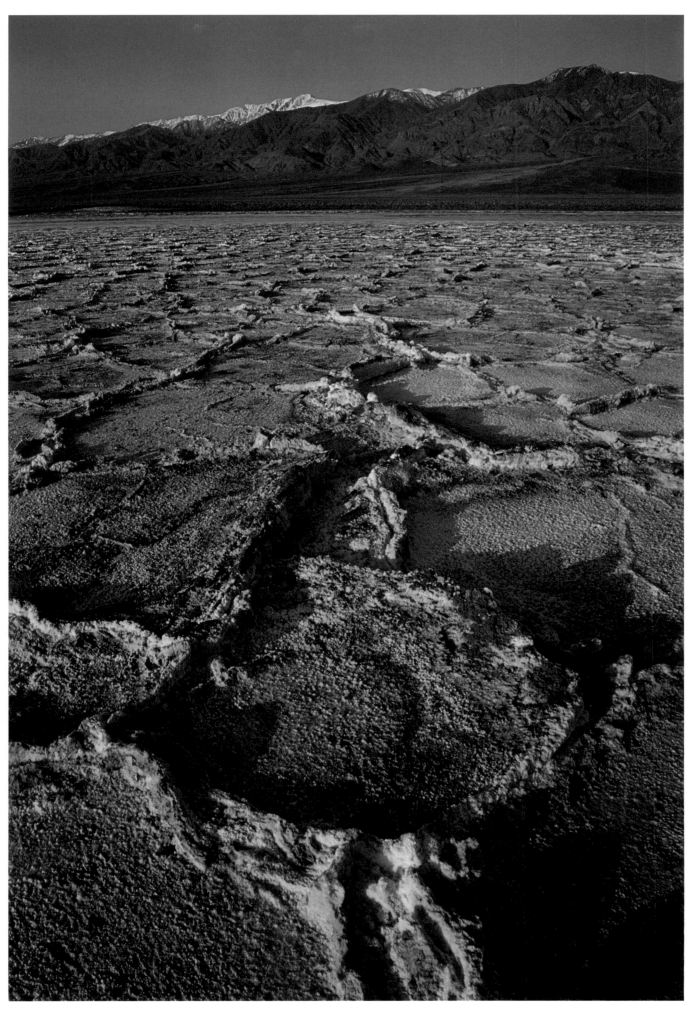

▲ Death Valley's salt flats, backdropped by the Panamint Range, were left behind by the evaporation of ancient Lake Manly. From a distance, the valley floor often shimmers, like a lake's surface, from reflected sunlight.

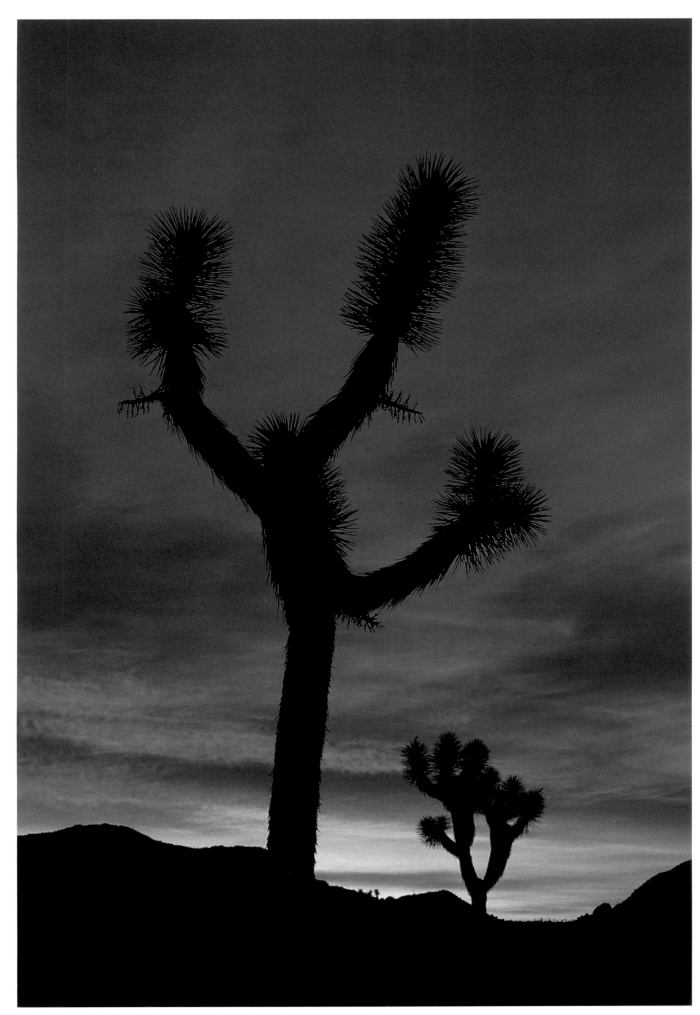

▲ Some have said that the spirits of Joshua trees dance in the dark. Besides the wonderfully contorted Joshua trees, the national monument also offers great rock outcrops, which are popular with climbers and sightseers.

In southern California, where the Colorado and Mojave deserts quietly slip together, there is a half-million-acre preserve set aside by the Department of the Interior for the protection of a fake. The charlatan is called a tree, but its trunk is fibrous; it shows off many branches, but its bark is soft and corklike; it produces clusters of shiny green leaves, but their ends could pass for daggers. Where the plants grow in profusion, they are called a forest.

But the whole premise is pure hyperbole. No one ever sipped lemonade beneath the impostor's cooling shade; laughing children have never swung from its branches; and no logger ever rushed the tree to market. For the plant is not a tree. It does not produce annual growth rings, and its branching is erratic. Were it not for the large, springtime blossoms and the larvae of the yucca-boring weevil, the fake would look nothing like a tree. It would, instead, be a pencil-like object about forty feet tall — and the whole farce would never have begun. Besides, who ever heard of a tree named Joshua?

Perhaps not many, and little wonder. The shaggy phony is really a large yucca belonging to the agave family.

Joshua Tree
&
the Southern Desert

Wall art at Glamis store, Imperial Sand Dunes

Botanically, it is *Yucca brevifolia,* but the curiously misshapen specimen has at times been nicknamed tree yucca, desert plant, giant yucca, and praying plant. The tree misnomer itself dates back to a time when early pioneers discovered the strange desert dweller and thought its many upstretched branches or "arms" resembled biblical Joshua waving them onward. They christened the unusual plant Joshua tree. And though it has proven an inaccurate title, it is still the one most commonly accepted.

The Joshua tree is one of the oldest-known desert plants. It is also the Mojave's most distinctive. Perhaps during the more humid prehistoric times, the Joshua populated a great portion of the low-elevation desert. But today, its crazy shape dots only the Mojave uplands, growing mostly above three thousand feet. In the thousands of miles of American desert, only a few small segments of California, Nevada, Utah, and Arizona claim the Joshuas' presence. Yet it is within Joshua Tree National Monument, 146 miles east of Los Angeles, that the impersonator attains its highest stature and its greatest beauty. Rising to a lofty thirty-five to forty

feet and producing a trunk two to four feet in diameter, the tree imitator sprawls across the monument's northern edge and eventually disappears into haze-hidden horizons.

Like any pristine woodland, the Joshua tree forest is a composite of unbranched infants, Medusa-crowned elders, fallen patriarchs, and every combination in between. A Joshua seedling begins life slim and pole-straight, with but one dense cluster of needle-tipped leaves at its crown. It can remain in that state for any number of years. The eventual mazelike branching is the result of a terminal bud's death — a process effected through both normal blossoming and yucca-moth activity. In either case, the tree is forced to send its damaged limb in a new direction.

Almost all yuccas rely on a small butterfly known as the Navajo yucca borer (or yucca moth) for pollination. Especially so the Joshua. Only this insect has the special ability to purposely collect and deposit the pollen necessary for seed production. This deliberate fertilization also ensures the survival of her species, for only pollinated flowers produce the seeds required to feed the larvae that hatch from the eggs deposited at the flower ovary.

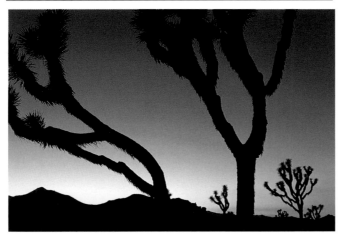

Sunrise, Joshua Tree National Monument

No matter its age, the pseudotree is commercially worthless. Yet in a land where commonplace trees are scarce, the counterfeit does meet some crucial needs. At least twenty-five different species of desert birds are known to use the Joshua tree as a nesting site. Scott's orioles incubate small eggs among shady leaf clusters, while the ladder-backed woodpecker and red-shafted flicker prefer to drill nest holes in a spongy trunk or limb. Others, like the sparrow hawk and loggerhead shrike, simply utilize the loftiest branches to eyeball an unwary grasshopper or skittering lizard.

As striking as the Joshua tree is, there is more to the national monument than its army of forest fakes. Within the park's 870 square miles are native fan palms, springs where birds and desert bighorn congregate, Indian petroglyphs that have never been deciphered, abandoned gold mines where winds still whisper of ambushes and gunfights, and a hidden valley that legend says was home to the McHaney Gang and their horde of rustled cattle.

Beyond all that, the monument claims some of the state's most scalable rock piles, a landscape whose geologic history is readily visible, at least a hundred miles of sandy trails, hints of a fortune in raw gold hidden by a prospector who met an untimely death, and one of the most impressive views of the Colorado Desert ever found.

The panorama called Keys View sits literally on the edge of a mountain. From its altitude of 5,185 feet, the great sweep of the Coachella Valley below appears a gigantic relief map. At center stage is the chocolate-colored San Jacinto Mountains, its uplands dominated by the 10,804-foot-high Mount San Jacinto. At the far right, plunging down from the north, are the San Bernardino Mountains, its highest point the 11,499-foot-high San Gorgonio Mountain glistening in the sun — often snow-dusted even into late summer. To the far left, thirty miles distant and 234 feet below sea level is the gray speck that is, in reality, the thirty-five-mile-long watercourse known as the Salton Sea.

The inland sea lies within a two-thousand-plus-square-mile depression in the earth known as the Salton Basin, Salton Sink, or Salton Trough. Whatever its name, the gigantic ditch stretches all the way from San Gorgonio Pass to the Gulf of California, and even though the trough is but a few miles wide along its northwestern edge, it widens out to nearly seventy miles across at the Mexican border. In its entirety, the Salton Basin constitutes the largest area of dry land below sea level in the Western Hemisphere, and within its borders lie not only the Salton Sea, but those fertile valleys named Mexicali, Imperial, and Coachella.

Oddly enough, this whole region was prehistorically a relatively flat, cool land where forests rimmed freshwater lakes and creatures large and small homesteaded the grasslands. The area's main waterway, the Colorado River, ever pushing itself southward, periodically altered its channel or overflowed its banks — either way, leaving behind quantities of fresh water. The moist coastal air, unhindered by mountains, flowed inland; frequent rainstorms fed the land.

But it was not to last. Movement along the San Andreas fault, which even today passes through the Salton Sea and San Gorgonio Pass on its way northwest, began creating a massive trough as the mountains pushed up and the land tilted down. With the moist coastal air partially cut off by the newly forming mountain ranges, the climate became ever drier. In turn, the San Andreas became more active; with each seismic episode the mountains pushed higher and the trough deepened. In time, with the coastal moisture completely cut off, the whole region turned to desert.

The Salton Sink remained essentially dry until the early 1900s. By then, irrigation canals built to divert water from the Gulf of California into the Imperial and Coachella valleys had begun zigzagging across the basin's aridity like concrete-lined arteries. Never mind that the river was forty miles away and nearly four hundred feet higher than the below-sea-level valleys. A steady supply of water would turn the valleys into agricultural meccas.

Everything worked well until 1905. That spring, the Colorado River flooded in Mexico; with its waters backed up on the south, the river breached a weakened levy near Yuma, Arizona, and began pushing itself northeast

through the concrete ditch. By late summer, the entire Colorado River was surging backward into the Salton Trough. By the following summer, the river was raising the level of the Salton Sea by seven inches a day over an area covering approximately four hundred square miles.

It took two years to get the river back on its original course, and all the while the Colorado's entire southward flow was being captured by the canals and dumped up in the Salton Basin to create a shimmering watercourse nearly as far below sea level as Death Valley and larger in its entirety than Lake Tahoe. It was an oddity in a land known for shifting sands and heated haze. And even though the inland sea had been birthed accidentally, its tourmaline depths teemed with transported river fish, and its sandy edges wore the constant signatures of hundreds of shorebirds, mammals, and sightseers.

Today, the Salton Sea continues to expand as agricultural runoff from surrounding valleys joins runoff from the local mountains and funnels into the desert waterway. The native river fish, which died out as the trapped water turned ever more saline, have been replaced by marine species, especially the orangemouth corvina, the sargo, and the gulf croaker—planted originally in the early 1950s by the California Department of Fish and Game.

Along the sea's northeastern shore lies the Salton Sea State Recreation Area with its boat ramp, swimming area, and campgrounds. On the sea's southern edge is the forty-seven-thousand-acre Salton Sea National Wildlife Refuge, established in 1930. Although much of the acreage was originally dry land, the sea's steady rising over the years has left only about two thousand acres on dry land. No matter. The refuge is still a haven for thousands of shorebirds, marshbirds, and waterfowl—not only those who inhabit the area year-round, but for the horde of Pacific Flyway stopovers as well. More than 371 bird species have been recorded on the refuge and its adjacent croplands, giving the Salton Sea National Wildlife Refuge title as harboring the most diverse bird species found at any of the more than four hundred national wildlife refuges.

A scant ten miles west of the Salton Sea, at the end of the Borrego-Salton Seaway, lies the six-hundred-thousand-acre Anza-Borrego Desert State Park—largest of California's state parklands and one of the largest state parks in the nation. Sprawling across nearly a fifth of San Diego County and parts of Riverside and Imperial counties as well—and stretching north to south from the Santa Rosa Mountains to the Mexican border—Anza-Borrego is host to some one million visitors annually. Not surprising. The park is a study in contrasts: mountains and badlands, palm oases and dry washes, old stagecoach trails and modern highways, common cholla cactus and rare elephant trees, minnow-like pupfish and magnificent bighorn sheep.

The park's double name, Anza-Borrego, commemorates two very different aspects of the southern desert: a brilliant Spanish explorer by the name of Juan Bautista de Anza, and the captivating rock-slope inhabitant, the bighorn sheep, the creatures long ago named *borrego* by the Spanish.

In 1774, with the Spanish crown's hold on Alta California shaky and encroachment by Russians and English ever a threat, the Viceroy of Mexico determined that what was needed most was a dependable inland supply route from Sonora, Mexico, to the struggling missions at San Diego, San Gabriel, San Luis Obispo, and Carmel. On January 9, 1774, Captain de Anza, then the commander of the Spanish presidio at Tubac in Sonora (now southern Arizona), began his pathfinder journey in the company of two priests, twenty-one soldiers, and two Indians—one an interpreter and the other a guide.

The entourage headed northwest, crossed the present international boundary in Imperial Valley, cut across the area that is now Anza-Borrego Desert State Park, traveled over the peninsular mountains at San Carlos Pass, and arrived at the San Gabriel mission on March 22, 1774. With the feasibility of a supply route between Sonora and the coast now a proven fact, the Viceroy of Mexico began to make plans to strengthen Spain's hold on the California territory. And who could better lead the new colonists westward than Juan Bautista de Anza himself?

Rock Hill, Salton Sea National Wildlife Refuge

The destination was near present-day San Francisco. With the Spanish population of California consisting of less than one hundred soldiers and not quite a dozen priests, Anza recruited and outfitted a party of nearly two hundred forty—mostly women and children—as well as a thousand head of stock. The odd assemblage left Tubac on October 23, 1775, retracing the route of the original expedition, and arrived in Yerba Buena on March 28, 1776. The Anza Trail had been established almost without mishap. It was a land route that would be used by at least three hundred colonists over the next five years; according to the Spanish census of 1790, approximately 50 percent of all Alta California colonists—as well as most of their horses and cattle—had entered California via the Anza Trail.

By 1824, Mexican explorers had blazed another route across the southern desert between the Colorado River and the coast. For the most part, their path paralleled Anza's, albeit ending in Los Angeles. It was called the Sonora Road and, later, the Southern Emigrant Trail. In time, it turned into the main thoroughfare across the southern

desert, used by General Stephen Watts Kearny's Army of the West, the Mormon Battalion, the Butterfield Overland Stageline, and hordes of cattlemen, homesteaders, and prospectors—all headed for coastal California.

Bits and pieces of the original trail are still visible within Anza-Borrego Desert State Park. Narrow, cobble-strewn, and churned up by hundreds of hikers' feet, the trail still casts a mesmerizing influence on those who seek it out. By day, it is little more than imagination into the past. But on those nights when clouds shroud the moon and thunder reverberates against a thousand granite hills, some say that on the wind comes the clinking sound of horse tack, the squeak of wagon wheels, the crack of a whip, and the pounding of a hundred hooves.

Inhabiting the park's craggy wilds is the *borrego*, better known as the Peninsular bighorn sheep. Stately in manner and nearly poetic in motion, the Peninsular bighorn reigns as patriarch of the southern desert and is considered to be San Diego County's official animal. Yet, even in its protected state, the Peninsular bighorn population has decreased dramatically over the last twenty years; whereas

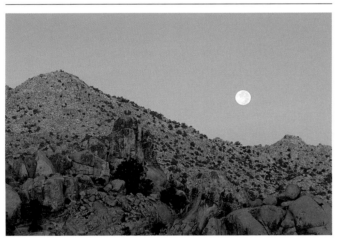

Moon at dawn, Joshua Tree National Monument

there were approximately 1,170 in 1979, today's nation-wide total of Peninsular bighorn is less than 400—with the largest population residing in Anza-Borrego.

They are believed by scientists to be relatives of wild sheep who migrated to North America via a Pleistocene land bridge that once existed between Siberia and Alaska. Within the state of California, the species known as *Ovis canadensis* has three subspecies: the *nelsoni* inhabit the area around Death Valley; the *californiana* live in the region around the White Mountains; and the *cremnobates* reside mostly in Anza-Borrego.

Whatever their scientific title, the creatures known collectively as desert bighorn claim some common characteristics. All have muscular bodies, thick necks, and hair colors that range from dark brown to light tan. They have patches of white on their belly, rump, backs of their legs, muzzle, and eyes, and all have a short, dark brown tail. The ewes have short, slightly curved horns, while the rams have impressive appendages that curve up and back over their ears and down around and up past their cheeks, rather like

huge cornucopias. Their bounding gate on level ground is about fifteen feet; on nearly perpendicular inclines, about thirty feet. Their running speed is around twenty-five to thirty miles per hour.

Perhaps even more astonishing than their ability to get around easily in places man can barely traverse, are their exceptional senses. Bighorns hear unusually well; their ability to smell is exceptional; and with eyesight eight times more powerful than the human eye, they can clearly see someone walking along the desert floor from at least a mile away.

All require steep, rugged terrain, adequate food, and permanent water. Lambs are born any month in the warm California desert, though most make an appearance in late winter and early spring. About 80 percent die in the first six months, mostly due to coyote or mountain lion predation. Those that escape predators or viruses can claim a life-span of eight to twelve years. Whether these seldom-seen creatures are spied atop a rocky crag, or silhouetted against the sunset, or munching on a barrel cactus, or snoozing on a warm rock, one thing is certain: seeing one of America's wild sheep is an experience seldom forgotten.

Even rarer in the southern desert than its bighorns is a curious plant with a swollen trunk, tentacled branches, blood-red sap, and papery bark that peels as readily as sunburned skin. Related to the tree family that pro-duces frankincense, *Bursera microphylla*, or elephant tree, usually grows farther south in northwestern Mexico. Yet other than a small showing in Arizona, this short, chunky tree makes its only United States appearance within the confines of Anza-Borrego Desert State Park, where the aromatic specimens reach heights of eight to twelve feet and claim diameters of approximately one foot.

Rarer still is a slim, silvery creature known as the desert pupfish. It is a relict species left over from a wetter past, and the few that remain live in small, usually salty bodies of water. Scientifically, the two-inch-long fish is *Cyprinodon macularius,* and its United States range is limited to the southern deserts of Arizona and California. Whatever its location, it has adapted to desert life so well it can live in water that ranges from mountain-fresh to ocean-salty. It tolerates water temperatures ranging from near freezing to 108 degrees Fahrenheit. Today, this remnant population is on the federal endangered species list—and those that call Anza-Borrego Desert State Park home have been relegated to manmade sanctuaries.

The southern desert is a storehouse of historical and geological treasures. It is a land where tamarisk trees shade an old stage station and wrinkled mountains still wear tailing scars of long-ago gold mines; where flowers bloom quickly or not at all and sunlit thorns of a teddybear cholla make it appear haloed in light; where interconnecting alluvial fans along mountain edges create bajadas and rock layers originally laid down horizontally have been folded, faulted, sheared, and uplifted into perpendicular masterpieces. It is both soothingly lonesome and wonder-fully alive. It is a seductive siren, and many are its suitors.

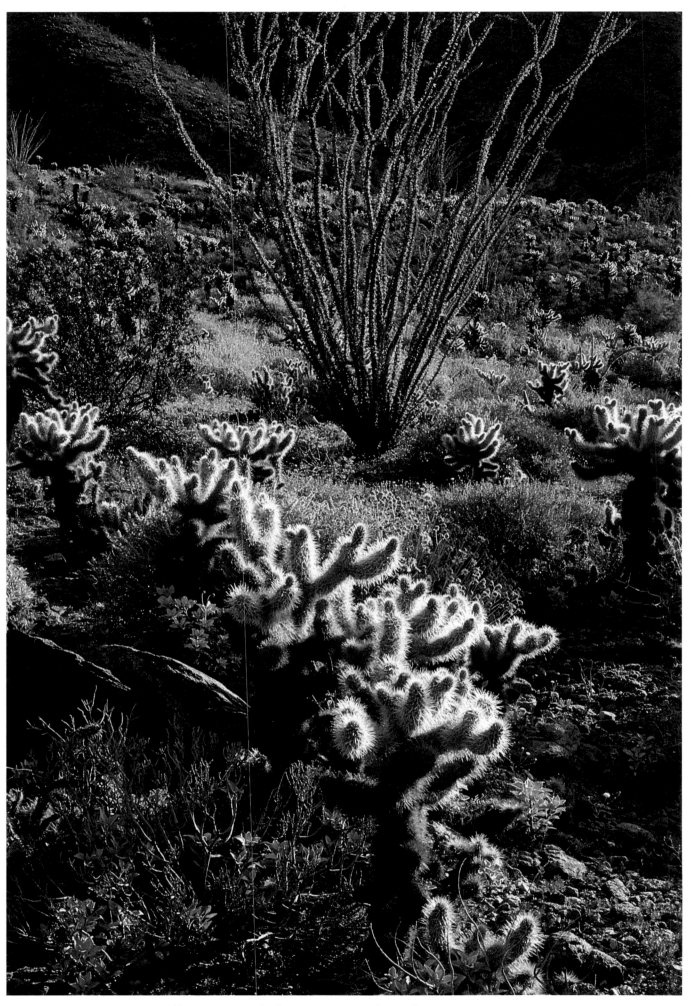

▲ Cholla (pronounced "choy-a") cactus and ocotillo ("o-co-tee-yo") are star attractions along the Cactus Loop Trail in Anza-Borrego Desert State Park. Ocotillo grows on open rocky slopes in many parts of the southern desert.

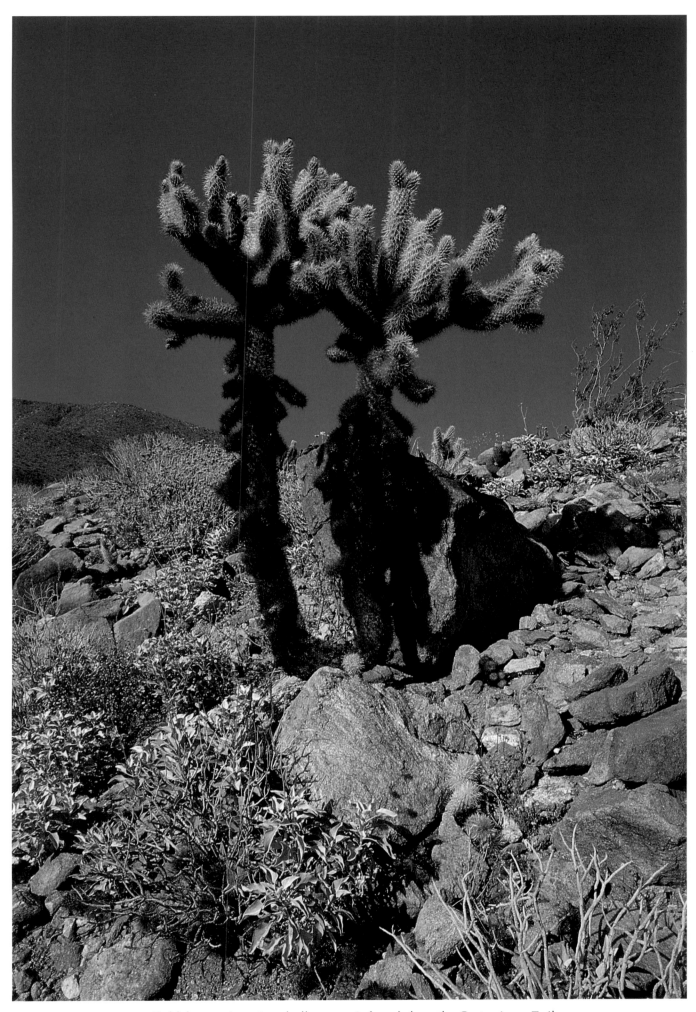

▲ Teddybear or jumping cholla cactus is found along the Cactus Loop Trail in Anza-Borrego. These plants may indeed look cuddly, but if you get too close, you will need tweezers or pliers to remove the barbed spines.

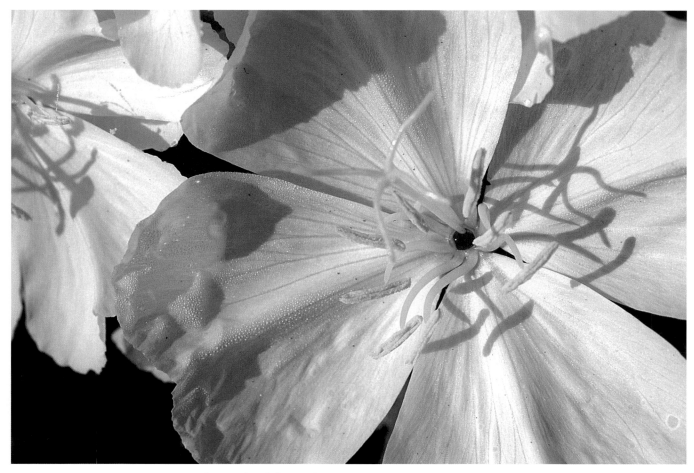

▲ In a good year, the delicate dune primrose and other wildflowers carpet much of Anza-Borrego. Blooms generally appear first on the Borrego Valley floor; as spring progresses, colors climb into the surrounding mountains. ► ► One of the desert's best overlooks, Fonts Point in Anza-Borrego, affords an eye-catching view of the Borrego Badlands' wrinkled landscape.

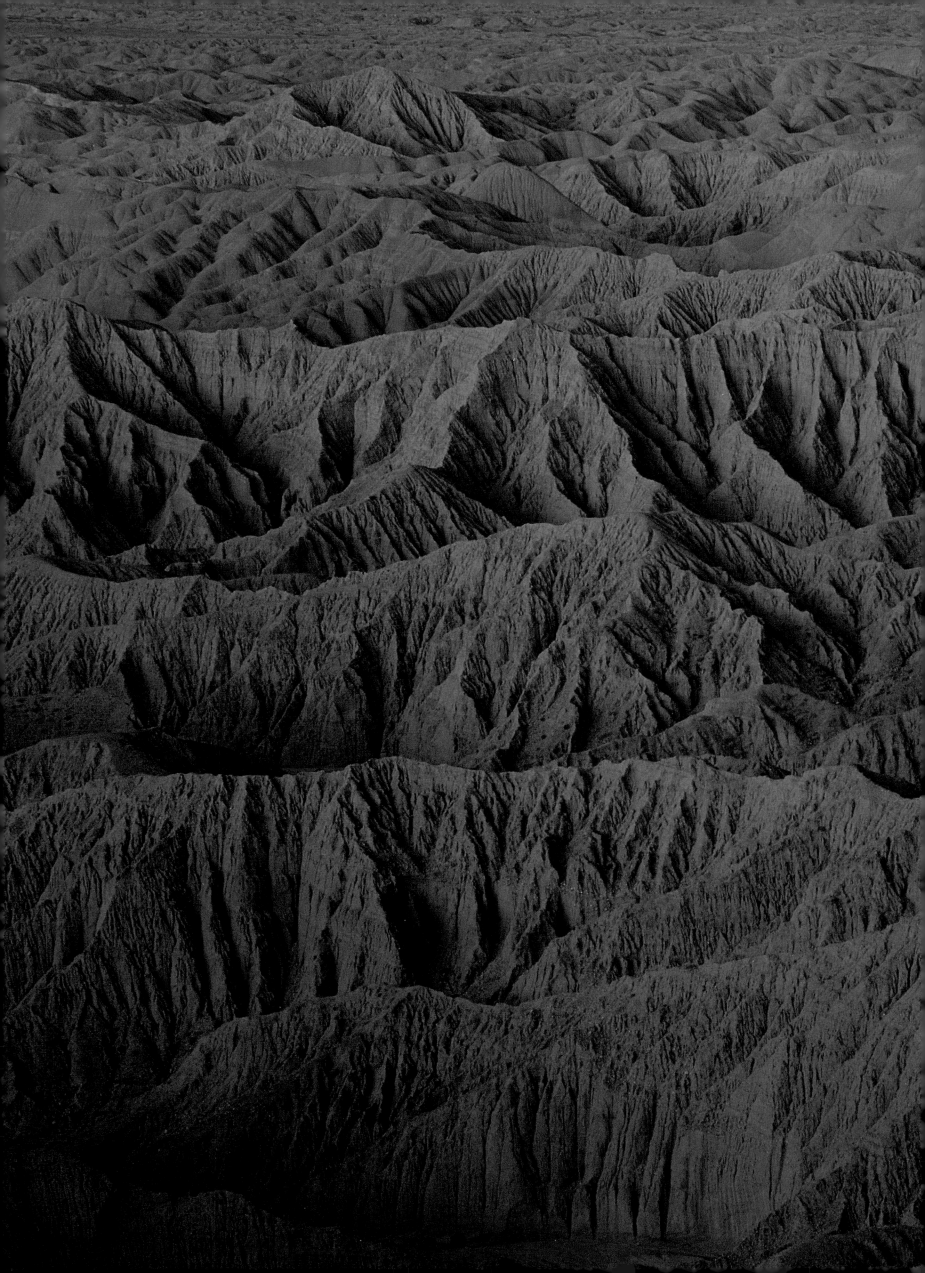

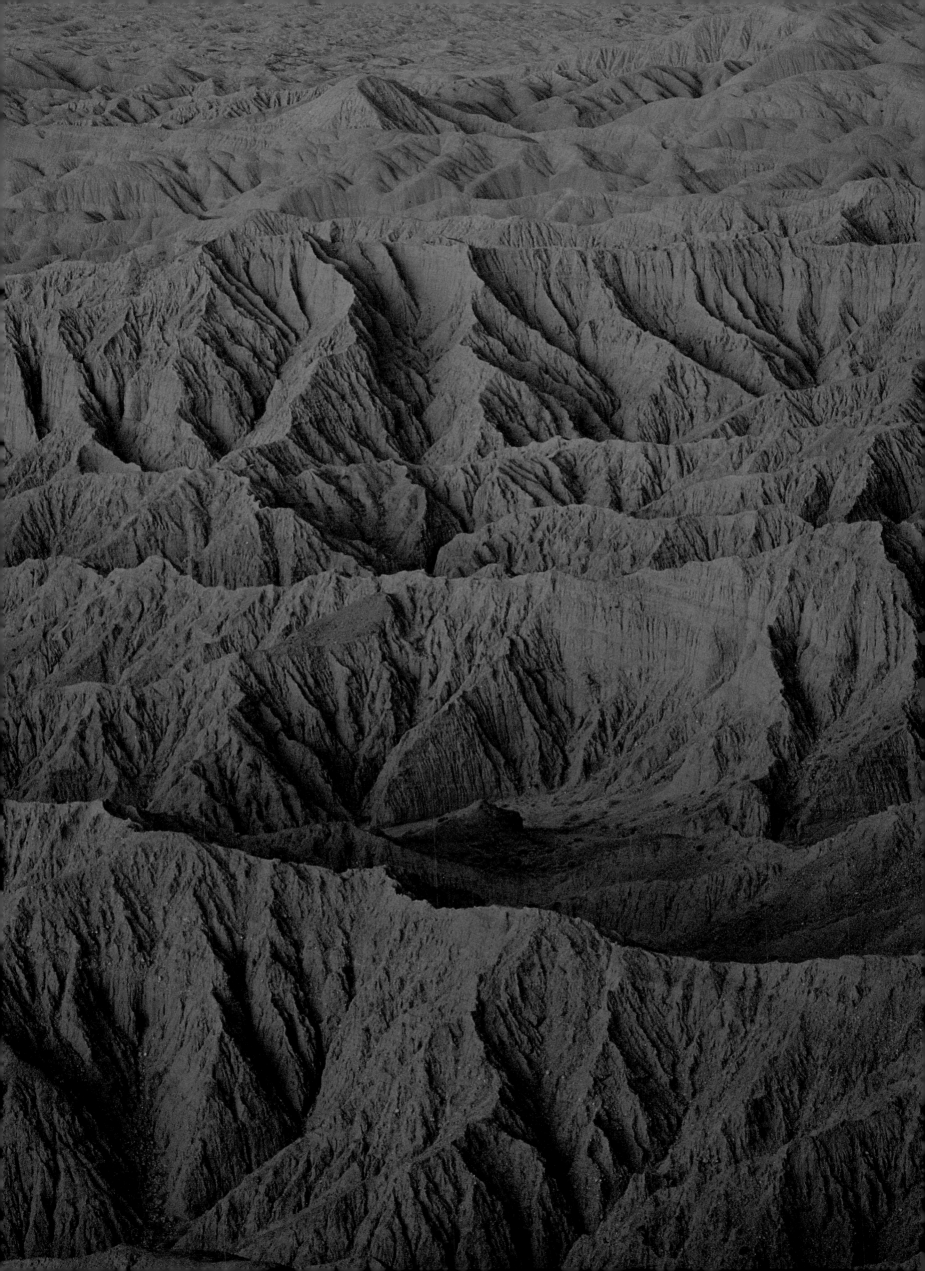

▲ Palm fronds grace some two dozen native groves in Anza-Borrego. Springs feed California fan palms and support wildlife and plantlife. These massive trees are considered the largest native palms in North America.
▶ Borrego Palm Canyon opens onto the desert floor near the Anza-Borrego Visitors Center. This canyon is the park's top draw, and here is why: about two hundred native fan palms swaying in the breeze, lots of lush vegetation, plenty of shade, and—in the wet season—a stream and mini waterfall.

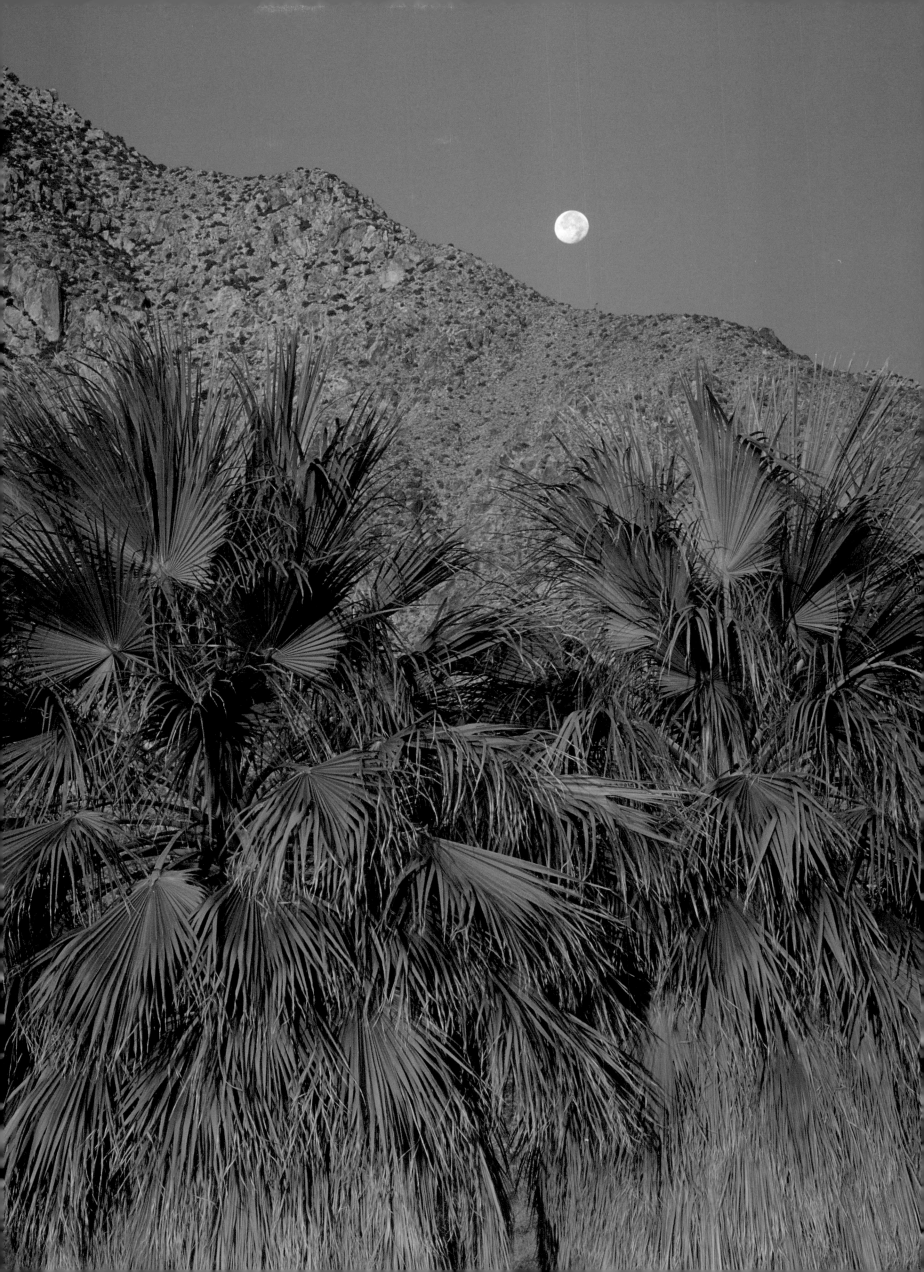

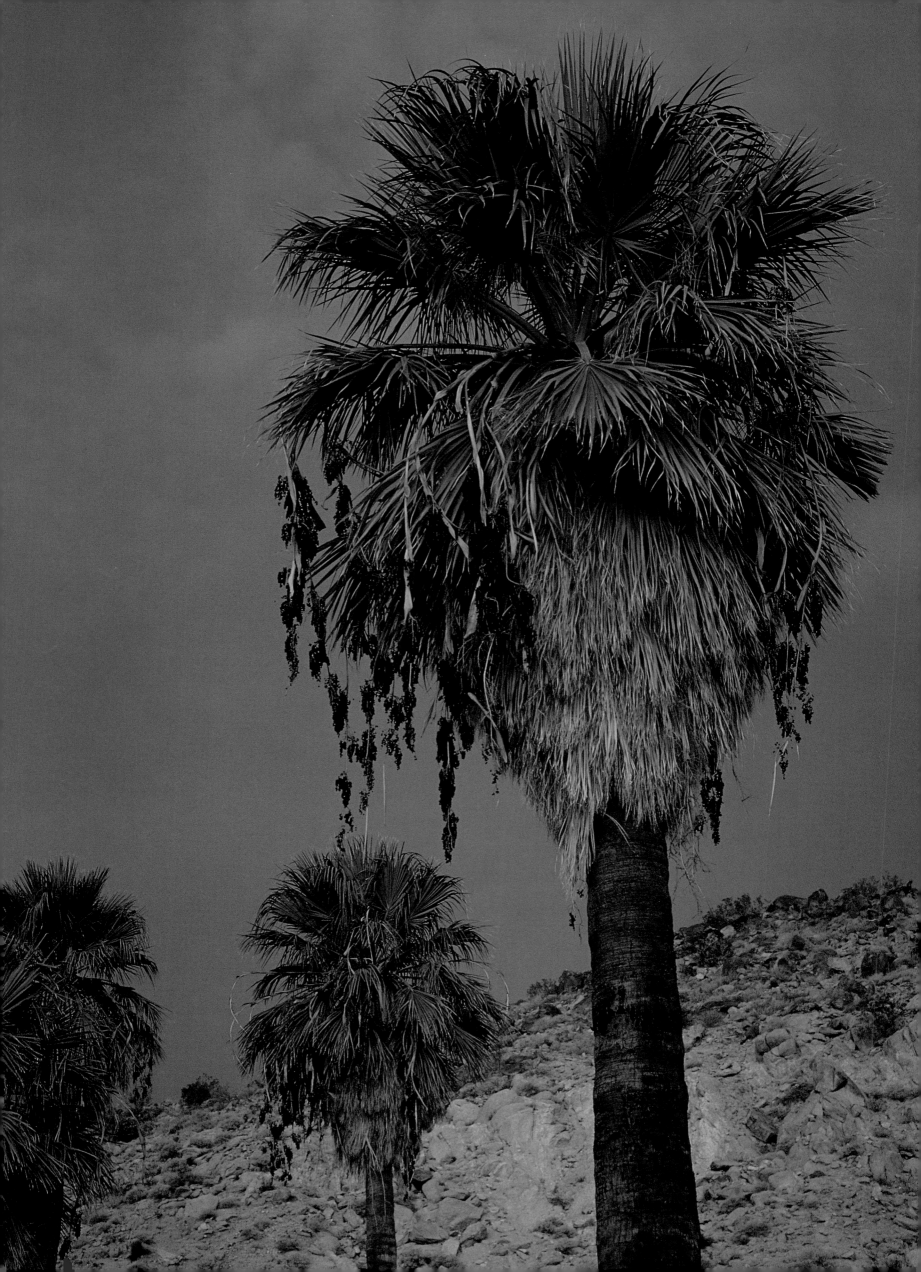

◄ Mountain Palm Springs consists of a cluster of native groves nestled in the canyons of the Tierra Blanca Mountains in southern Anza-Borrego.
▲ This Vallecito Stage Station once serviced the Southern Emigrant Trail.

▲ Big boulders, a natural spring, and cool temperatures highlight Culp Valley in Anza-Borrego's high country. From some viewpoints, an impressive panorama stretches from the Borrego Valley to the Borrego Badlands.

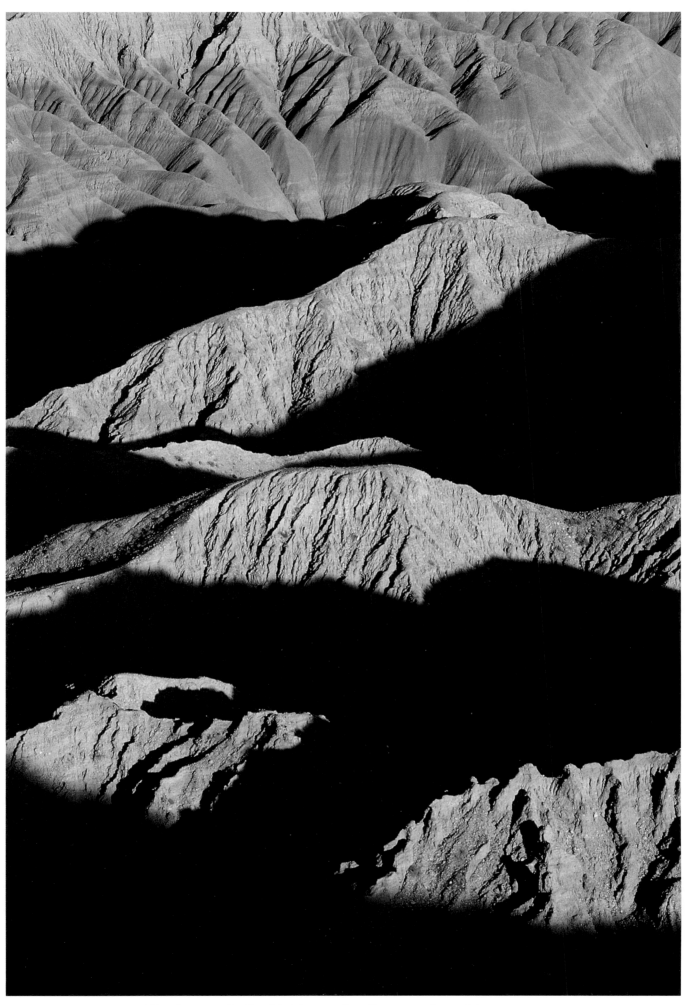

▲ The Borrego Badlands' ridges and gullies were formed by rainwater cutting into the soft, layered sediments. Because of the four-mile, sandy approach to this overlook, a four-wheel-drive vehicle may be required.

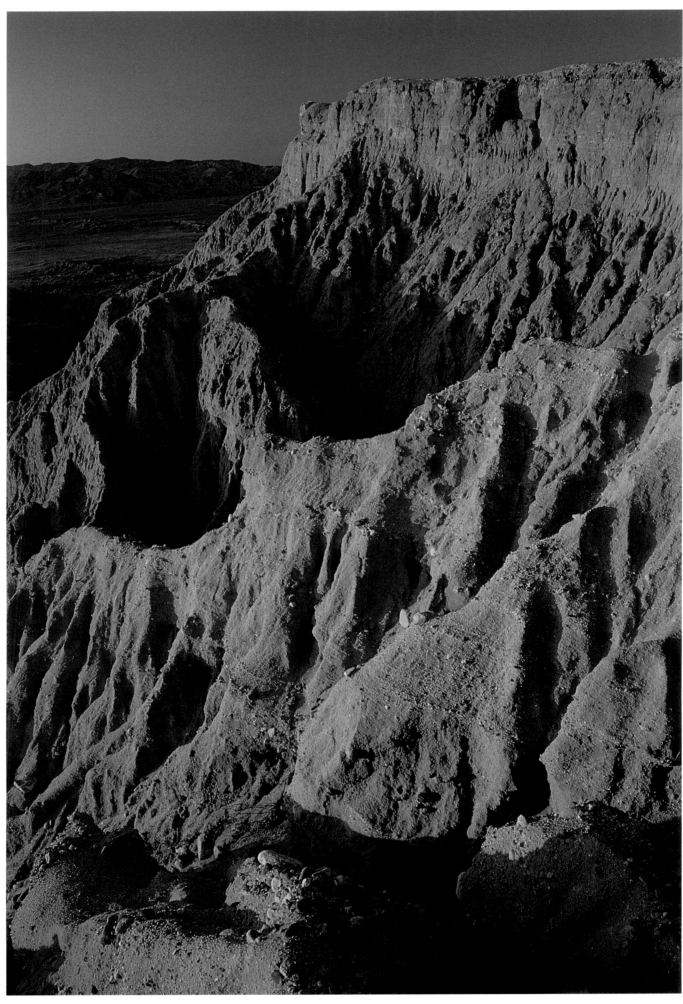

▲ On a clear day from Fonts Point, the view extends from the Borrego Badlands all the way to the Salton Sea. California's other dramatic desert overlooks are Dantes View in Death Valley and Keys View in Joshua Tree.

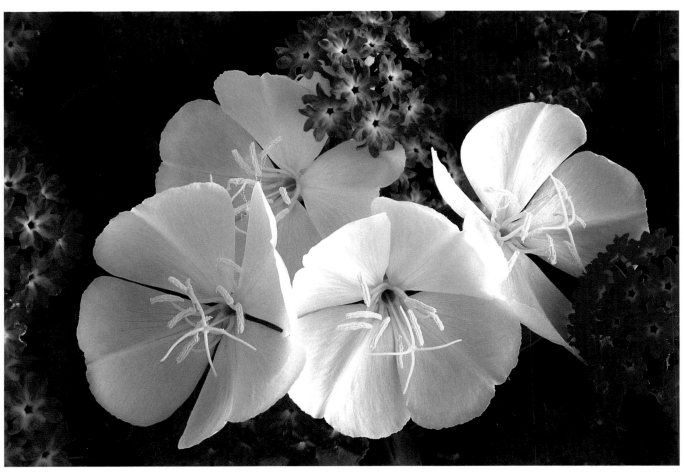

▲ Common springtime sights in Borrego Valley include the purple sand verbena and the white dune primrose. The quality of the wildflower season depends on the timing and amount of rainfall, along with temperatures.

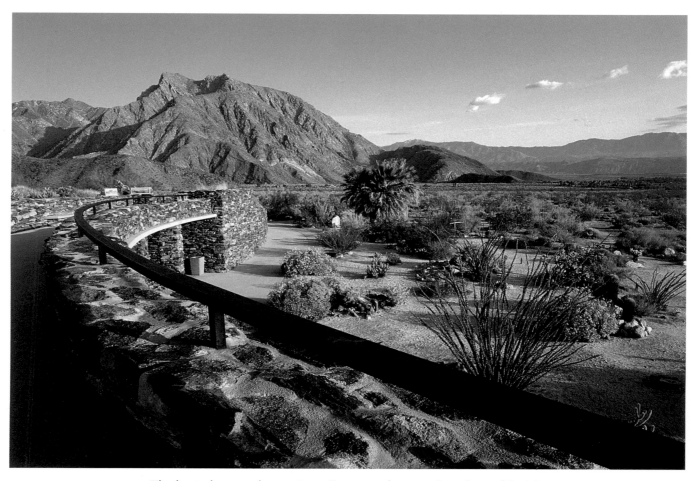

▲ The best place to plan an Anza-Borrego adventure is at the park's visitor center, just outside the area's commercial hub—the resort community of Borrego Springs. This semi-underground center was designed to blend into its desert setting: a garden of native plants, for example, covers the roof.

▶ Early-spring sunflowers carpet the desert floor along Henderson Canyon Road in Borrego Valley. Later, the season's show moves to upper elevations of Anza-Borrego—places like Culp Valley, Blair Valley, and Indian Gorge.

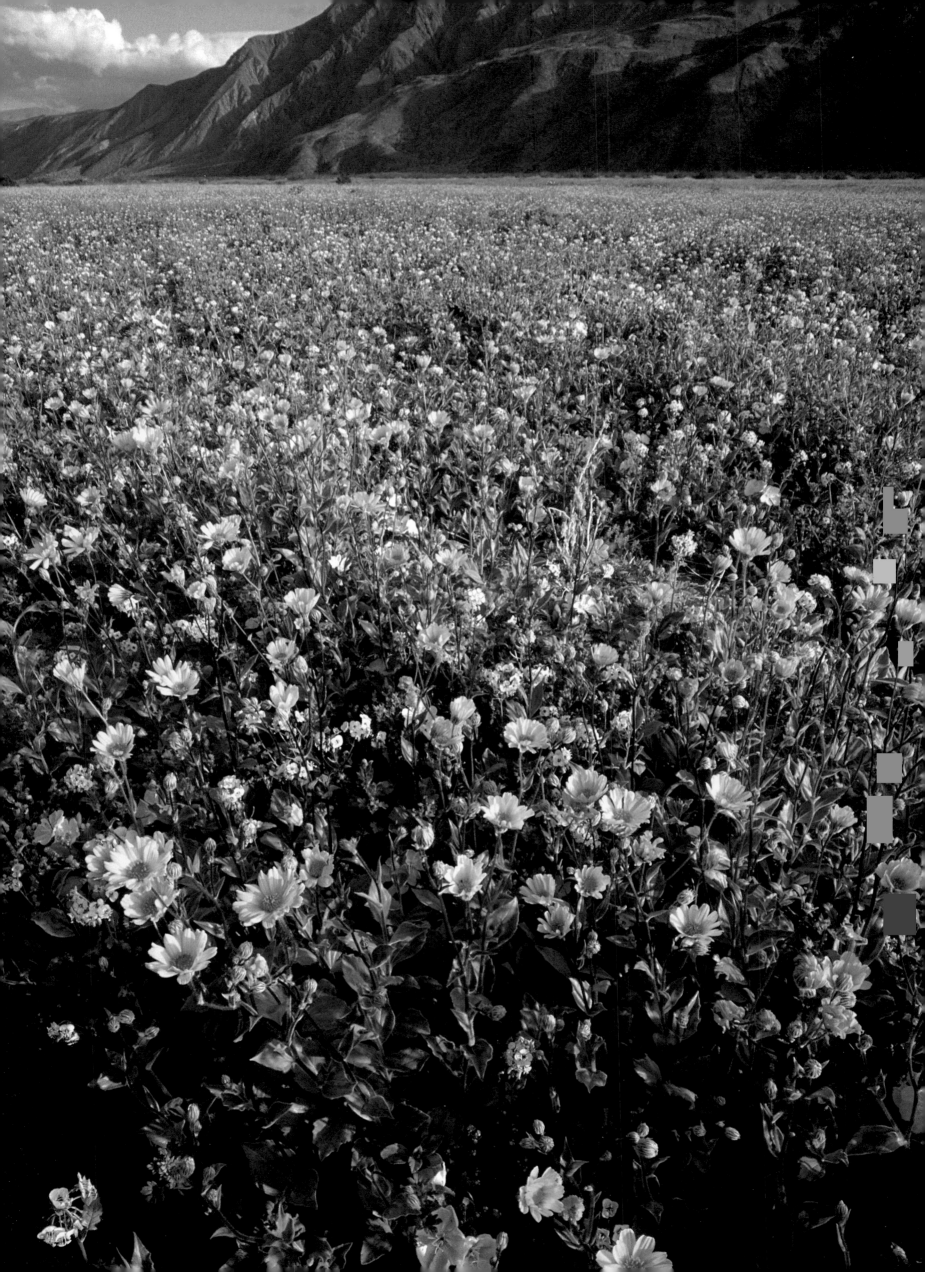

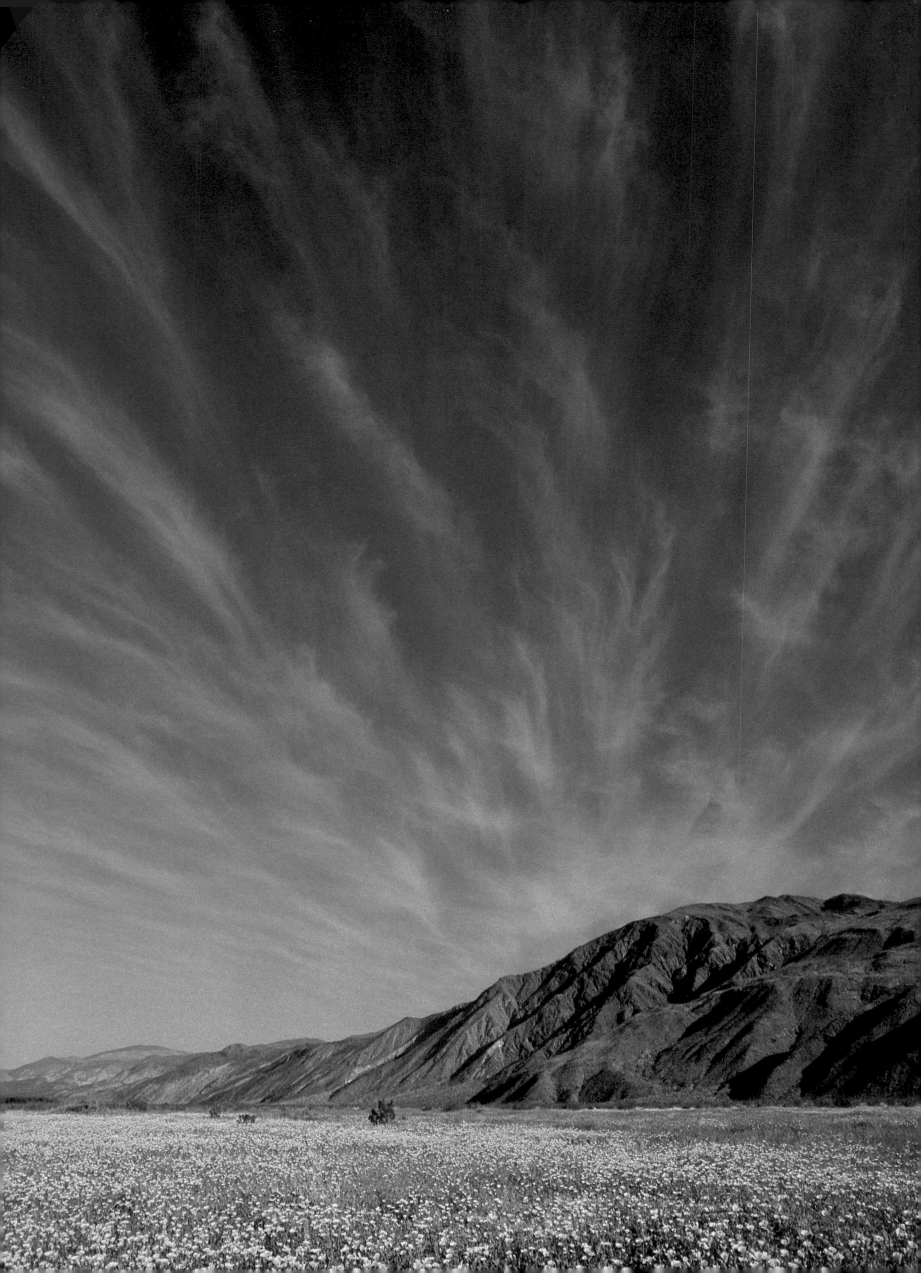

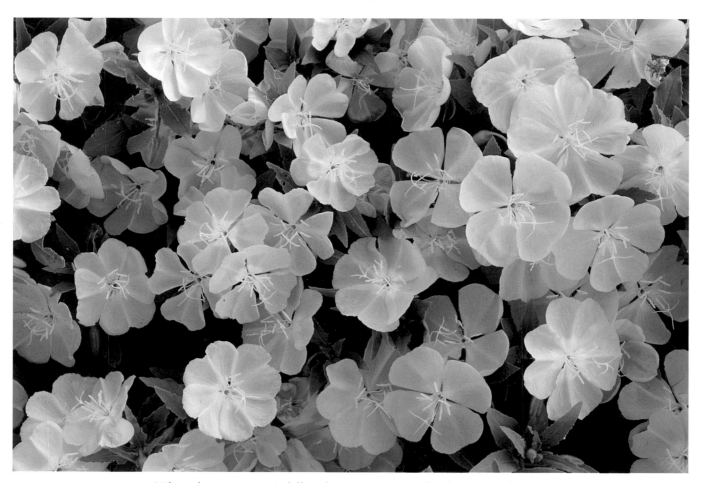

◄ When the season's rainfall and temperatures strike the perfect balance, the desert of Anza-Borrego bursts with color. One of the first stops on the spring color tour in the park is the mountain-ringed Borrego Valley. ▲ In a spectacular year, the dune primrose whitens broad expanses of Anza-Borrego like a light blanket of snow. At other times, the blooms look like tissue paper that has been scattered throughout the desert.

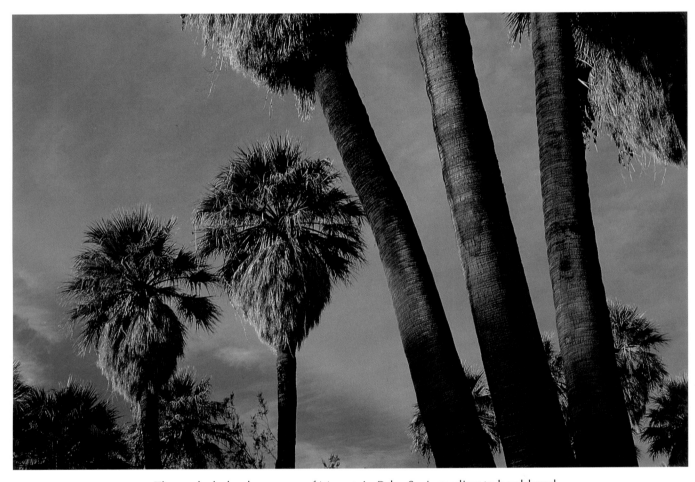

▲ The secluded palm groves of Mountain Palm Springs cling to bouldered canyons in the south part of Anza-Borrego. From Baja California through California's southern desert to Arizona, oases supply water for fan palms.
▶ Petroglyphs, age-old designs etched on rock, are found in the California desert. Good examples of Native American rock art adorn Corn Springs, a palm oasis nestled in a rugged canyon in the Chuckwalla Mountains.
▶ ▶ Cholla cacti boast many names: Bigelow, teddybear, and jumping.

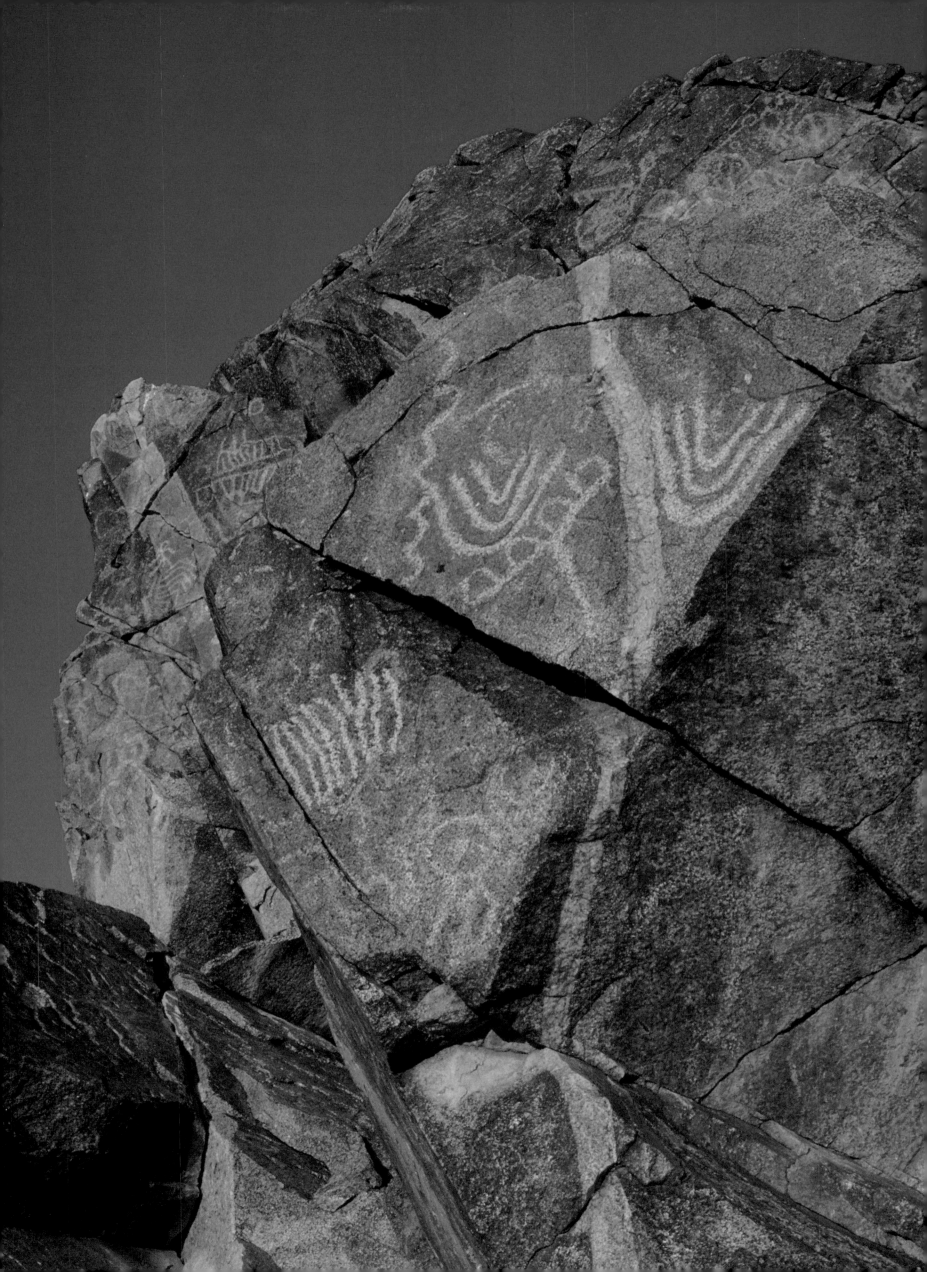

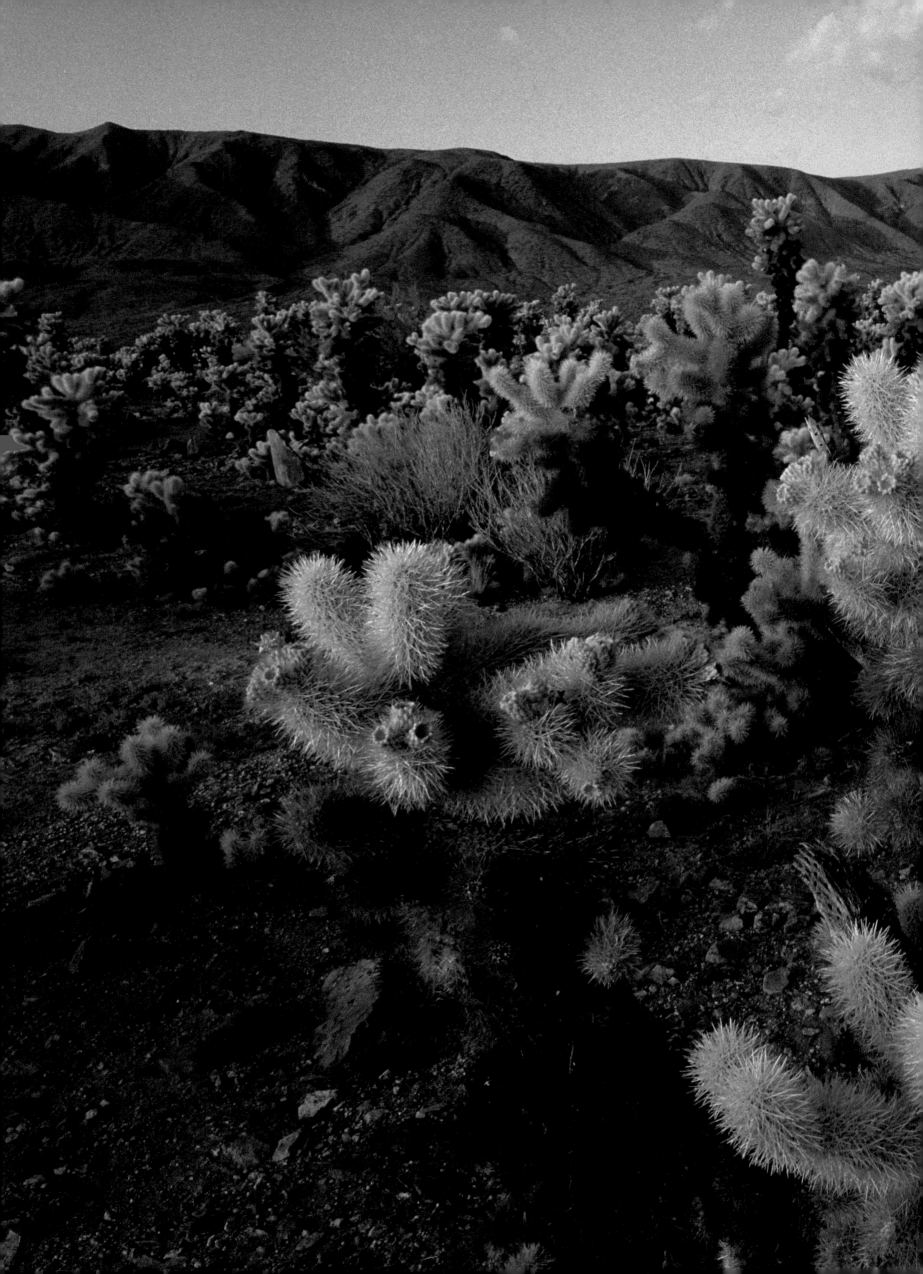

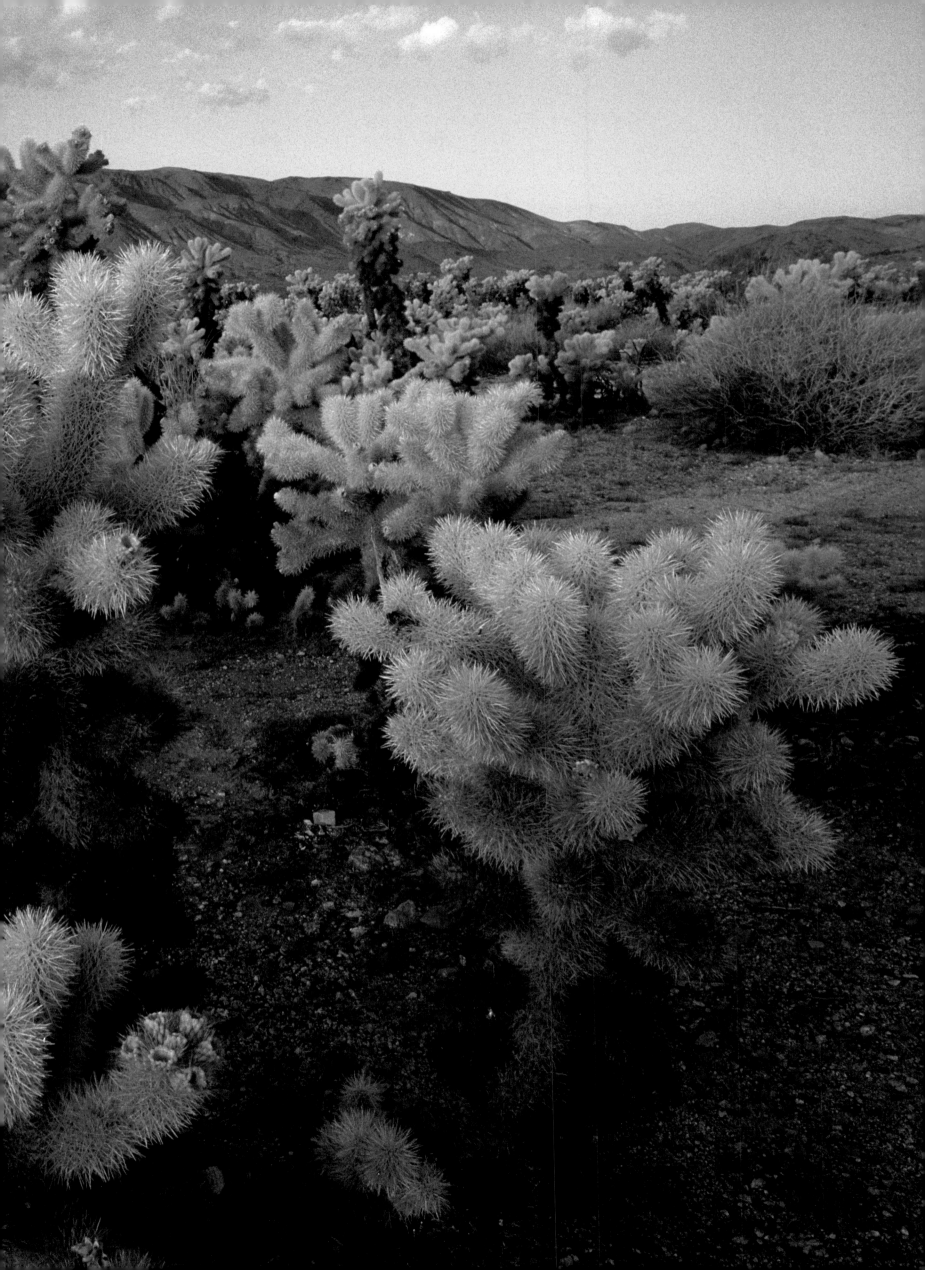

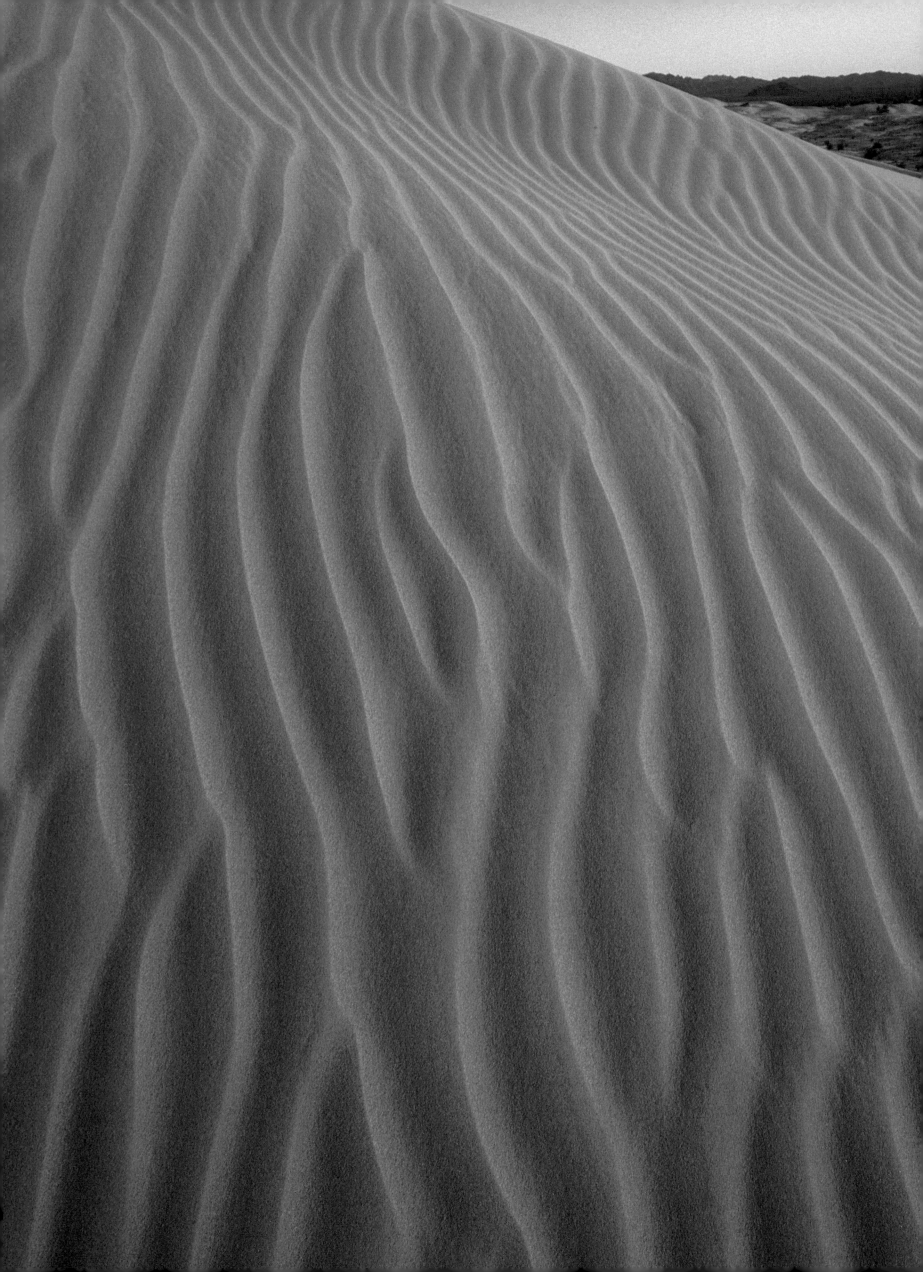

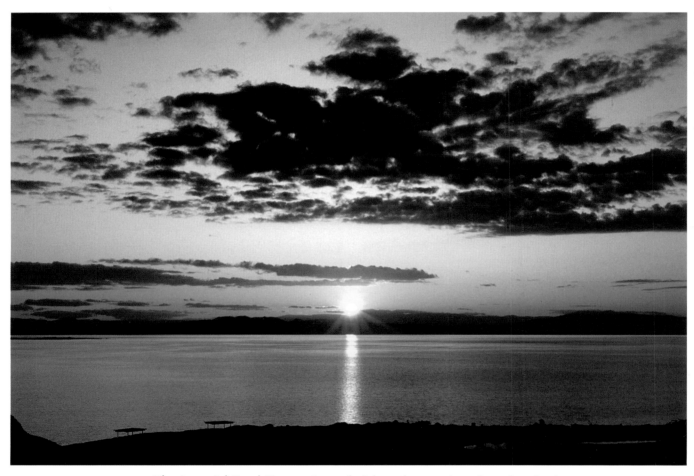

◄ The Imperial Sand Dunes rise to heights of more than three hundred feet above the surrounding landscape. Prevailing winds cause the dunes to migrate toward the southeast at the rate of about one foot per year.
▲ The sun sets over the Salton Sea from Red Hill, an Imperial County park and marina. This saltwater lake was formed in the early 1900s, when the Colorado River spilled over into the below-sea-level Salton Basin.

▲ The Imperial Dunes play host to off-highway-vehicle enthusiasts. About two-thirds of the dunes are set aside for off-road activity. The area's mild climate from fall through spring attracts tens of thousands of recreationists.
▶ In the early 1940s, General George S. Patton led war games in the California desert. At Iron Mountain, the remains of the chapel, along with tracks made by the tanks, can still be seen. West of Desert Center, the Patton Memorial Museum features memorabilia from World War II.

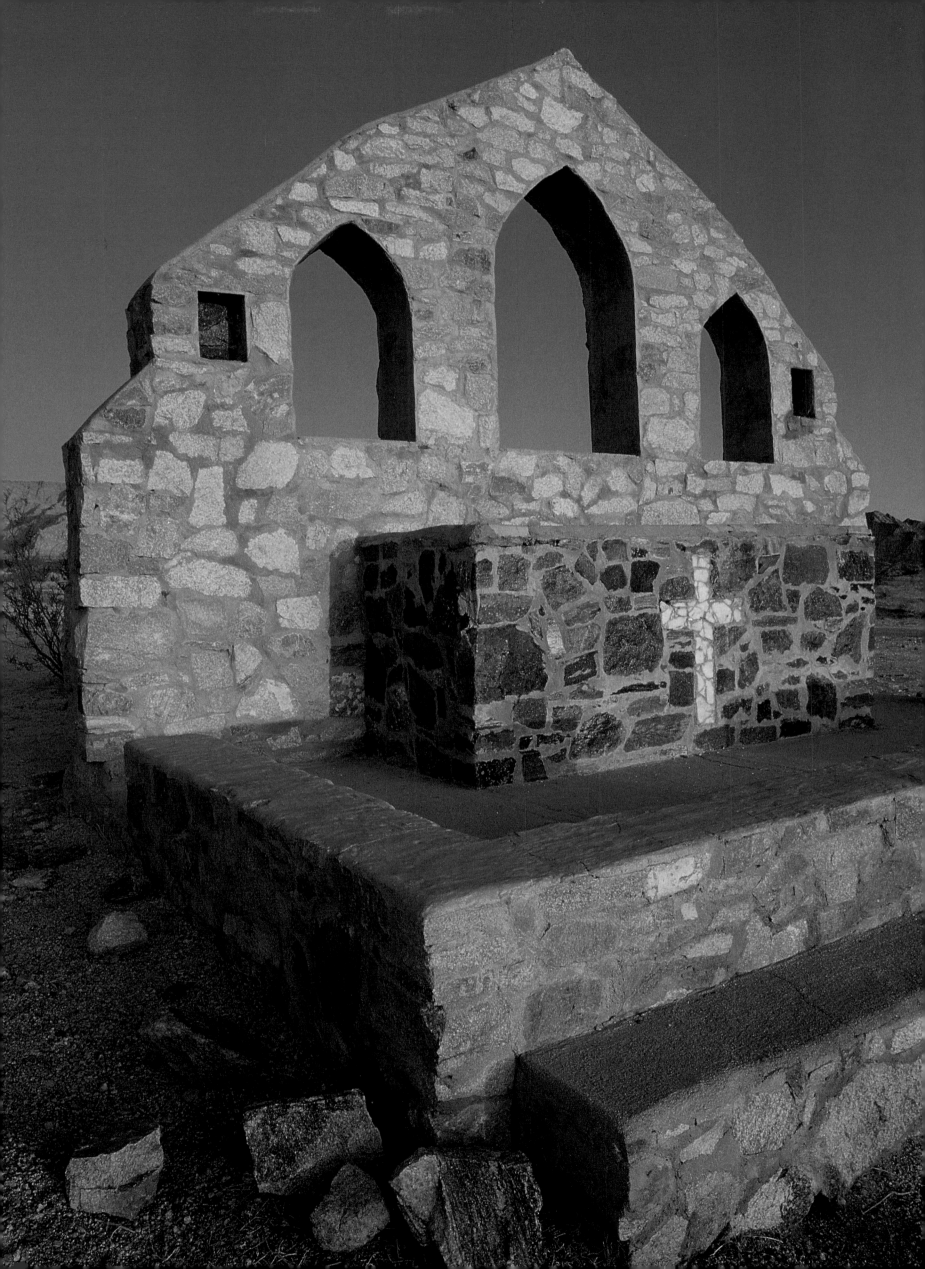

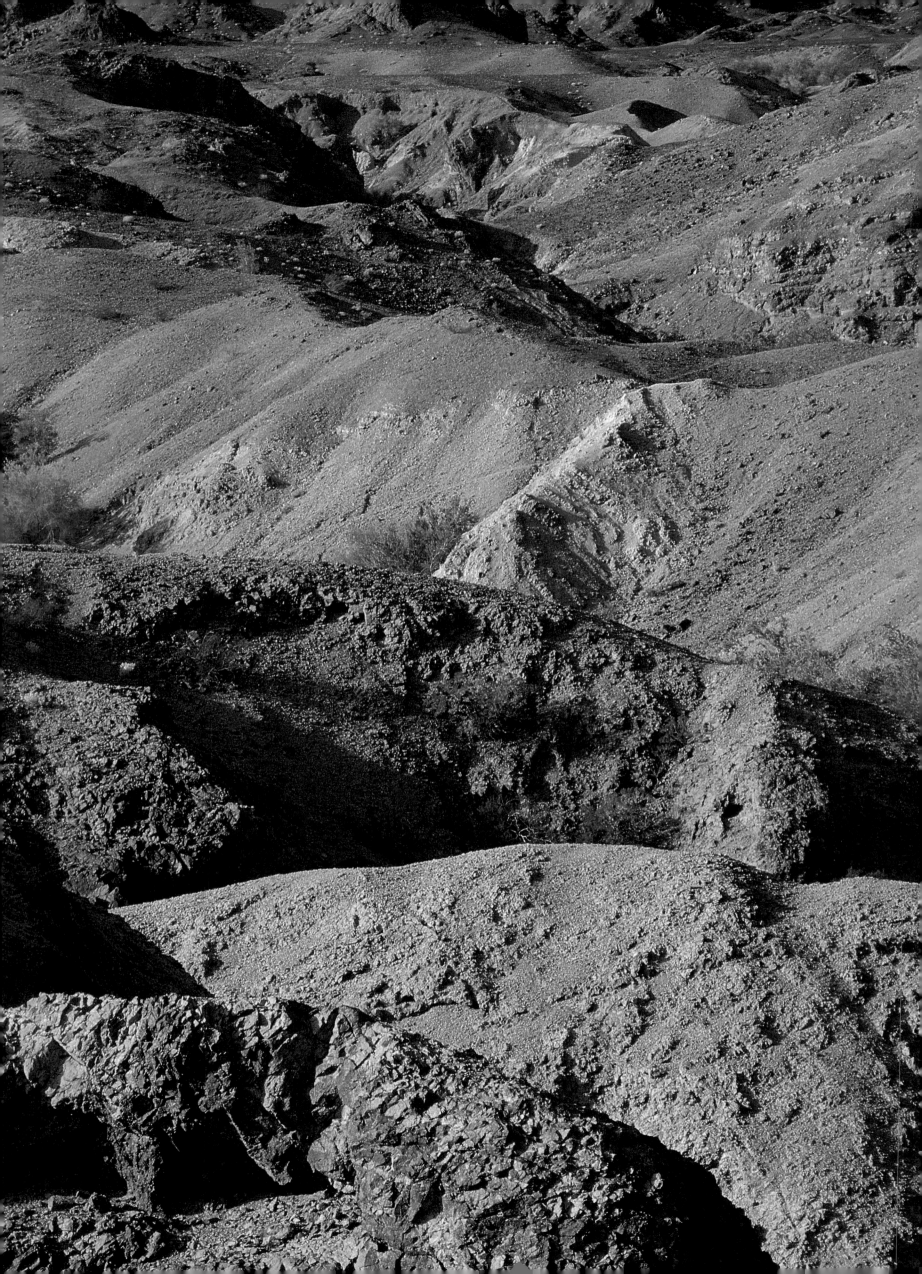

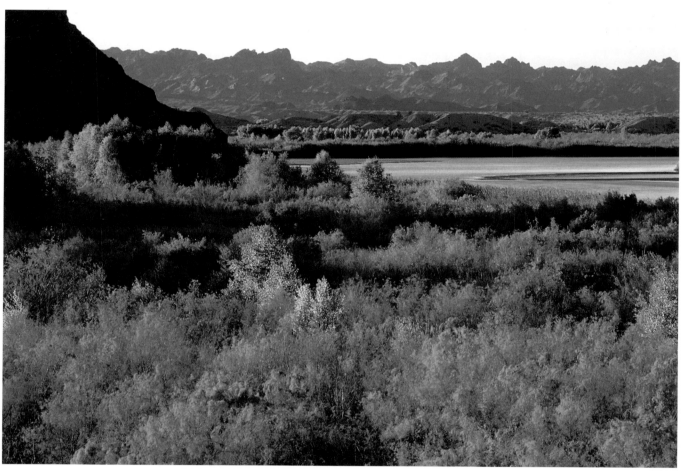

◄ The remote Picacho State Recreation Area occupies the lower Colorado River Basin. The park is rich in geology; its plug-dome outcroppings, interesting shapes, and colorful slopes testify to past volcanic activity.
▲ The Colorado River flows through California's lower desert along the Arizona border. The Picacho area boasts river sports, quiet backwater lakes, springtime wildflowers, fall colors, gold-mining history, and wildlife.

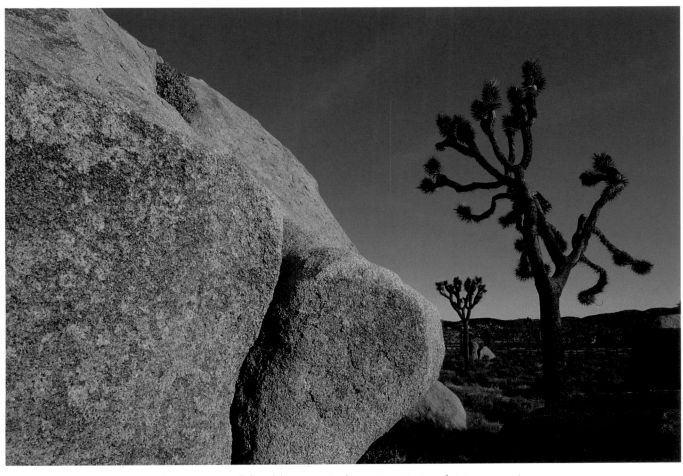

▲ Joshua trees and boulders are Joshua Tree National Monument's top draws. Some rock formations—which rise up to several hundred feet above their high-desert surroundings—appear alone; others stand in great groups.

▶ In addition to the cholla cactus, the Mojave prickly pear cactus is another plant to be treated with respect. Prickly pear cactus is found not only in Joshua Tree, but also in many other parts of the California desert.

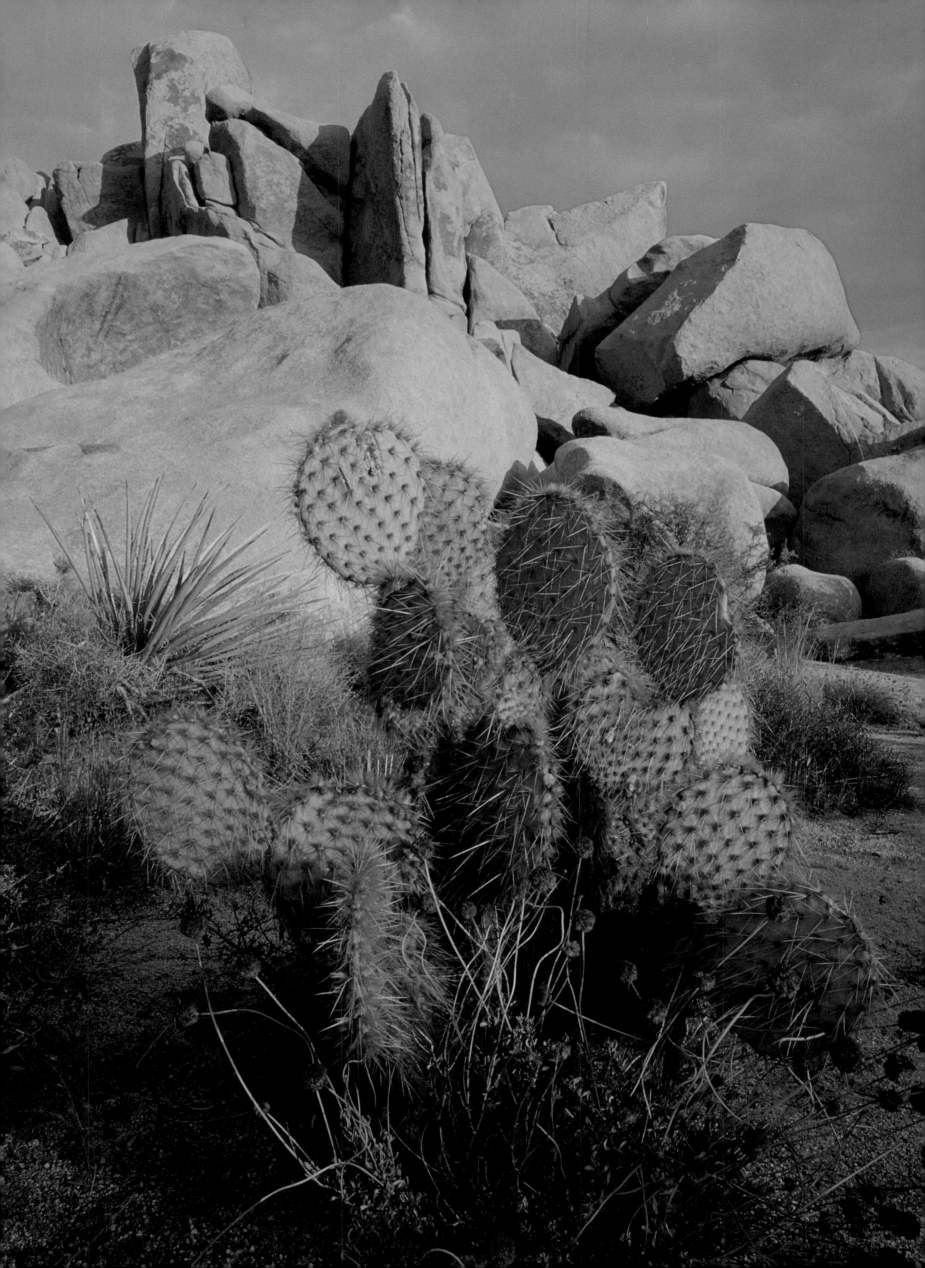

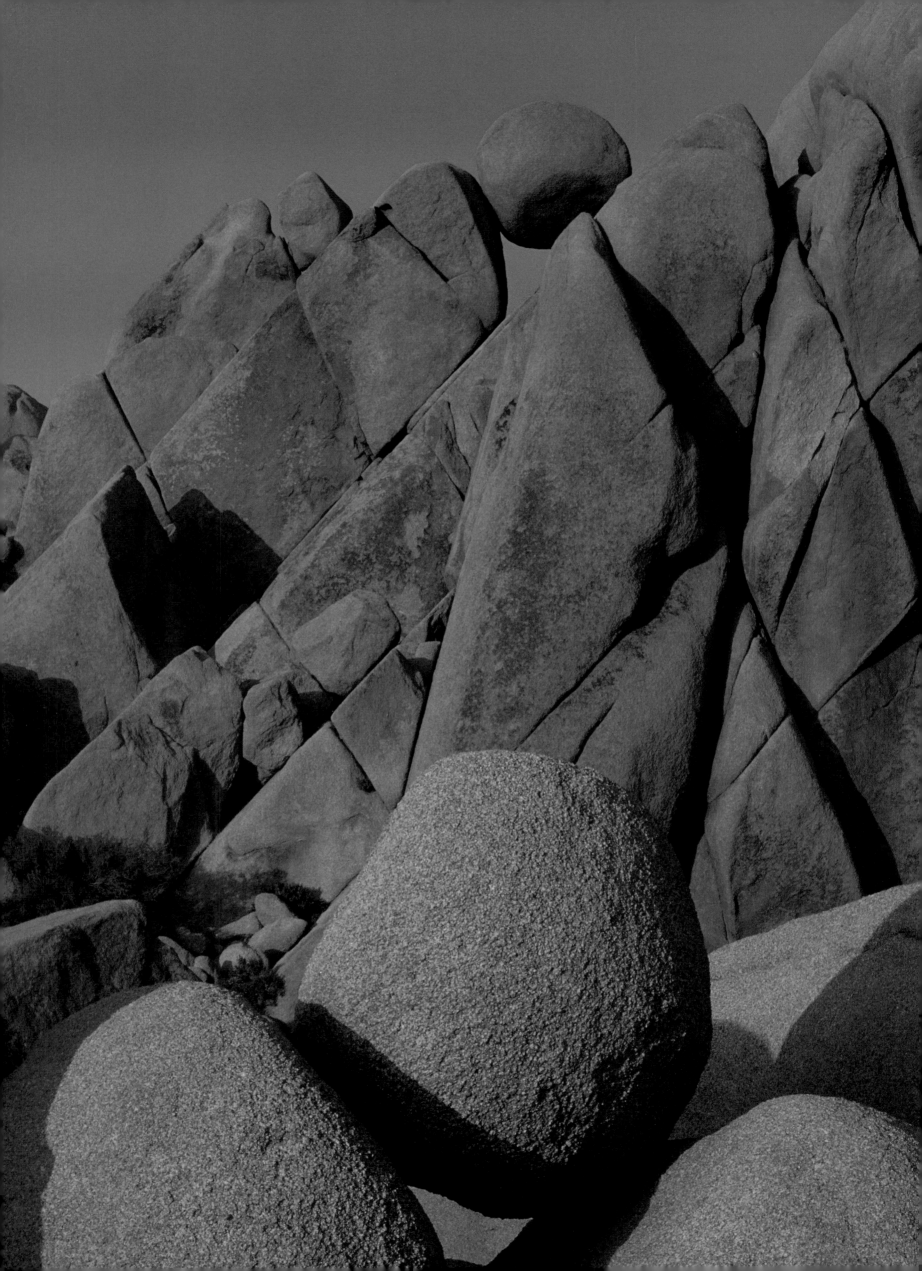

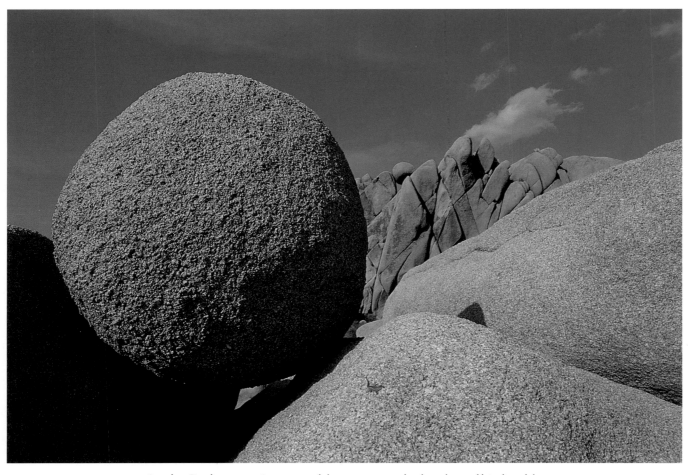

◄ Jumbo Rocks comprises one of the most popular batches of big boulders in Joshua Tree. The rockbound Hidden Valley, another high-profile area, was once the reputed hangout for the cattle-rustling McHaney Gang.
▲ Joshua Tree National Monument straddles two deserts—the higher Mojave Desert, as seen here at Jumbo Rocks, and the lower Colorado Desert. Elsewhere in Joshua Tree, the two deserts meet in a transition zone, which contains plants and animals that are representative to each.

▲ The walls of Hidden Valley, along with those at Jumbo Rocks and other areas, lure climbers from all over the world. *Outside* magazine, in fact, once dubbed Joshua Tree "the Woodstock of international rock-jockdom."
► Joshua Tree boasts several thousand climbing routes for adventurers. Many of the routes lie next to campgrounds, picnic areas, and parking lots.

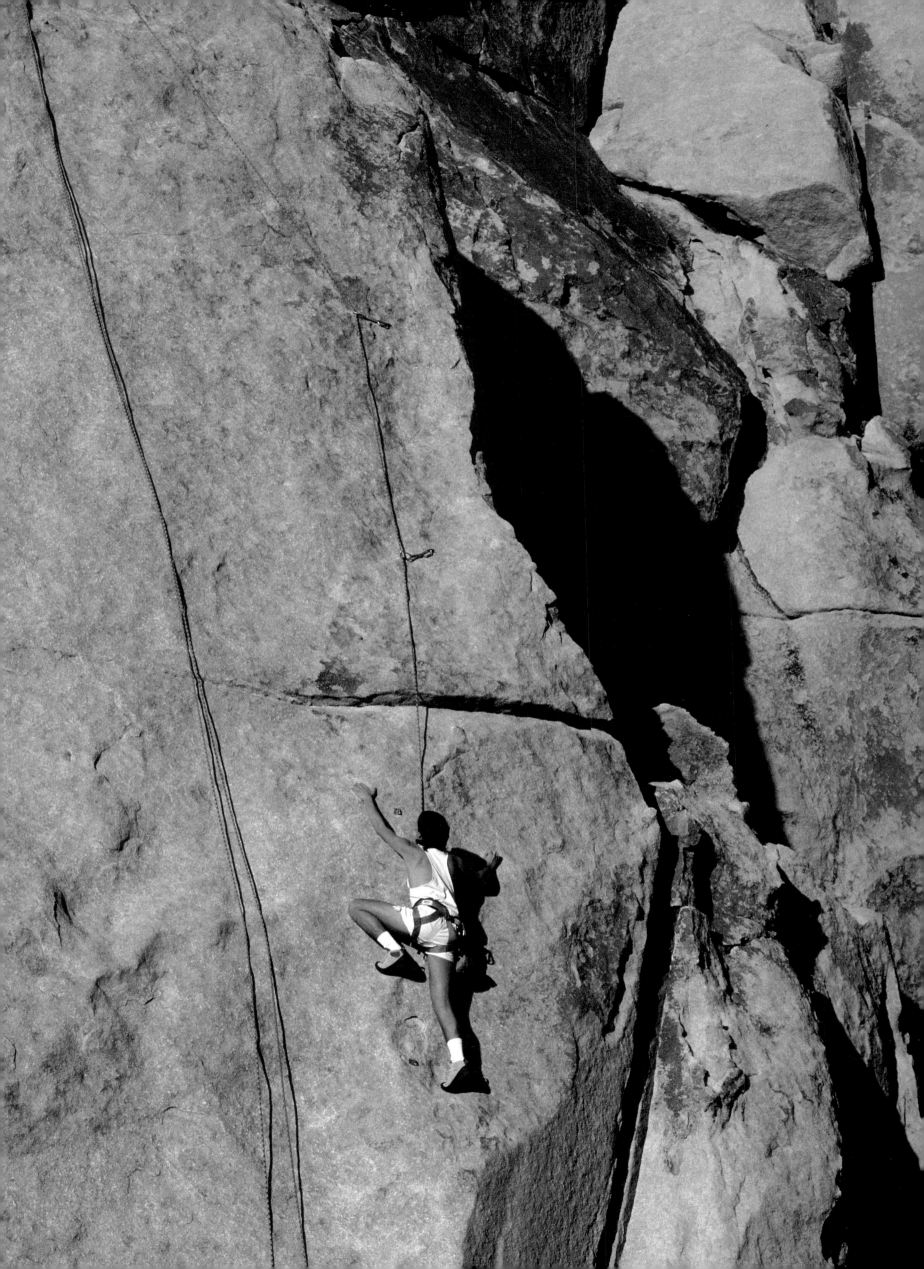

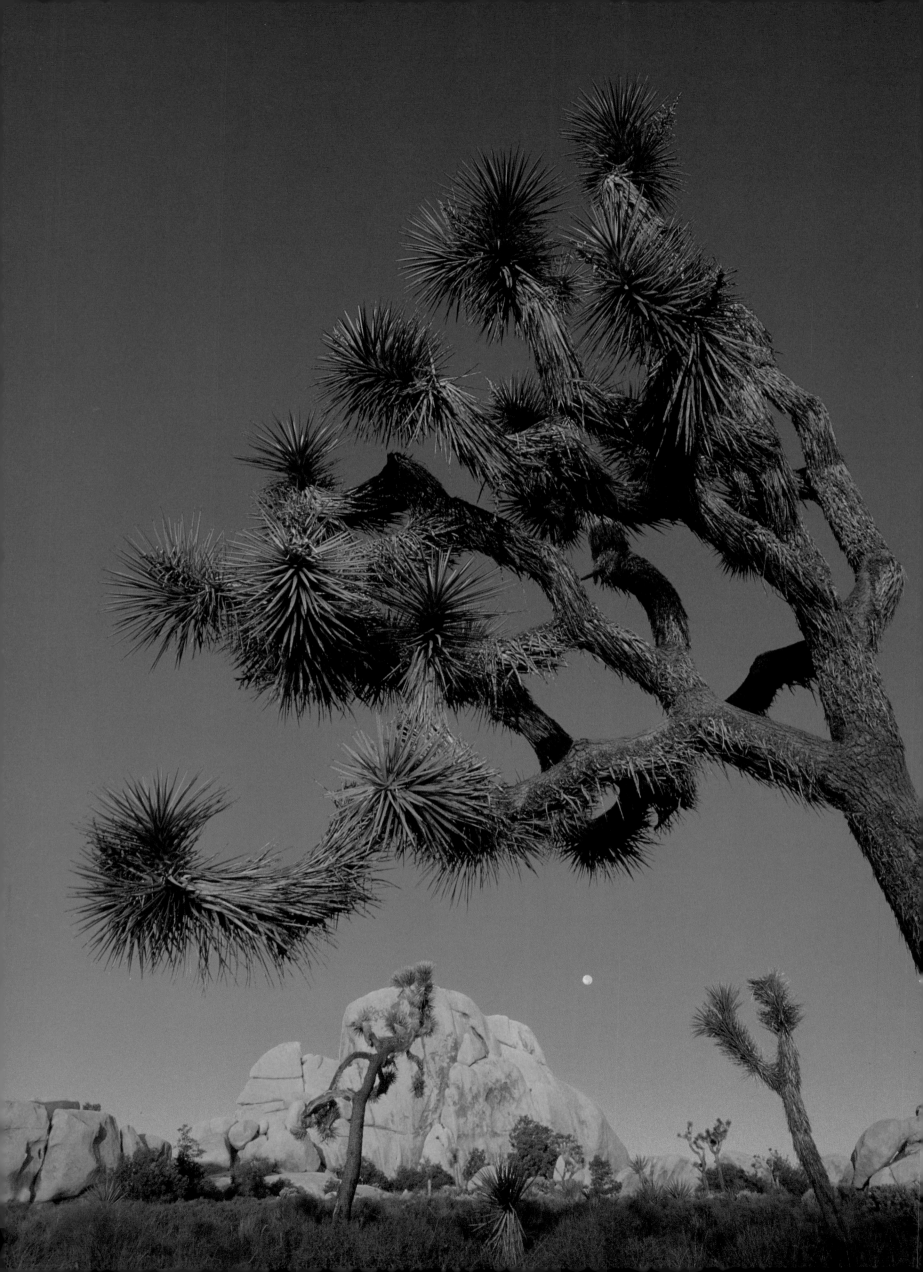

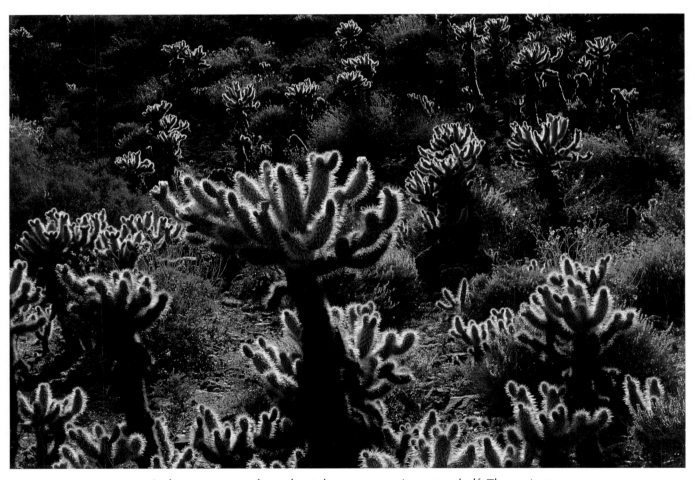

◄ Joshua trees grow throughout the monument's western half. These giant, spiny-leaved yuccas are hallmarks of the cooler, higher, and wetter Mojave.
▲ Good places to see varieties of cholla include Anza-Borrego's Cactus Loop Trail and Joshua Tree's Cholla Cactus Garden. Despite some people's descriptions, a jumping cholla doesn't jump; it is only a painful illusion.
► ► Temperature, rainfall, and elevation influence Joshua Tree's flowering season. Cacti, such as Mojave mound, bloom any time from March to June.

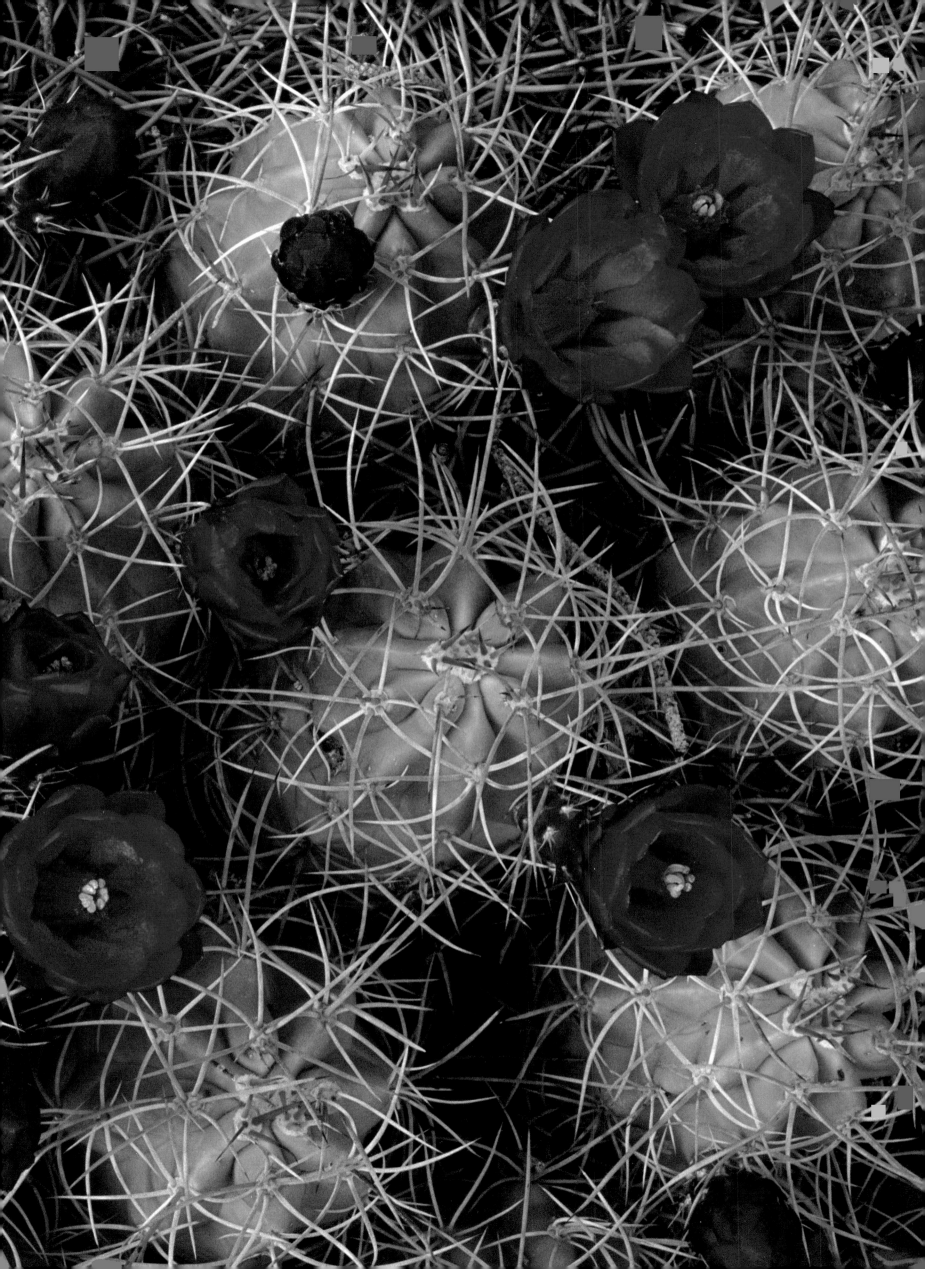

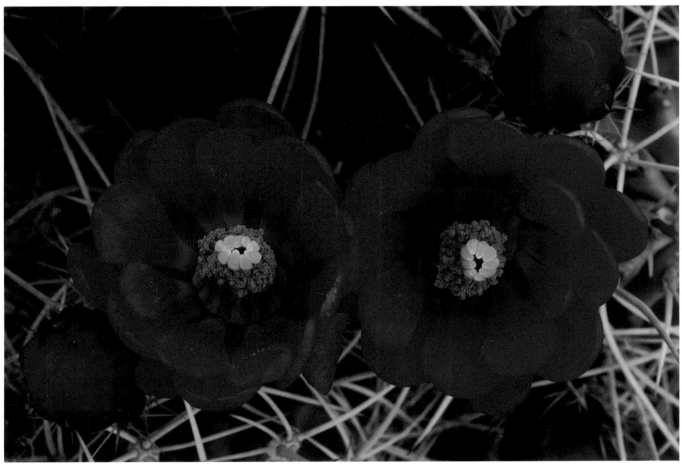

▲ The amount of moisture the area receives in a particular winter is a major factor in determining the quality of the desert's spring bloom, including that of this Mojave mound cactus in the Hidden Valley area of Joshua Tree.
► Balancing boulders, huge monoliths, and mounds of eroded rocks are distinguishing marks in Joshua Tree's high country. These geologic features testify to the tremendous earth forces that shaped this land.

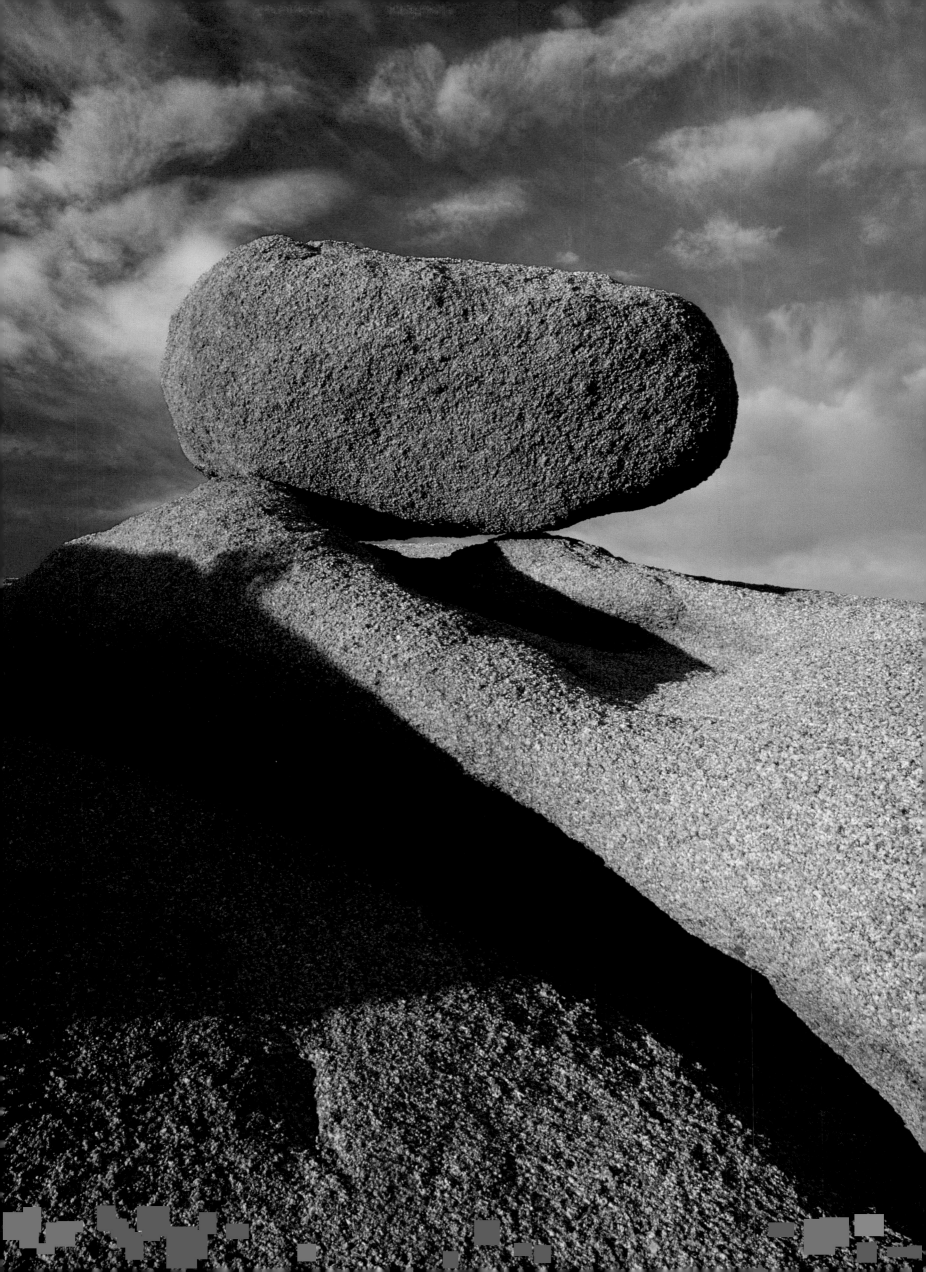

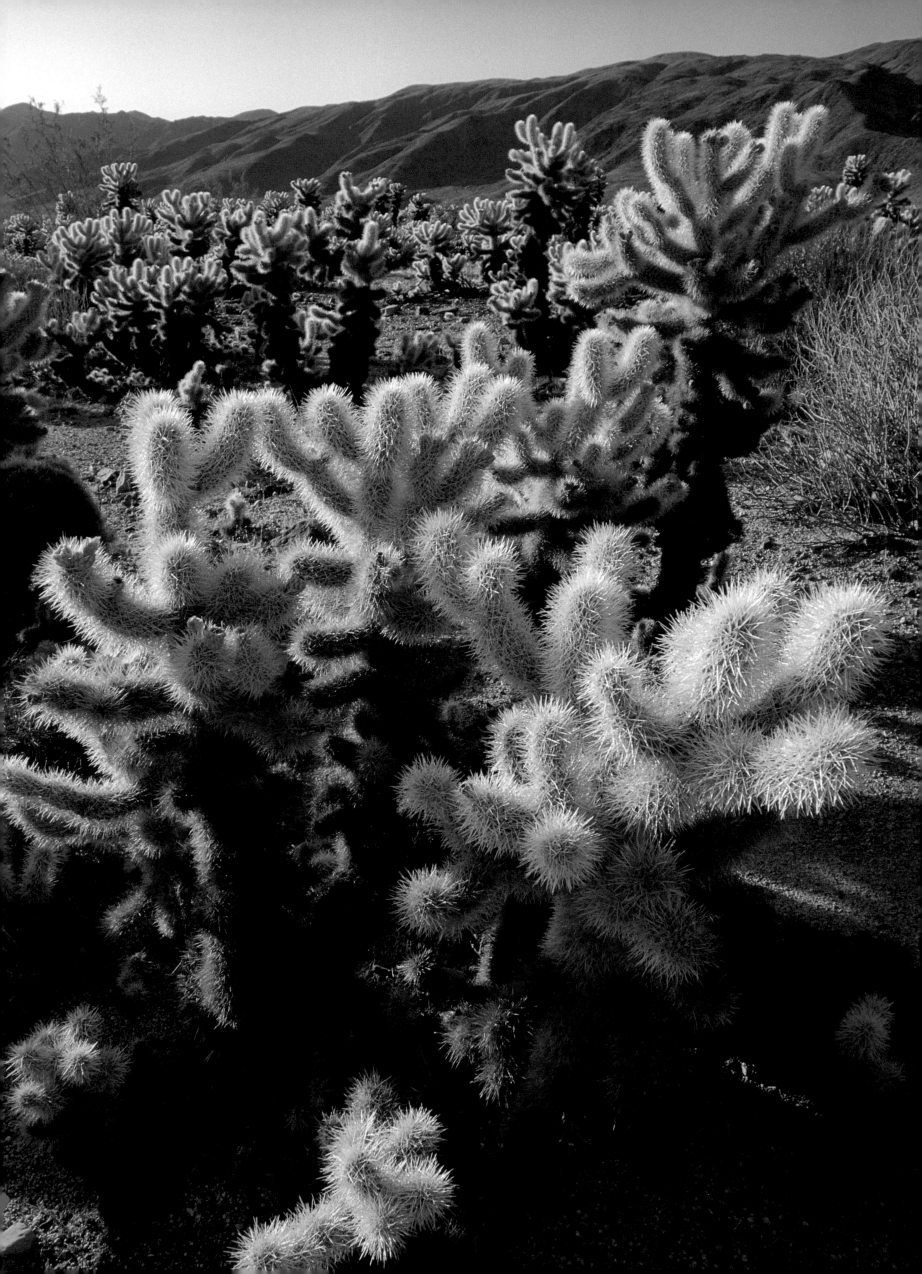

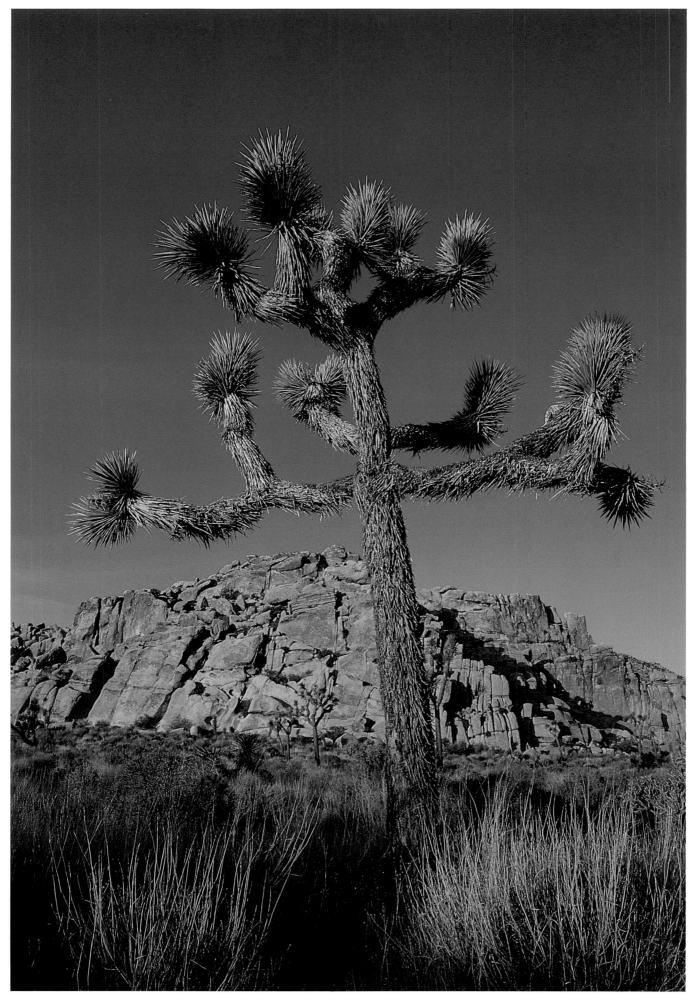

◄ Cholla Cactus Garden's variety ranges from Bigelow cactus to wildlife.
▲ Joshua Tree features also include native fan palms, the old Lost Horse Mine, an overlook called Keys View, and Native American petroglyphs.

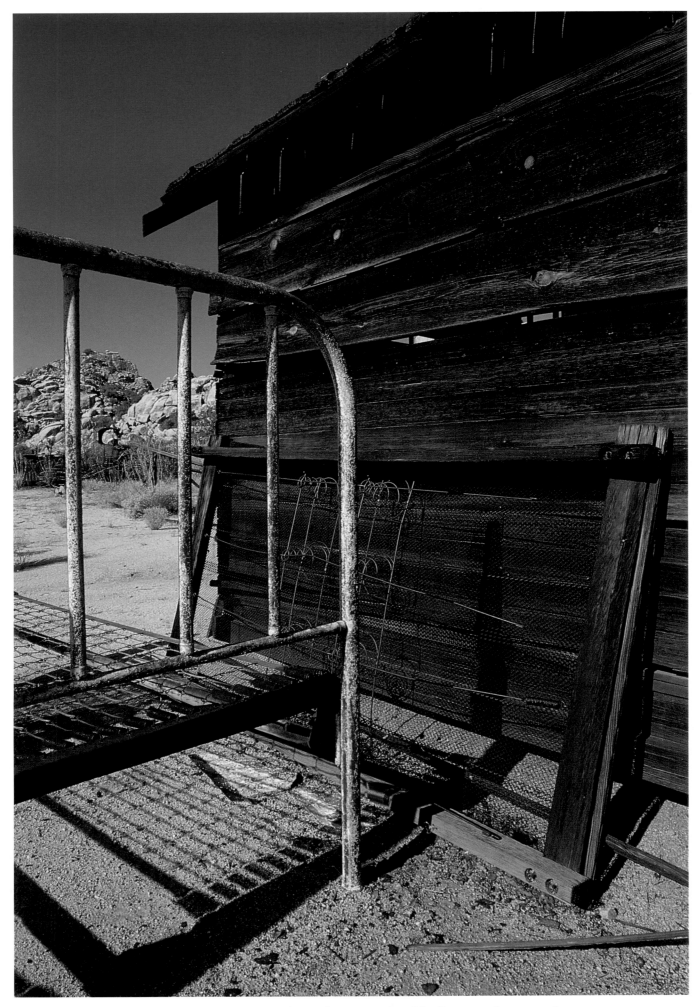

▲ The Desert Queen Ranch at Joshua Tree is the old relic-strewn homestead of Bill Keys, devoted pack rat and colorful character. Keys worked the ranch, raised a family, and collected things from 1917 until his death in 1969.

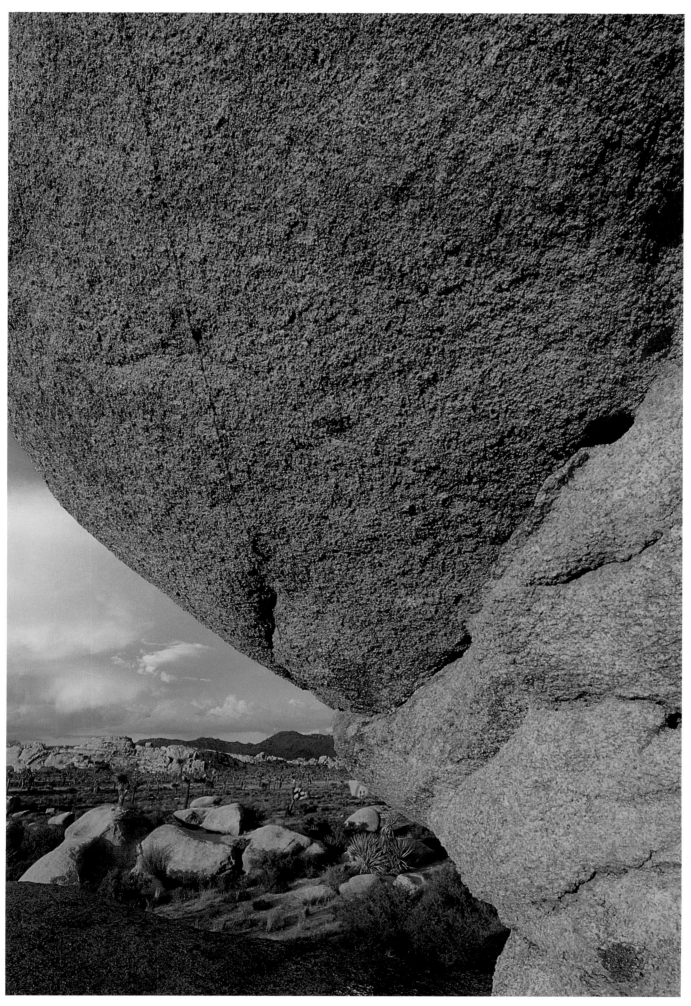

▲ Many Joshua Tree visitors come to camp, picnic, explore, and learn more about those odd-looking desert dwellers—Joshua trees—that early pioneers believed resembled Joshua beckoning them on to the promised land.

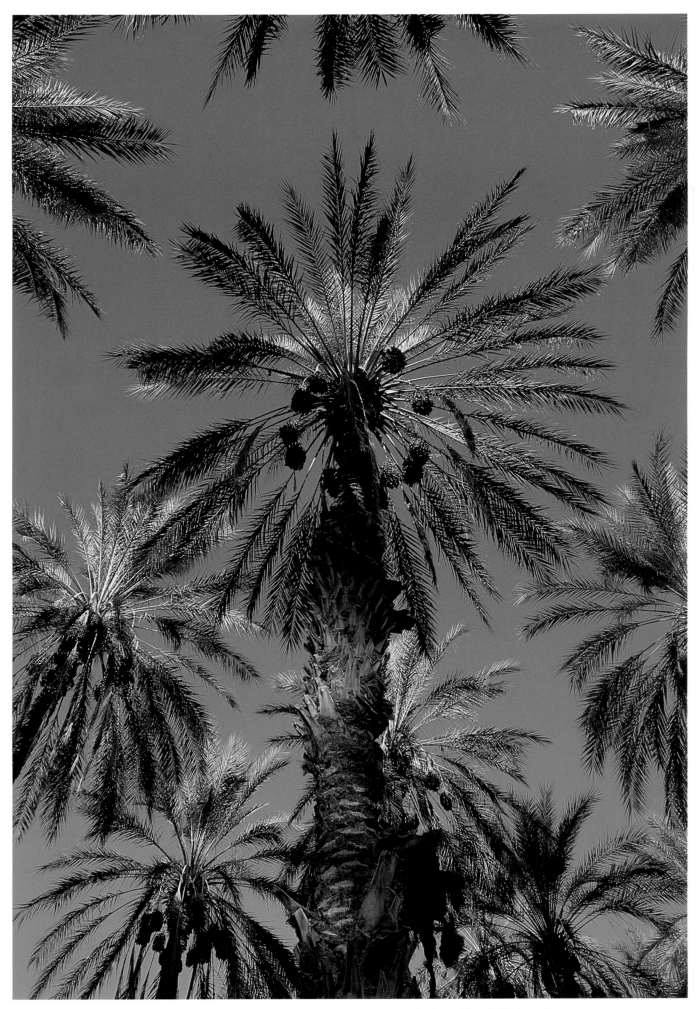

▲ Towering date palms grace much of the Coachella Valley, billed as the "Date Capital of the World." Many of the ranches are open to visitors, while roadside stands sell date products, such as the date milkshake.

Palm Springs
&
the Coachella Valley

In 1539, the Spanish conquistador Francisco Vasquez de Coronado and his retinue of two thousand men marched north from Mexico in search of the Seven Cities of Cibola, a legendary place whose streets were said to be paved with gold. He wound his way as far north as Kansas before deciding to give up the quest and turn back toward home. How could he have known his explorations were in the wrong part of the continent and several hundred years too early? For today, the seven golden cities actually exist. They are clumped, jewel-like, along the western edge of southern California's Coachella Valley, and their names are Palm Springs, Cathedral City, Rancho Mirage, Palm Desert, Indian Wells, La Quinta, and Desert Hot Springs.

Palm Springs, little more than a hundred miles east of Los Angeles, is the indisputable queen of the seven ritzy cities. Snuggled along the foot of the sheer-faced Mount San Jacinto itself, Palm Springs fans out onto the desert like an elaborate cloak fashioned of velveteen sands and emerald acreage dotted with red-tiled roofs and azure pools—the whole thing sequined and spangled with millions of shimmering lights. Bound on the west and south by the San

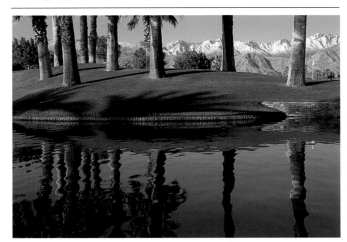

Golf course in Coachella Valley

Jacinto and Santa Rosa mountains, the world-renowned city has, in little more than a century, risen up out of seemingly desert wasteland to become one of the most popular resort areas in the world.

It all started with the hot water. Bubbling naturally to the earth's surface at 106 degrees, Palm Springs' unusual mineral waters contain thirty-two trace elements, including iron, manganese, magnesium, calcium, potassium, copper, and zinc. Exactly how long these hot springs have existed here is unknown, but in 1823 Captain Jose Romero, a Spanish explorer searching for a passageway across San Gorgonio Pass to the Colorado River, recorded coming across a group of Indians living alongside waters they believed beneficial—both therapeutically and spiritually. He named the Indians *Agua Caliente*, hot water, and after enjoying the springs' restorative services himself, left them in peace in the place they called Se-Khi.

During the 1850s, United States government topographers, searching for a railroad route across the Peninsular Mountains, recorded their discovery of San Gorgonio Pass.

They also noted finding a group of friendly, healthy Indians who inhabited an oasis around a hot spring. It was the Agua Caliente, and though the land had forever been theirs, the U. S. Government divided it into square-mile sections, checkerboard fashion, and awarded every odd-numbered section to the railroad and every even-numbered section to the Agua Caliente Band of the Cahuilla Indians. By the turn of the century, with subsequent trust patents issued by the government, the Cahuilla tribe's land totaled 31,127 acres—most of which is today leased to merchants and hoteliers, including Section 14, which contains downtown Palm Springs. The gold was beginning to surface.

In 1884, a San Francisco lawyer by the name of Judge John Guthrie McCallum, searching for a healthy climate for his tubercular son, purchased land from the railroad and settled his family in Palm Springs, making them the first white people to call the area their permanent home. Enamored of the place he called Palm Valley, McCallum urged other prospective land buyers to visit the region, though few came—mostly due to lack of accommodations. Not to be deterred, the judge persuaded an astute Scottish

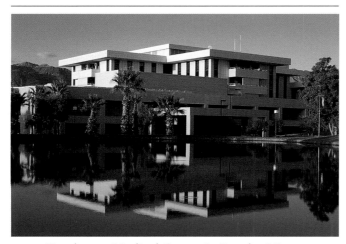

Eisenhower Medical Center in Rancho Mirage

friend to meet the need, and in 1886 the Scotsman opened the small Palm Springs Hotel and—soon afterward—leased the hot springs from the Cahuillas, built a bathhouse, and opened it free to hotel guests and at a charge of twenty-five cents a dip to anyone else.

By 1909, the Desert Inn was on the scene, and by 1920, both hotels were flourishing—especially the Desert Inn, which boasted not only a swimming pool but a tennis court and an adjoining nine-hole golf course. By the late 1920s, Palm Springs was a favorite hideaway, and by 1928, the incomparable El Mirador Hotel opened for business, showing off its flawless amenities as well as its seventy-five-foot swimming pool. By 1942, with the Second World War in full swing, the army turned El Mirador into a hospital, and by the time the war had ended, the place now named Torney General Hospital had seen nineteen thousand soldiers pass through its medical facilities.

By the 1950s, El Mirador had been refurbished and once again turned into a fashionable resort. New hotels began taking their place in the Palm Springs community:

the Thunderbird, with its championship golf course; the Riviera, with its convention facilities. By the late 1950s, the Agua Caliente Tribal Council agreed to a ninety-nine-year lease of their hot springs, and the spacious, five-story Spa Hotel was born. As outlying communities continued to grow up around Palm Springs, the cities stretching elbow-to-elbow for nearly thirty miles down the valley began to shimmer in what seemed to be a golden haze. The Seven Cities of Cibola come to life? Not quite. They called themselves the "Palm Springs Desert Resorts Area." But by any name their streets were paved with gold.

Today, more than two million visitors make the trek annually to the Desert Resorts Area—most during winter months. Not surprising. The climate here is as near perfect as it gets. With winter daytime temperatures averaging in the 70s and less than six inches of rain a year, the desert resorts boast a catalog of winter sports that turn the rest of the nation green with envy: golf, tennis, swimming, horseback riding, and even hot air ballooning. The entire area has long been touted as the Golf Capital of the World. Little wonder. The Palm Springs Desert Resorts Area claims nearly ninety public, private, and semi-private golf courses and more than a hundred annual tournaments, including such well-noted events as the Bob Hope Chrysler Classic in January or February and the Nabisco-Dinah Shore LPGA Major Championship in March.

Even if golf is way down on the list of favorite pastimes, there is nothing to fear. The area boasts more than six hundred tennis courts, many lit for nighttime play, and each year the top men in pro tennis compete in the Newsweek Champions Cup held at the Hyatt Grand Champions Resort in Indian Wells. For the water bugs, there is the twenty-one-acre Oasis Waterpark with its nine waterslides, a wave-action pool for the surfer set, and two championship beach sand volleyball courts. But even above that, the Desert Resorts Area shows off more than ten thousand swimming pools, with most of the luxury resorts claiming at least one massive pool, several outdoor Jacuzzis, and even wading pools for the younger set.

For history buffs, there is the Palm Springs Desert Museum with its intriguing art and natural science center, galleries, fountains, and American Indian artifacts display. For those interested in experiencing a bit of Palm Springs' pioneer history, there is the popular Village Green Heritage Center which displays two nineteenth-century houses: the John McCallum Adobe, the oldest building in the city, moved from its original location in the 1950s and now home to the Palm Springs Historical Society; and a small, brown house built of old railroad ties and known as Miss Cornelia White's Little House—but initially a bungalow attached to the original Palm Springs Hotel.

For hikers and horseback riders, there are the five Indian Canyons that reach up into the San Jacinto Mountains like the fingers of a giant hand. Their names are Murray, Palm, Chino, Andreas, and Tahquitz canyons, and they are safeguarded by the Agua Caliente Band of Cahuilla Indians as natural preserves. The fourteen-mile-long Palm Canyon

was known to the early Spanish explorers and the Indians as *La Palma de la Mano de Dios,* "the Hollow of God's Hand." Today, the canyon's more than three thousand native palms give it the distinction of being the world's largest fan palm oasis. Because of the heavy concentration of native fan palms, Andreas, Murray, and Palm canyons are all listed in the National Register of Historic Places, and though all the Indian canyons are open to visitors from September through June, getting into the Tahquitz Canyon requires a special permit from the Agua Caliente Tribal Council.

Adventurers will likely take to the Palm Springs Tram, the world's longest single-span aerial tramway. The tram's two eighty-passenger cars climb up the steep wall of Chino Canyon to the San Jacinto Mountain Station, 8,516 feet above sea level. The two-and-a-half-mile trip takes less than fifteen minutes and, in that time, passes through five different climatic zones with flora and fauna approximating what would be seen on a six-thousand-mile drive from Mexico to Alaska. The view from the tram's wide windows is in itself worth the trip, affording panoramas that stretch out across seventy-five miles of countryside—all the way from the peak of Mount San Gorgonio to the Salton Sea.

Those interested in seeing desert flora and fauna up close and personal will enjoy the twelve-hundred-acre Living Desert along the foot of the Santa Rosa Mountains. More than six miles of hiking trails lead not only to natural wildlife settings featuring desert bighorn, arabian oryx, grevy's zebras, and desert tortoise, but to ten different North American desert habitats, with each habitat revealing the plant life indicative to that region. Tucked into the different desert re-creations are intriguing asides: the Indian ethno-botanic garden in the Sonoran Desert, showing how the Cahuillas used native plants for food, clothing, medicine, and housing; the hummingbird garden and oasis in the Yuman Desert; the golden eagle aviary and smoke tree garden in the Baja Desert; and at the far end of the trail, a tree-fringed Sonoran pond where scores of desert pupfish play tag among the reeds.

Some claim that the Palm Springs region is America's desert playground. Perhaps it is so. How fortunate then that those who come here to play have such a wide variety of accommodation choices. With the desert resorts offering more than three hundred hotels, as well as an assortment of RV parks and campgrounds, the happy wanderer will find everything from full-service luxury resorts to modest bungalow courts, to European-style bed-and-breakfasts, to down-home kitchenettes, to parklike places where the whole gang can rally around the campfire.

Though most who visit here tend to stay close to the resort areas with their plethora of things to see and do, some venture out into the rest of the Coachella Valley, which is bound on the north and east by the San Bernardino and the Little San Bernardino mountains, on the west by the San Jacinto (the second-highest mountain range in southern California) and the Santa Rosa mountains, and on the south by the Salton Sea. In its entirety, the valley extends fifty miles in a southeasterly direction, and though the

northern region is devoted to resort living, the southern portion is dedicated to feeding the nation.

Scientists claim that the Coachella Valley has the most consistently dependable weather of any place on the North American continent. Perhaps so. Year-round sunshine, coupled with excellent water management, has resulted in the Coachella Valley producing the highest output per irrigated agricultural acre anywhere on the globe. Between Indio and the Salton Sea, a distance of about twenty miles, there are approximately seventy thousand acres of desert-turned-farmland, thanks to Colorado River water transported via the concrete ditches of the All American Canal. Though dates and grapes are the primary crops of the valley, vegetables, citrus, cotton, nuts, and alfalfa are all part of the Coachella produce basket.

The valley has long been known as the "Date Capital of the World." Easy to see why. Ninety-five percent of the nation's date crop is grown here. Legend claims that God created the date palm from the clay still stuck to His hands following the creation of Adam, and, although scholars claim there is little proof that apple trees ever existed in the

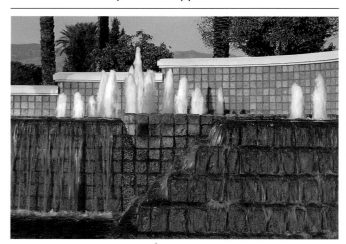

The entrance to three Indian Wells resorts

Garden of Eden, there is ample evidence that date palms spanned biblical history, for their fruit has been found in the tombs of early Egyptians.

They are one of the oldest fruits known to man. In the Middle East, land of their origin, dates have long been a staple food, a "bread of the desert" sustaining millions who had little else to eat. While a diet of dates is certainly not recommended, it is claimed that many Mid-Easterners have lived as long as six months solely on dates and milk— and remained in good health while doing so.

Despite being high in calories and low in protein, dates are considered a valuable food by nutritionists. The slender spheres are a rich source of iron, magnesium, potassium, phosphorus, calcium, and copper, as well as vitimins A, B1, D, and G. They are low in sodium and fat and high in roughage, are easily digested, and contain abundant invert sugars that satisfy the sweet tooth while supplying quick energy in a natural and healthful way.

More than one hundred kinds of dates exist worldwide, though only two main classifications: semidry and soft.

Semidry dates withstand more handling and are usually what is available on supermarket shelves. Soft dates are so sweetly fragile they are seldom shipped long distances, though as luck would have it, they are also the most delectable—something to take into consideration when visiting one of the many Coachella Valley date stands.

Date palms have thrived in the valley since the early 1900s. In 1903, the first offshoots were separated from the parent trees and planted to survive on their own. In another eight to fifteen years, the transplanted children were bearing full loads of dates themselves and, in time, produced offshoots of their own—with each parent tree, male or female, always producing progeny of its own sex.

Since 1921, Indio, the valley's oldest city, has hosted the National Date Festival, a ten-day celebration that takes place in February. It is a little bit of Arabia and a whole lot of county fair rolled into one. And while the valley's date crop is the festival's honored guest, there is plenty of pizzazz put into the costuming of the sheiks and harem girls who participate in the nightly outdoor musical depicting a tale out of *One Hundred and One Arabian Nights.*

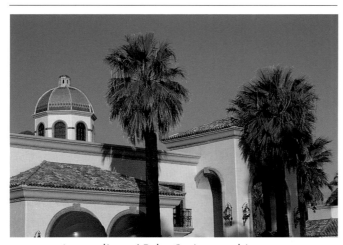

A sampling of Palm Springs architecture

Approximately ten miles northwest of Indio, spreading almost to the other side of the valley, is the thirteen-thousand-acre Coachella Valley Preserve. The area was originally set aside to protect the Coachella Valley fringe-toed lizard and has been jointly purchased and administered by the Bureau of Land Management, the United States Fish and Wildlife Service, the California Department of Fish and Game, and The Nature Conservancy. Today, with resort and agricultural areas ever pushing outward into the valley's raw desert, the preserve is one of the last large and accessible tracts of land where native flora and fauna remain much as they have for millions of years.

It is also one of the few places in the southern California desert that supports a large grove of native fan palms. And while the preserve's several scattered oases do not come close to approximating the number of fan palms growing in the Palm Springs Indian Canyons, the reserve's Thousand Palms Oasis is still one of the largest in the state.

Named in honor of our country's first president, the *Washingtonia filifera* is North America's largest native palm. Known popularly as the California fan palm, it can reach heights of sixty feet and diameters up to three feet—and grows naturally only in southeastern California, southwestern Arizona, and northern Baja. Interestingly enough, this desert palm survives only in areas where water is either at or near the surface; it needs to take in approximately one hundred gallons of water each day. Though the fan palm is devoid of a taproot, it does claim an eight- to twelve-foot-deep fibrous root system consisting of thousands of small roots about as big around as a human thumb.

As intriguing as the palm is botanically, it is its full, sweeping petticoat that catches the eye. Headdressed in shiny green and skirted all the way to the bottom of its trunk in the faded tan of dead leaves, the California fan palm seems dressed more for a Hawaiian luau than a desert waterhole. Unlike all the world's other palm species, this one wears its dead leaves throughout its lifetime—which is believed to be approximately two hundred fifty years. Only when the old leaves have been burned away or torn off by floods or destroyed by extremely high winds do the trunks stand naked and exposed to the elements.

Yet it is virgin groves, more than any other, that become havens for a wide variety of things that creep, fly, skitter, and crawl. Spiders and bats secrete themselves behind the fronds, while lizards and snakes skulk through the skirt in search of prey. Packrats and mice set up housekeeping in the petticoat's lower reaches as do doves and roadrunners. Orioles gather frond fibers for weaving teardrop-shaped nests, and everything from coyotes to kangaroo rats feasts on the palm's huge clusters of berry-sized fruits.

Where the palm oasis ends, sand dunes begin. And where there are sand dunes, so, too, is the valley's fringe-toed lizard. On the national list of threatened species, this diurnal creature is well adapted to living in the sand. Easy to see why. This lizard comes equipped with snowshoes, a sort of comblike fringe along its toes that keeps it not only from sinking when walking but which allows it to swim into the sand, thereby avoiding either capture or the noonday sun. Its scientific name is *Uma inornata,* and—unlike the subspecies *Uma notata* or Sonoran fringe-toed lizard that lives in the desert regions of California, Arizona, and Mexico—the Coachella Valley fringe-toed lizard's habitat is confined solely to the arid dunes and sandy flats of Coachella Valley and San Gorgonio Pass.

There is enough in Palm Springs and the Coachella Valley to delight the eye and the mind almost without end. From October till June, the sun that terrorized the valley all summer is now but a gentle globe that smiles and soothes, and horizons once hidden behind a wall of heat stand out with a clarity that elicits admiration from even the most nonchalant onlooker. This is a place that exudes its own magnetic force. For it is here, where the golden days slip into magic nights, that the vault of sky seems vaster and one need not wait until spring to witness the desert bestow its spasm of beauty. Little wonder it is a playground populated by the rich, the famous, and the regular. Coronado will never know what he missed.

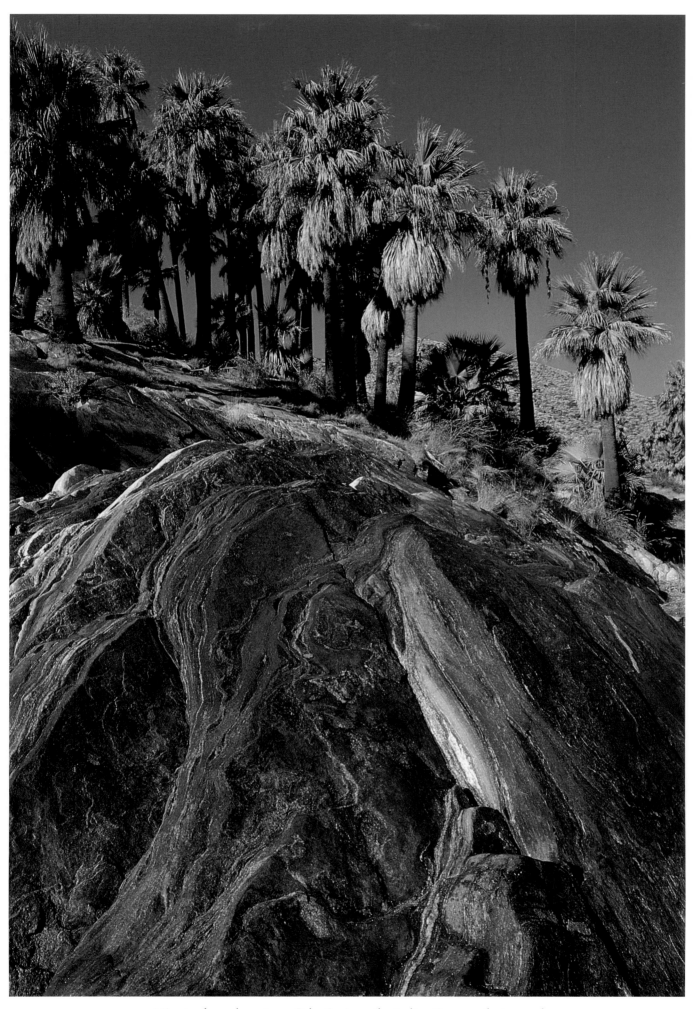

▲ Minutes from downtown Palm Springs, the Indian Canyons feature palm groves, secluded pools, rock formations, picnic grounds, hiking/riding trails, and a trading post selling Native American art, jewelry, and basketry.

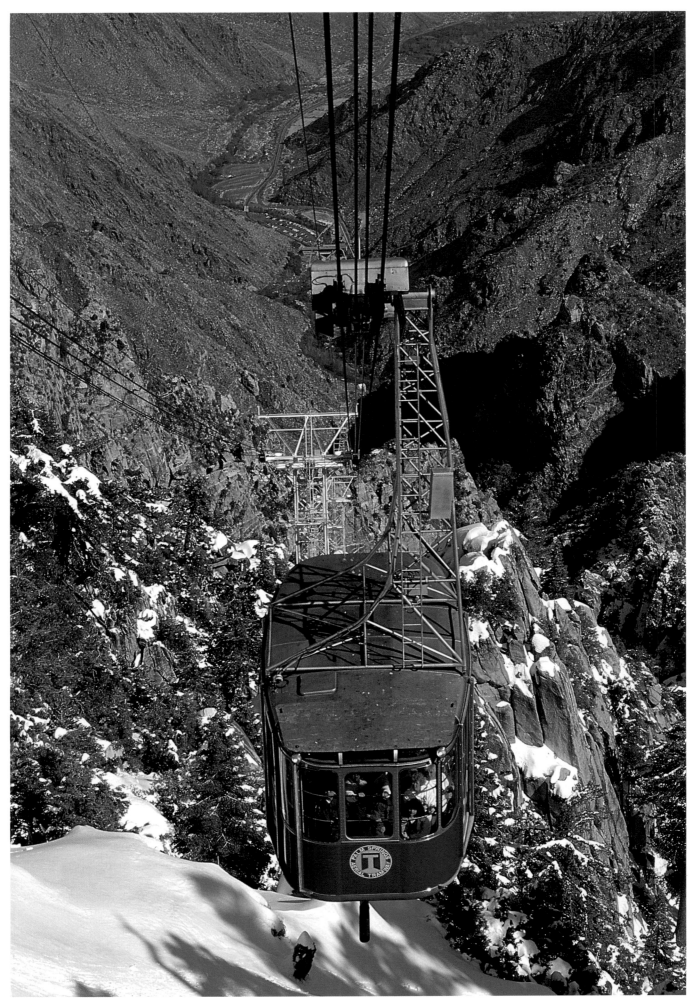

▲ The Palm Springs Aerial Tramway climbs more than a vertical mile up the flanks of Mount San Jacinto. At the tram's top, the alpine station includes a restaurant, gift shop, and access to San Jacinto State Park and Wilderness.

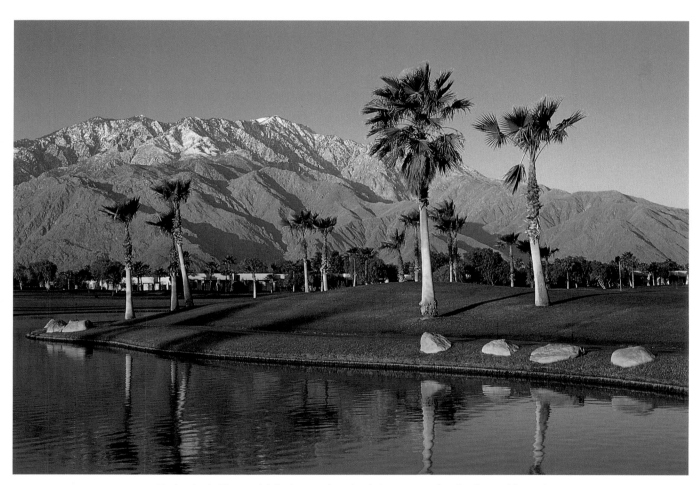

▲ Cathedral City, which is sandwiched between the high-profile Palm Springs and Rancho Mirage, sports its own share of major, elegant resorts, such as the luxurious Doubletree Resort at Desert Princess Country Club.
► ► PGA West takes in four golf courses at the base of the Santa Rosa Mountains in La Quinta. Besides golf, the resort city's attractions include its annual La Quinta Arts Festival, which draws thousands of visitors.

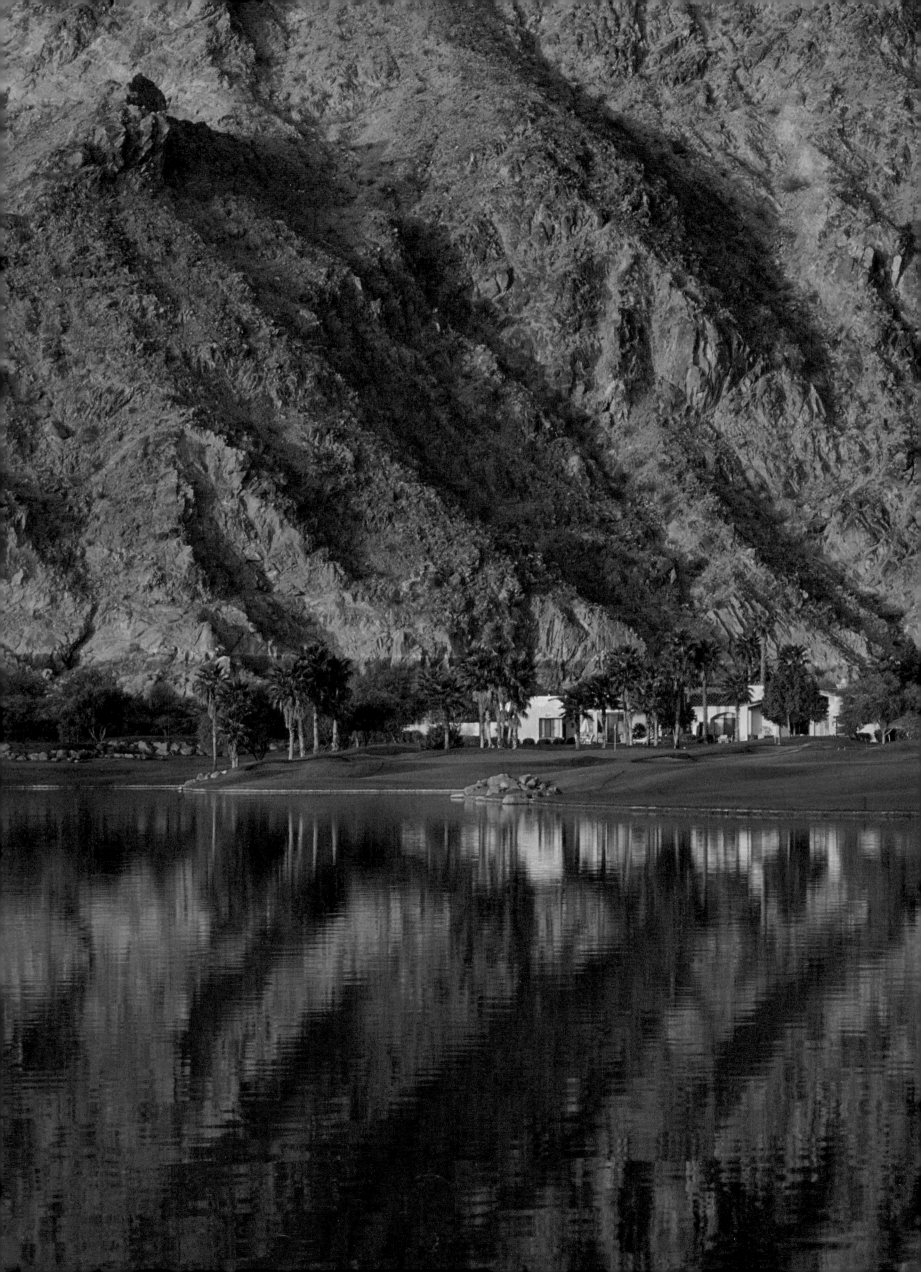

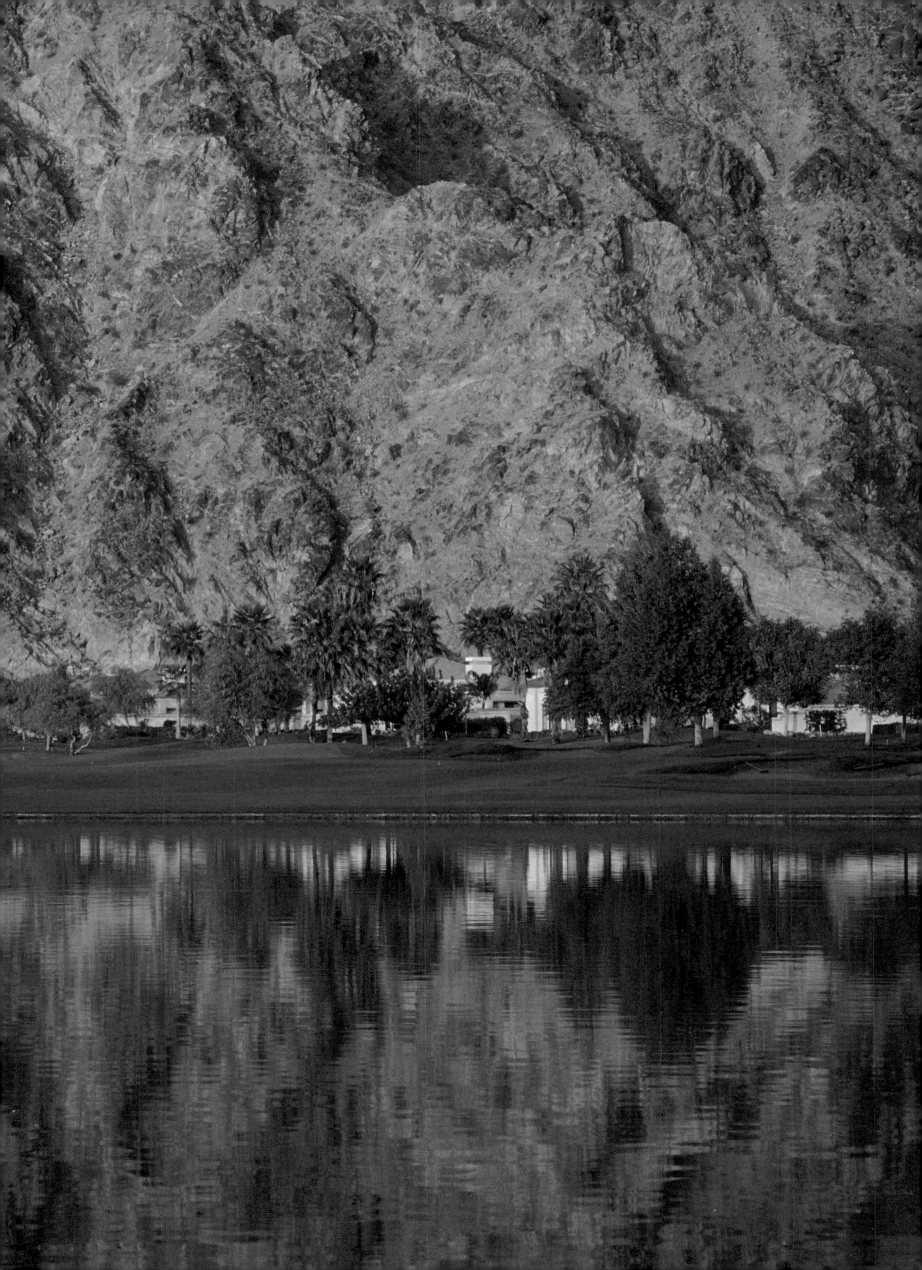

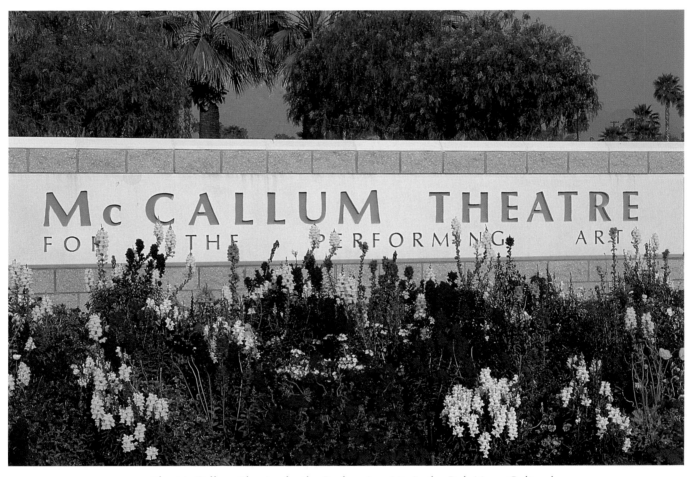

▲ The McCallum Theatre for the Performing Arts in the Bob Hope Cultural Center opened in Palm Desert in 1988. The theater was the result of years of local efforts to create a first-class showplace for major entertainment.

▲ Desert resort cities boast almost ninety golf courses—including Mesquite Country Club in Palm Springs—plus myriad swimming pools, polo fields, tennis courts, upscale shops and restaurants, and hiking and riding trails.

▲ Colorful flower gardens—plus lush lawns, distinctive designs, and sparkling fountains—spice up the resort hotels, country clubs, public buildings, and other vacation facilities found throughout the Coachella Valley.

▲ The Palm Springs Desert Museum, across the street from the Desert Fashion Plaza, houses classic and contemporary Western U.S. art, sunken sculpture gardens, natural science exhibits, and the Annenberg Theater.

▲ A leftover from El Mirador Hotel, this tower—a replica built following
a fire in 1989—is the centerpiece of Desert Hospital in Palm Springs.
▶ In the spring, California poppies blanket many parts of the desert.

◄ Ballooning is a colorful pastime in the Coachella Valley, with several firms offering charter flights for the adventurous. Another popular activity, polo, is planned regularly at the Eldorado and Empire polo clubs in Indio. ▲ Classic car shows take place throughout the Coachella Valley, including at these popular, major events each fall: the Empire Balloon, Wine and Polo Festival, which occurs in Indio; and the Palm Springs Road Races.

▲ Since 1938, Moorten's Botanical Garden in Palm Springs has showcased desert plants from around the world. Included in its international displays, this famed private reserve features a special section of the California desert. ▶ Greenery creates a lush, jungle-like setting in the grand atrium of Marriott's Desert Springs Resort in Palm Desert. Canopied boats ply the small river that runs through the grounds and into the main hotel building.

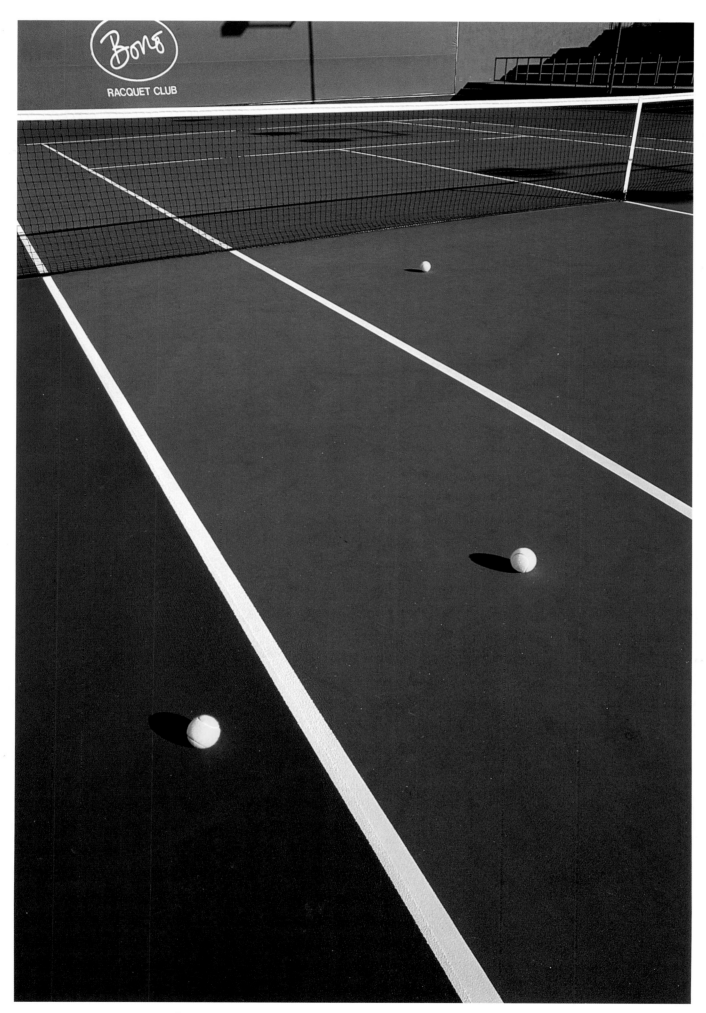

◄ Built in 1926, La Quinta Hotel inspired Capra's "It Happened One Night."
▲ The Coachella Valley features stadium courts and night-lighted tennis
facilities. One major complex, in Palm Springs, is the Bono Racquet Club.

▲ Westin Mission Hills Resort in Rancho Mirage offers bold landscaping.

▶ Desert Resorts Area events range from golf to polo to art and music fairs.

▶ ▶ Mount San Jacinto forms one of America's most abrupt escarpments.

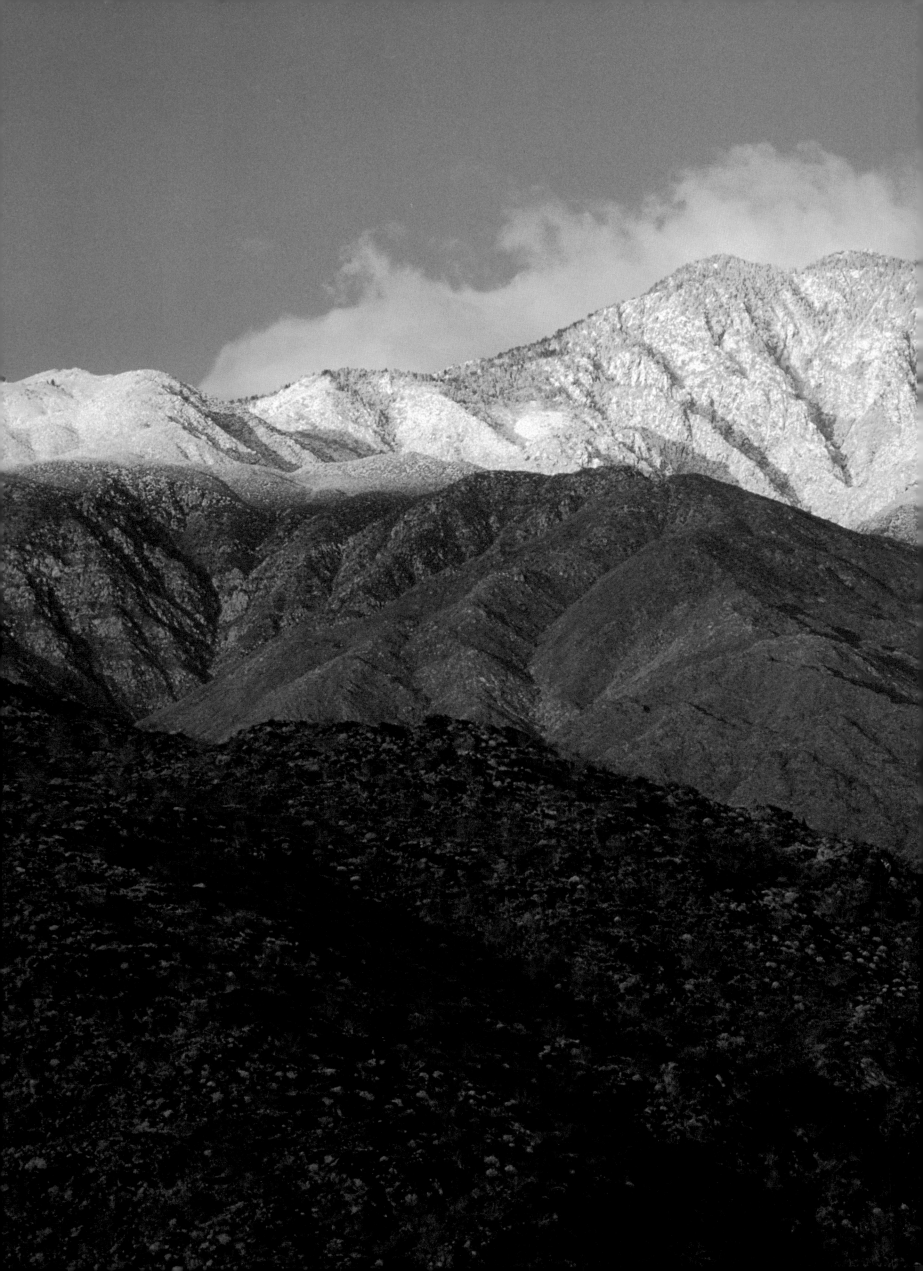

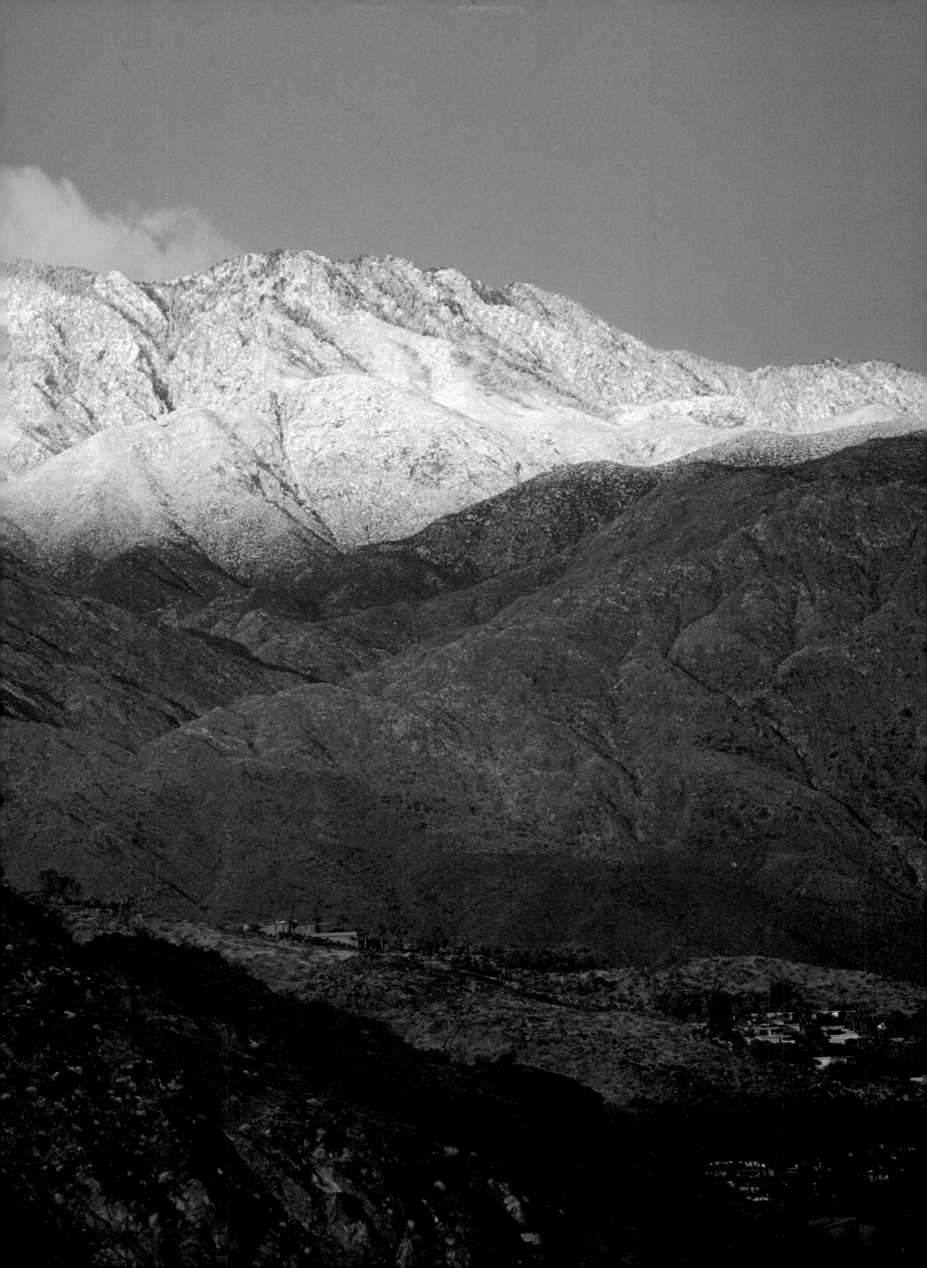

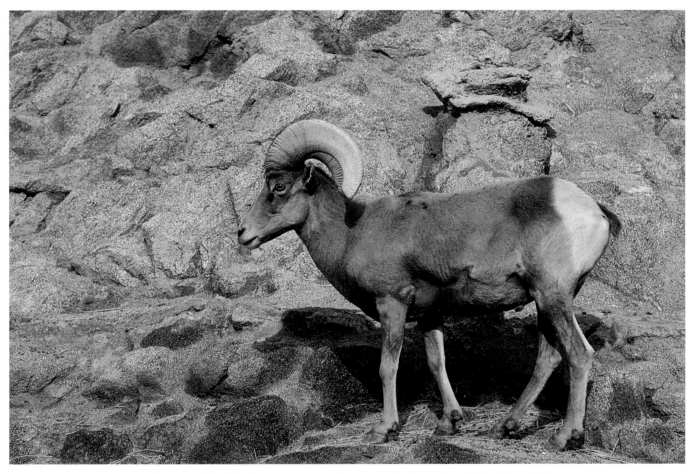

◄ Eye-catching landscapes grace the grounds throughout the Coachella Valley. The use of colorful flowers and artistic fountains in well-thought-out designs, for example, spices up many resort and country club scenes.
▲ This bighorn sheep is a star resident of the Living Desert, a wild animal park and botanical garden in Palm Desert. The preserve has a walk-through aviary as well as an "After Sundown" display of nocturnal desert dwellers.

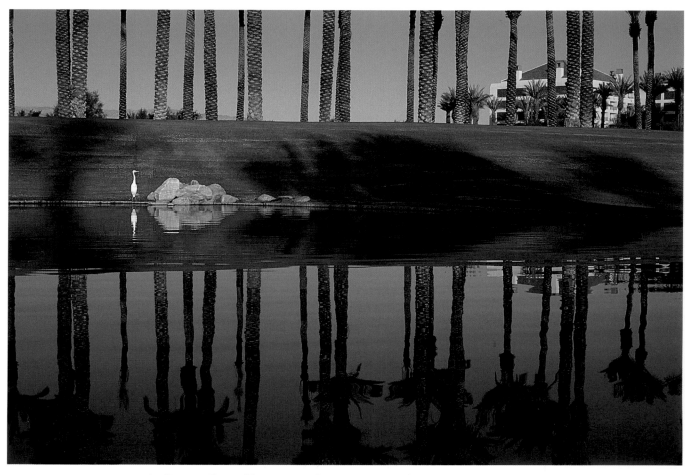

▲ Indian Wells Golf Resort and Stouffer Esmeralda Resort highlight the desert community of Indian Wells. This pair of resorts shares the same fountain-and-palm entrance with the adjacent Hyatt Grand Champions.

▲ Garden sculptures at the Hyatt Grand Champions Resort profile two of
the valley's most popular activities: tennis and golf. The Hyatt is known for
the big-time tennis tournaments that occur in its professional stadium.

▲ Indio's National Date Festival is one of the California desert's top draws.
The festival occurs in February and features an Arabian Nights pageant,
a carnival, camel races, agricultural exhibits, and even elephant rides.

▲ In the middle of the Palm Springs Desert Resorts Area are two neighboring resort towns, Palm Desert and Rancho Mirage, with prominent resorts, exquisitely landscaped country clubs, and fashionable neighborhoods.

▲ This fountain on Frank Sinatra Drive marks the entrance to the Ritz-Carlton resort, which is perched on a secluded hilltop above Rancho Mirage and the nearby residential community known as the Mirada.
▶ Beautifully landscaped country clubs and hotels, such as the Wyndham Palm Springs, are found in every desert city in the Coachella Valley. The Wyndham is the neighbor of the Palm Springs Convention Center.

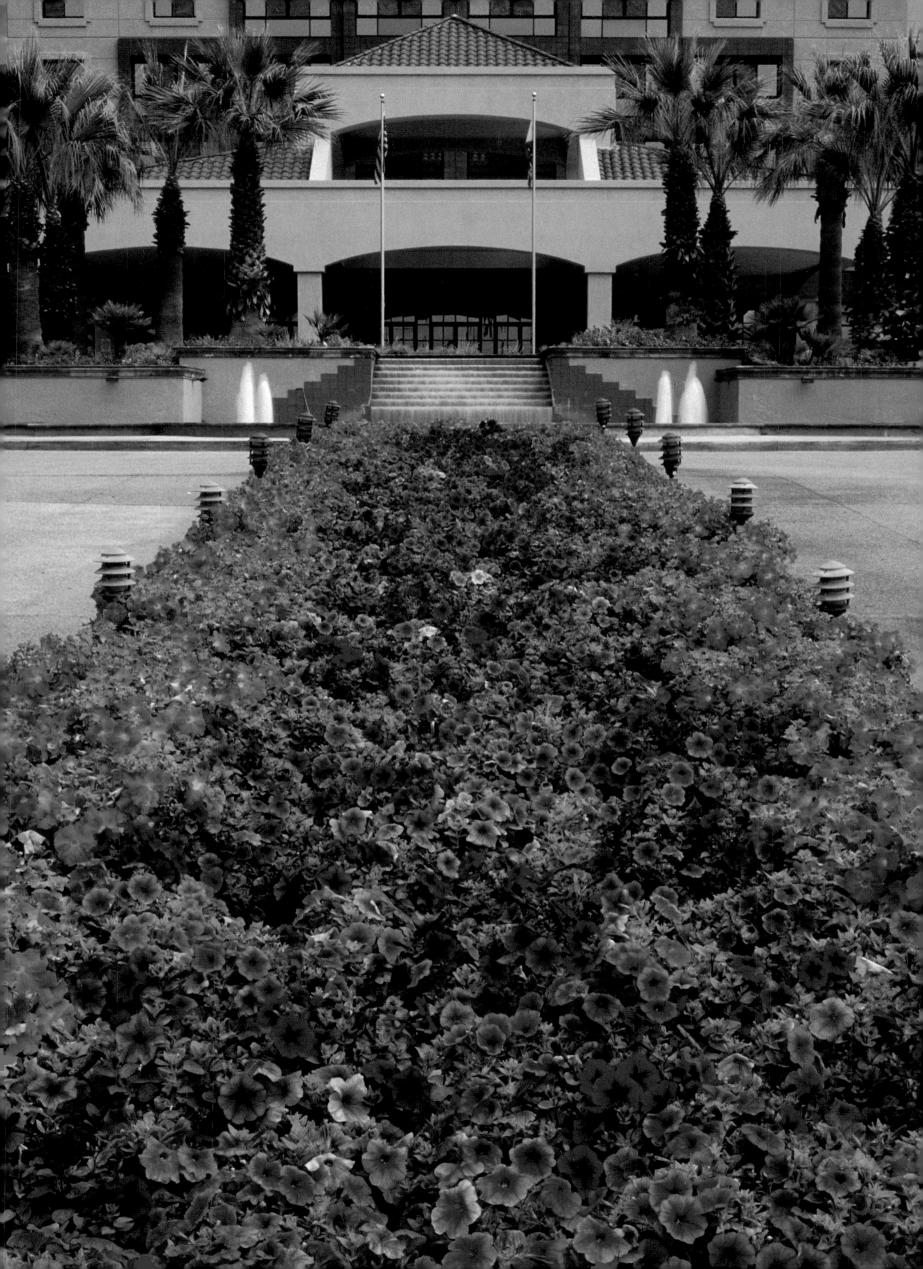

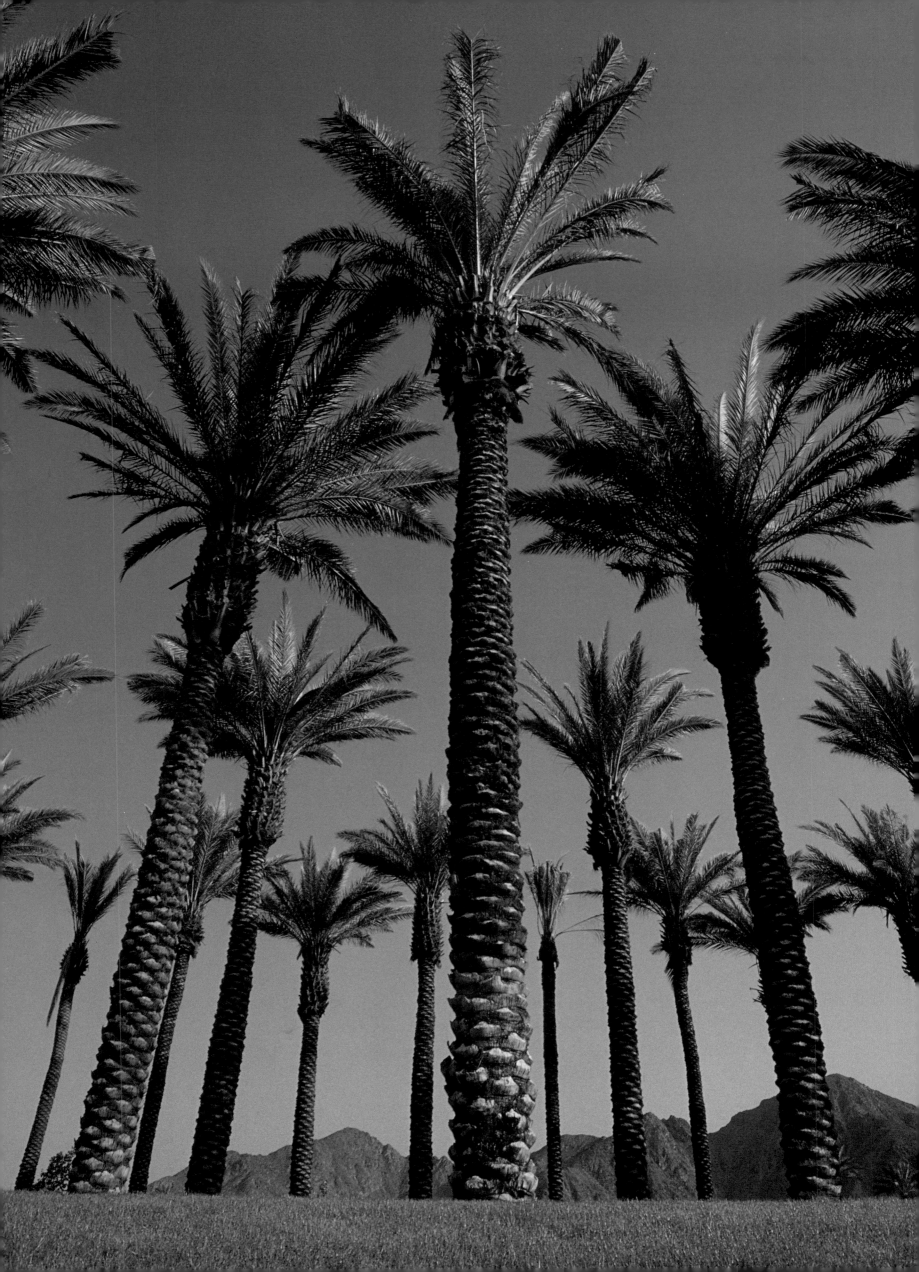

◄ Much of Palm Springs' fame began in the 1930s, when Hollywood stars Ralph Bellamy and Charlie Farrell opened their Racquet Club. Today, the valley resorts have spread out to other cities, such as Indian Wells.
▲ Centuries ago, ancestors of the Agua Caliente Cahuilla Indians settled in the Palm Springs area. Rock art and other traces of these communities can be seen in the Indian Canyons, home of rushing creeks and palm groves.

▲ The historic buildings of the Village Green Heritage Center document the lively past of Palm Springs. Village Green fronts Palm Canyon Drive, a palm-lined avenue filled with boutiques, art galleries, and specialty shops.

▲ Art festivals, gallery showings, and even outdoor exhibits—including these lifelike sculptures by Seward Johnson, Jr., along exclusive El Paseo in Palm Desert—take place year-round in many Coachella Valley cities.

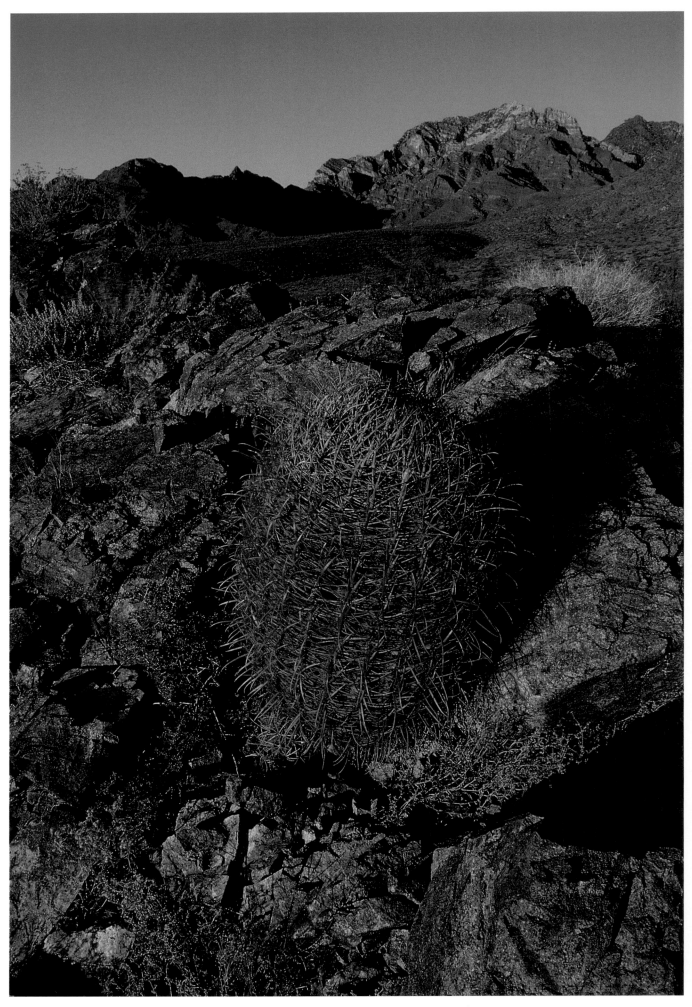

▲ Many types of well-adapted cacti thrive in a variety of ecosystems in the California desert, including this barrel cactus on the rocky flanks of the Providence Mountains in the East Mojave National Scenic Area.

How peculiar that nearly a million people a year should willingly seek out a place whose topographical titles evoke impressions of a netherworld that few would ever care to think about and fewer still would ever want to visit. Yet they come here in droves, and for no other reason than to investigate the likes of places named Devils Golf Course, Furnace Creek, Badwater, Dantes View, Blackwater Wash, Hells Gate, Desolation Canyon, Devils Cornfield, Black Mountains, and Funeral Peak—all of which comprise a land so foreboding it bears the name Death Valley.

But the morbid reputation is mostly without merit. True, some have perished here—as they have in all parts of the desert, for it is a land that plays by its own set of rules. Yet Death Valley is alive with light and color. It is a rangy, rawboned province graven in multi-colored hues, a land where ocher badlands give way to snow-white playas, and canyons are called Golden and Mosaic and Mustard; where seismic upheavals have created steep, mountainous uplands, and volcanic explosions have sired giant craters; where bristlecone and limber pines forest the mountain tops, and saltbush and pickleweed freckle the salty plains.

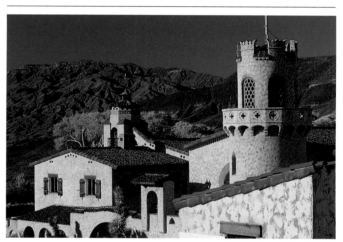

Scotty's Castle, Death Valley National Monument

The place called Death Valley National Monument lies about three hundred miles northeast of Los Angeles and, in its entirety, sprawls across more than thirty-two hundred square miles of desert scenery, creating a parkland as large as Rhode Island and Delaware combined. The valley itself is approximately one hundred fifty miles long, though only about one hundred twenty miles of it is enveloped by monument borders. Bound on the west by the Panamint Range with its 11,049-foot Telescope Peak and on the east by the Amargosa Range with its 8,738-foot Grapevine Peak and centered by Badwater Basin at 282 feet below sea level, the monument includes everything from saltpan flats to snow-capped highlands.

Strange as it may seem, Death Valley is not really a valley. It is, instead, a ditch or graben formed as blocks of the earth's crust separated along fault lines, creating up-tilted mountain ranges like the Panamint and Amargosa and down-dropped basins similar to Death Valley. Such land-forms are known as basin and range topography. Death Valley and its adjoining mountains are but one in a series of

Death Valley
&
the Northern Desert

north-south-trending basins and ranges that follow one another all the way from California's Sierra Nevada to central Utah and from Idaho south to Mexico.

Although desert basins are common, Death Valley itself is not. It reigns supreme as the hottest, driest, and lowest place in North America. Its highest recorded summer temperature was in 1913 when the mercury reached 134 degrees Fahrenheit at Furnace Creek. Its mean summer temperature really is mean, hovering well in excess of one hundred degrees, making summertime in Death Valley one of the hottest spots on earth. Rain, when it does come, is less than two inches annually—with most falling during winter months. January, the coldest month, claims a thermometer resting in the low fifties, temperatures still warm enough to evaporate most standing water. Add to the list of hottest and driest the fact that more than five hundred square miles of valley floor are below sea level (and still sinking) and it is easy to understand how the valley came by its unfortunate repute.

Scientists believe Death Valley has been inhabited for at least nine thousand years, and even though the Old Spanish

Cottontop cactus, Death Valley National Monument

Trail crossed the valley's southern end by 1830, it was 1849 before white men came in contact with the valley interior. It was nearly their undoing. History tells that emigrants heading for the California gold fields via the Old Spanish Trail crossed paths with a packtrain whose leader showed them a map alleging a shortcut that would save them weeks of travel. Only a few wagon drivers played it safe and stuck with the tried and true Spanish Trail. The majority headed off into unbroken and unknown territory.

Their nightmare was about to begin. The rocky terrain was such hard going wagons covered a scant fifteen miles a day—sometimes not even that. To top things off, the land offered little food or water; by the time the emigrants managed to bump down Furnace Creek Wash, they were nearly out of supplies—forcing some families to have to eat their oxen and abandon their wagons. Nearly three months had passed between leaving Salt Lake City and arriving in the valley interior. It was Christmas Day. Yet celebrating was not foremost on anyone's mind, for to their dismay, they soon discovered that there was no obvious way out.

By the time they spent one more day seeking a path across the Panamints and yet another traveling south on foot, hoping to discover an escape route in that direction, they were down to two wagons and almost no food. In desperation, they decided the two youngest and most fit, William Manly and John Rogers, would leave the others camped at a small spring and hike across the Panamints and get help. After all, Los Angeles must be just the other side of the mountain, and in ten days or so, the "boys," as they were called, would return with plenty of provisions.

Manly and Rogers did find a way across the Panamints. But Los Angeles was more than two hundred miles away—even hiking in a nearly straight line. By the time the boys returned with supplies and pack animals, more than three weeks had passed. Some of the emigrants had waited the allotted ten days and, with Manly and Rogers nowhere in sight, struck out on their own. Most managed to find their own way across the mountains. Two families awaited the rescuers' return, and when Manley and Rogers reappeared, they were near starvation. Loading up their few possessions, they left the valley, and as the forlorn group crested the Panamints via the pass the "boys" had discovered, one of the women looked back and spoke words that would become legend: "Goodbye, Death Valley."

The valley's bad reputation got around, though it seemed not to deter others from coming. Prospectors came to look for gold and silver, entrepreneurs came to collect borax, a wealthy Chicagoan came to build a castle, and tourists still come to see why all the others came. Valley lore has reached almost epic proportions. Not surprising. History abounds here, and the monument itself has become almost a repository for yesteryears' relics. Most intriguing of all are the crumbling adobe buildings, rusted machinery, and two huge wagons atop a knoll overlooking almost infinite acres of white desolation. Hard to imagine this was once a bustling business called the Harmony Borax Works.

Although borax was discovered in Death Valley in 1873, refining operations at the Harmony Borax Works did not begin until 1883, mostly because there were obstacles to overcome: climate, distance from a railroad, and other borax locales that were more accessible. That borax compounds were valuable had long been known; the Chinese had been using it in their porcelain glazes for at least sixteen centuries. The white crystals, composed of sodium, oxygen, boron, and water molecules, were found in dry lake beds and could be used to remove impurities from molten materials, in the manufacture of glass and enamel, and as an excellent laundry additive.

It had a ready market—if it could just get there. With the nearest railroad 165 miles away in Mojave, a wagon road across the desert was a necessity. Perhaps worse than crossing the Panamints and the rocky reaches beyond was the knife-edged impediment of salt pinnacles known today as Devils Golf Course. It proved to be the hardest construction problem of all and was finally solved by having Chinese laborers actually sledgehammer the ground smooth where the wagons would pass. The sledgehammering continued

until the end of Death Valley's borax era, for salt pinnacles were growing entities, a sort of self-elevating ground that had to be continually pounded down.

To move tons of borax at one time demanded wagons unlike any others that had ever been built. The end product boasted a bed sixteen feet long, four feet wide, and six feet high. Its rear wheels stood seven feet high; its front wheels, five feet high. Its tires were cast of steel eight inches wide and one inch thick and weighed a hefty six hundred to a thousand pounds apiece. Each wagon cost approximately nine hundred dollars, could carry ten tons, and—empty—weighed seventy-eight hundred pounds.

It took twenty pack animals (contrary to popular belief, the twenty mule teams actually consisted of eighteen mules and two horses) to pull each double-wagon shipment. No small feat, for the two wagonloads of borax and the water-wagon caboose weighed more than thirty-six tons. Getting the creaking caravan to the Mojave railroad involved ten to twelve days of jostling across nearly impossible terrain and almost as many getting back to Death Valley. Yet not one of the wagons ever broke down, and by the time the Harmony Borax Works ended production in 1889, the amount of Twenty-Mule-Team Borax they had carried out of Death Valley came to more than ten thousand tons.

Scattered throughout the monument are the historic remains of the gold-producing Keane Wonder Mine, the Ashford Stamp Mill, and the original Stovepipe Well, one of the valley's wide-spaced sources of fresh water. At the monument's far northern edge is Death Valley Ranch, commonly known as Scotty's Castle. Built in the 1920s by Chicago millionaire Albert Johnson as a winter retreat, the turreted structure appears more a palatial home than a castle. Johnson's friend, Walter Scott, acted as a sort of caretaker for the ranch and, being no stranger to tall tales, allowed many to believe that the "castle" was actually his—and even though the facts prove different, the imposing structure is still called by Scott's name.

That anyone purposely came here seems incongruous. The valley floor is a salt-encrusted salina that was formed as salts, borates, and other water soluble minerals collected in the arid basin. Mountains are knife-edged, canyons are steep, mudhills are barren, salt pinnacles are sharp enough to cut through leather, and the travertine-laced water really is bad. It is a credit to our forefathers that they survived their sojourn here. What makes the difference today is perspective, and air conditioning, and bottled water, and lodging, and a steak house at Furnace Creek. Amidst all that, it is easy to revel in a land where sweeping vistas give way to more sweeping vistas, and tough, wiry plants form tiny islands of green, and mile after mile of asphalt connects one magnificent discovery to another.

About thirty miles from Death Valley's southernmost boundary is a 1.5-million-acre wedge of desert known as the East Mojave National Scenic Area. It is an integral part of the California Desert Conservation Area created by Congress in 1976, and in 1980 was designated as the country's first National Scenic Area. Approximately 80 percent of its acreage is federal public land administered by the Bureau of Land Management (BLM), with the remainder split under both state and private ownership.

Few roads cross its wilds. It is bound on the north by Interstate 15, on the south by Interstate 40, and it is crisscrossed by eight backcountry byways created and maintained by the BLM. Most of the byways are paved and accessible to regular passenger vehicles; several require four-wheel drive. Supplies of any kind are few and far between, yet taking time to investigate all or part of the East Mojave National Scenic Area is to discover a world set apart—a land of volcanic cinder cones, early army forts, old mines, Indian petroglyphs, singing sand dunes, granitic mountains, and limestone caves.

Rising three hundred feet above the sandy washes and black lava flows along the Scenic Area's eastern edge are the thirty-two volcanic cones known as Cinder Cones National Natural Landmark. The dark red and black symmetrical formations are remnants of the Mojave's volcanic age and are estimated to have erupted somewhere between eight hundred and a thousand years ago. Farther down the road

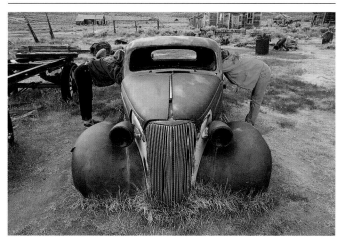

Abandoned car, Bodie State Historic Park

are the Kelso Dunes, the continent's third-highest dune field. Built over the last hundred thousand years of sand blown in from the Mojave River Sink thirty-five miles west, the quartz and feldspar grains have created white dunes six hundred feet high. Their most intriguing asset is not their color, though it is spectacular, but their ability to "sing," for when the sand grains rub against one another they produce a low rumbling that to many sounds like humming.

Along the East Mojave's northern edge are the Clark Mountains, at nearly eight thousand feet the highest peaks in the Scenic Area. Just to the south is Cima Dome, an almost perfectly rounded rock form that rises fifteen hundred feet above the surrounding desert. The entire dome covers about seventy-five square miles and was born a batholith—a mass of liquid rock beneath the earth's surface. Over time, the molten mass hardened, uplifted, and eroded into the form seen today—a highly visible landmark whose top is forested with a dense stand of Joshua trees.

The Scenic Area's southern reaches are home to the seven-thousand-foot-high Providence Mountains with their

hidden cache of twelve-million-year-old limestone caverns. Providence Mountains State Recreation Area, owned and administered by the state, includes the fascinating Mitchell Caverns with its stalactites, stalagmites, cavern coral, and flowstone. Crossing the entire width of the East Mojave National Scenic Area is the four-wheel-drive Mojave Road. Once an Indian trade route between coastal villages and the Colorado River, it was later developed by the United States Army into a wagon trail connecting Los Angeles and Prescott, Arizona. Today, it is a recreational two-track with a history that recalls the days of army supply trains, emigrant wagons, stage coaches, and mail riders.

North of Death Valley, across the ominous Panamints, stand the White and Inyo mountains—a single block of earth's crust uplifted to heights that nearly rival those of the Sierra Nevada in whose shadow it stands. The mountainous block stretches one hundred ten miles in length, with the northern section wearing the name Inyo Mountains; the southern section, the White Mountains. White Mountain Peak, at 14,246 feet above sea level, is California's third-highest peak, and the highest outside of the Sierra itself.

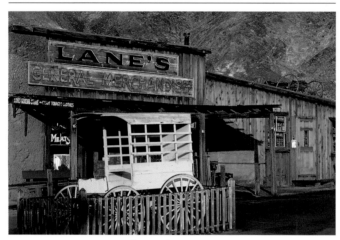

Street scene, Calico Ghost Town near Barstow

Here in the White Mountains' oft-frozen uplands stands a bunch of wonderfully ugly trees—coniferous ancients that live on the edge of subsistence and, oftentimes, on the brink of perpetual cold. Scientifically, they are *Pinus longaeva*; more commonly, bristlecone pine. By whatever title, they are the oldest-known living things on earth.

For nearly fifty centuries, they have stood here, and the tale each one tells is much the same. Every bend, wrinkle, and spiral denotes screaming winds and continual desiccation, soil that refused to hold fast, and moisture—its abundance or its lack. For the most part, the feisty trees grow where others cannot, homesteading alkaline soils that are both rocky and shallow. Though young specimens boast dark gray bark and dark green needles, the patriarchs look more like standing driftwood than living trees.

Because the bristlecone prefers elevations from seventy-five hundred to ten thousand feet, they have had to adapt to climatic conditions that are far from ideal. No problem. When things get really tough, they slow down the process of living by curtailing cell expansion. Other times, part of the tree will die so the living portion can remain in balance with variations of weather and climate.

In sheltered places, the bristlecone becomes what it was inherently meant to be: a beautifully symmetrical tree forty to fifty feet high. But here, where desert winds sandblast the trunks into burnished satin and razor-sharp ice crystals kill nearly every twig-forming bud that rises above the protective snowpack, the trees have become living ruins. Seldom are they taller than twenty-five feet—whether standing upright or growing parallel to the ground. Even during the best of times, their growth is slow, usually less than one inch in diameter every hundred years. And yet they survive, not so much in spite of adversity, but because of it. If even a few small veins of living tissue remain, the bristlecone will not only live, but produce fertile cones.

The White and Inyo mountains front the Owens Valley, the first basin and range on the Sierra's eastern edge. The valley, known as the deepest in America, stretches 145 miles, culminating on the north at Mono Basin. This is the western edge of the expansive Great Basin Desert, most of which lies outside California's boundaries. One hundred sixteen thousand acres are included in the Mono Basin National Forest and Scenic Area—a land of volcanic craters, cinder cones, and one of North America's oldest lakes.

Mono Lake is surrounded by desert, yet lies in the shadow of some of the country's tallest mountain peaks. The lake covers nearly seventy square miles, has no outlet, is saltier and more alkaline than seawater, and is said to be around seven hundred thousand years old. Throughout its existence, salts and minerals have washed into its sapphire depths, and, as the salty lake water mixed with the underground freshwater springs, they precipitated out as calcium carbonate that hardened into limestone towers of tufa—some of which stand thirty feet high.

The lake claims two volcanically formed islands. Negit, the smallest, is thought to be around seventeen hundred years old; Paoha, with its hot springs and fumaroles, is young by volcanic standards—less than three hundred years. The islands, lake, and surrounding terrain comprise one of California's most important bird habitats. Mind-boggling numbers of migratory and nesting birds come each year: by May about 50 thousand gulls mate and lay eggs; during the height of summer, at least 140 thousand Phalaropes gorge themselves on brine flies, which reproduce here by the trillions; between August and October, approximately 750 thousand eared grebes will have passed through. In all, about eighty species of birds and waterfowl use Mono Lake each year, and at least three hundred bird species have been sighted in Mono Basin.

The Mojave and Great Basin deserts comprise some of the wildest land left in all of California. It is a textbook on seismology, volcanism, and erosion—quite possibly the very entities that have kept it marginally inhabitable and open to discovery. This is a landscape of eternity wherein is recorded the process of unimaginable time; amidst its rawness, the handiwork of man is seldom apparent. It is both fascinating and repelling—but it is never monotonous.

▲ The Kelso Dunes in the East Mojave are sometimes called "booming" or "singing" dunes, since the sand seems to "hum" as it slides down slopes. These dunes rise more than six hundred feet above the desert floor.

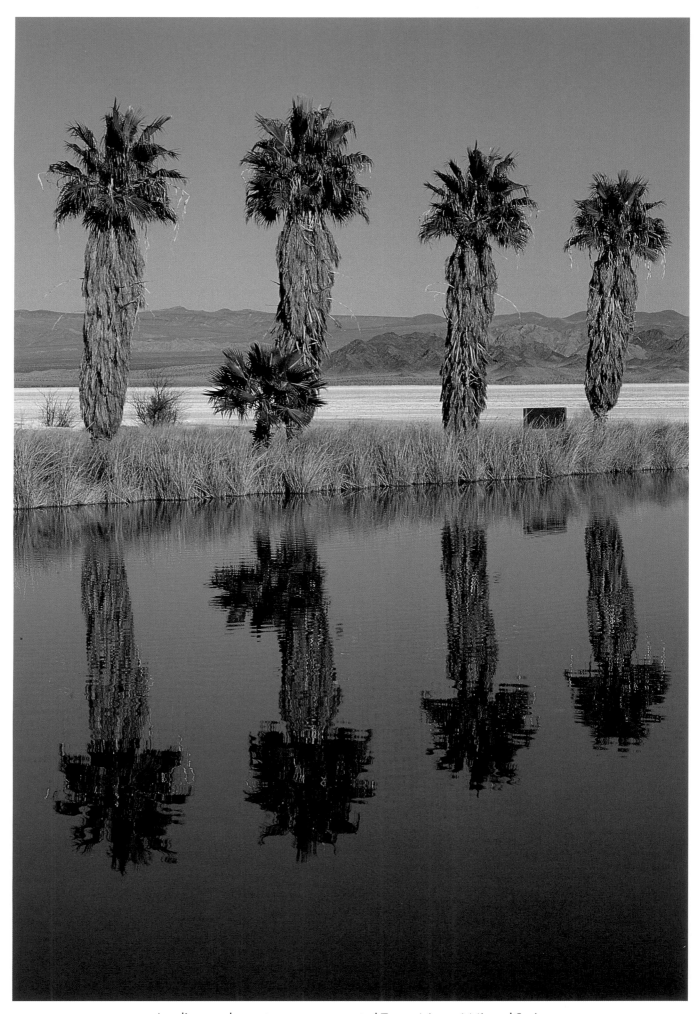

▲ A radio preacher-entrepreneur operated Zzyzx (zizz-ex) Mineral Springs and Health Spa at Soda Springs in the East Mojave from 1944 to 1974. The Desert Studies Center now occupies the resort's buildings next to this pond.

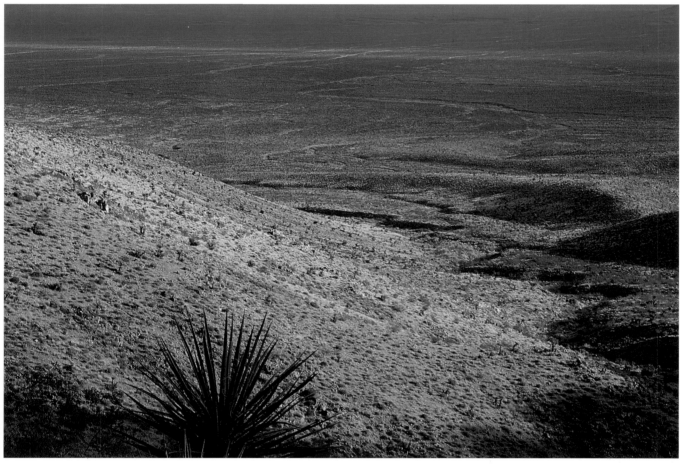

▲ The Providence Mountains State Recreation Area is known for Mitchell Caverns and great desert views. The main gateway to the East Mojave is Baker, home of the tallest thermometer (134 feet high) in the world.

▲ Volcanic rock formations and "Swiss cheese"-style cliffs highlight the East Mojave's Hole-in-the-Wall country. An area adventure involves a "trail" that drops into a narrow passageway and winds up in an enclosed (box) canyon.
► The cliffs, columns, and colors of Red Rock Canyon give some first-time visitors a sense of *deja vu*. This state park has been a favorite backdrop for movies, including many shoot-'em-up, head-'em-off-at-the-pass Westerns.

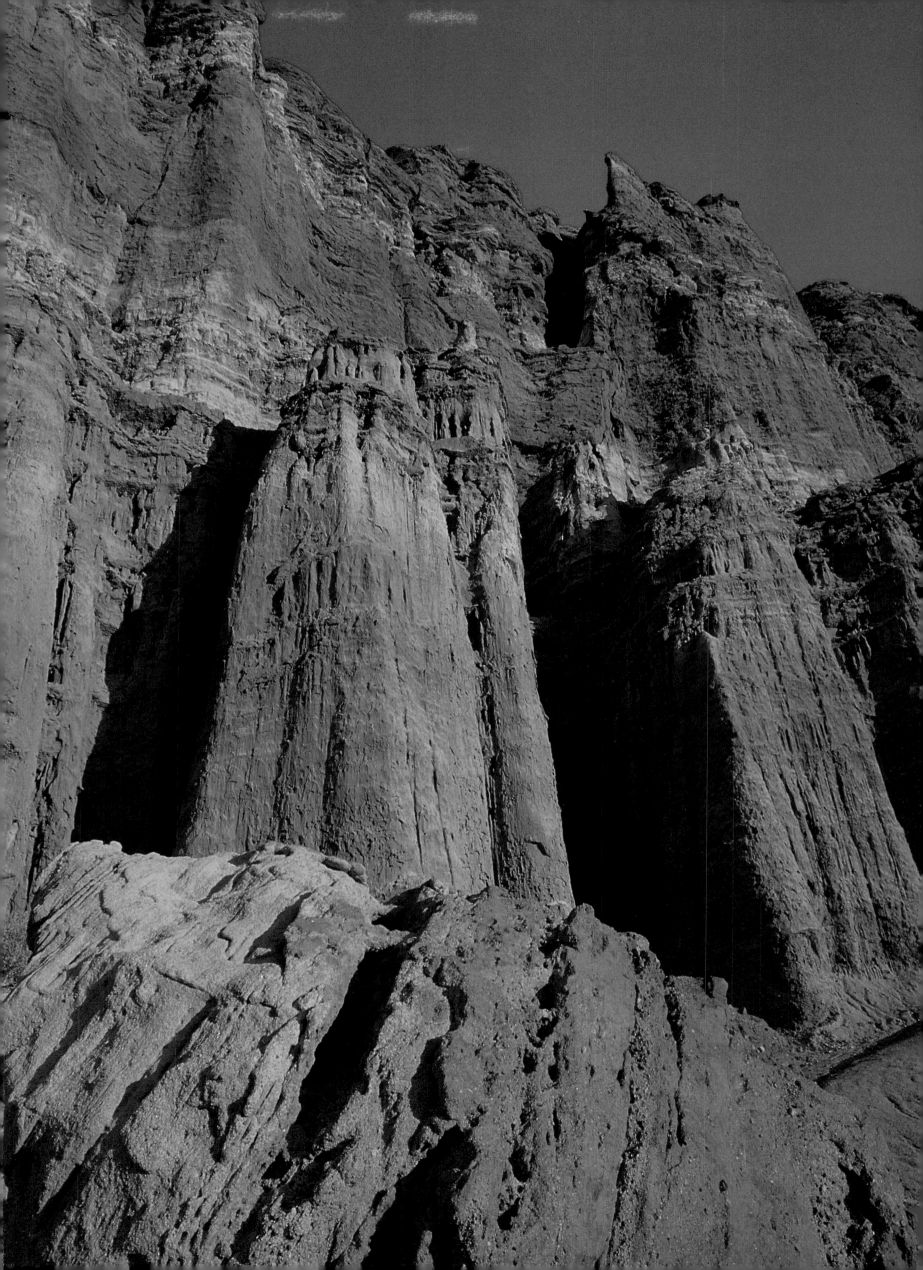

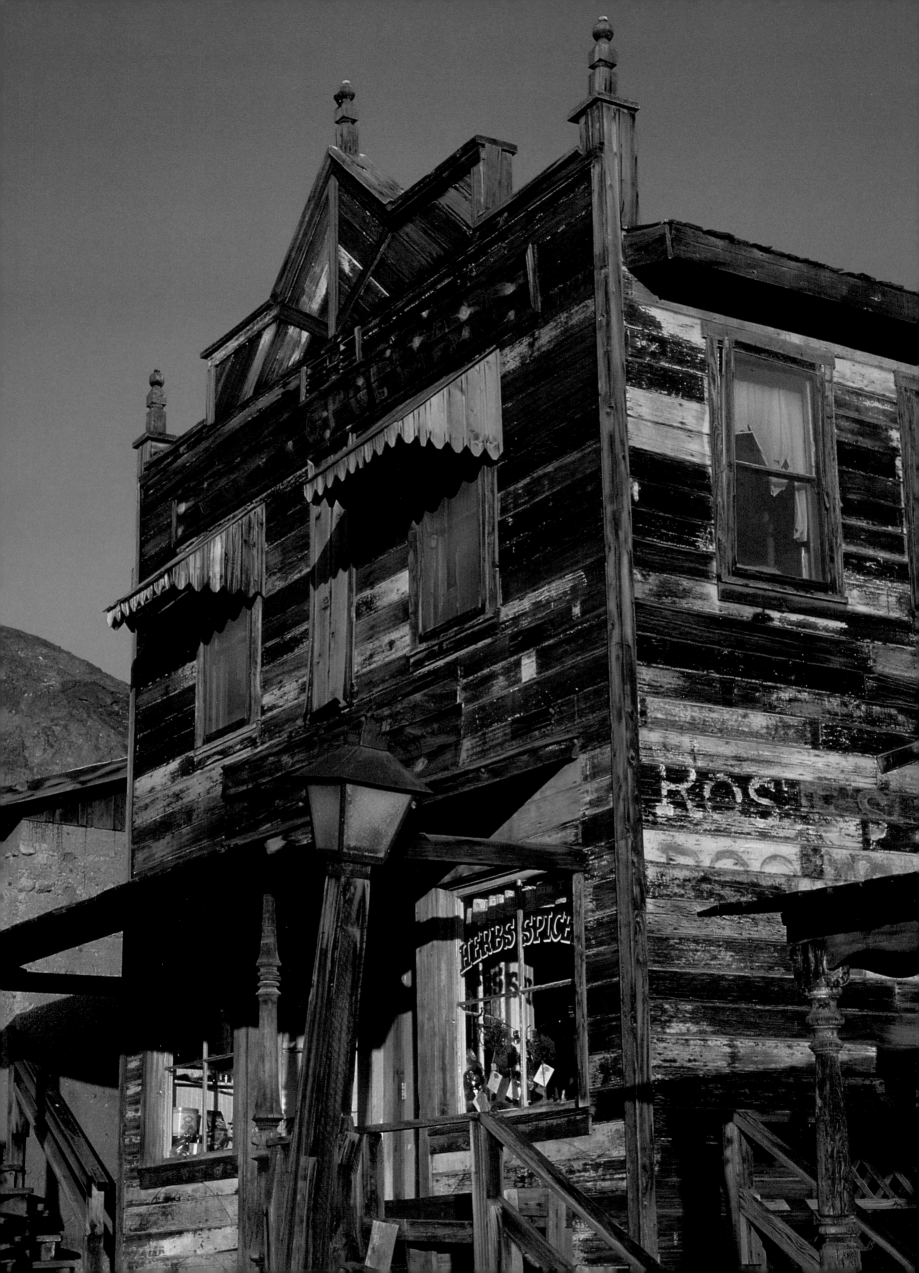

◄ Calico Ghost Town offers old-time stores and saloons, tours of an old mine, train rides, a shooting gallery, and even a playhouse that presents melodrama—complete with details like booing, hissing, and cheering.
▲ In the 1950s, Walter Knott of Knott's Berry Farm fame bought the old boomtown of Calico as a tourist attraction. This "windblown theme park," as it has been called, is now a San Bernardino County regional park.

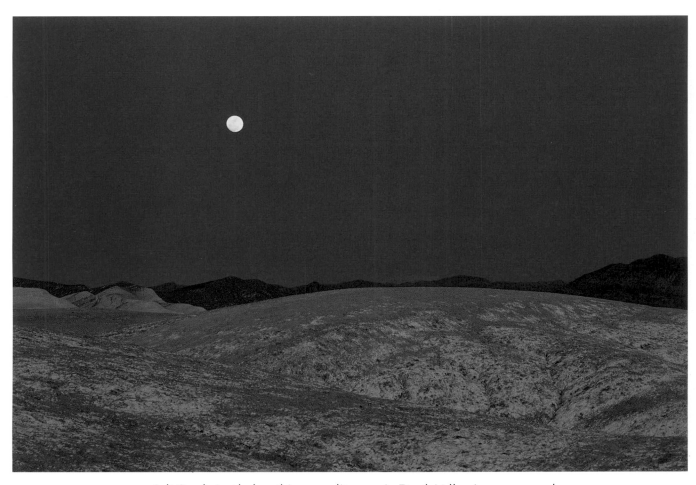

▲ Salt Creek, just below this moon-lit scene in Death Valley, is a year-round desert stream—including fish! But these are not your everyday, run-of-the-mill fish. They are the diminutive Ice Age leftovers called pupfish.
▶ Death Valley's grand Furnace Creek Inn boasts verandas, arches, red tiles, terraced lawns, and a rock-walled swimming pool. Nearby, Furnace Creek Ranch claims the world's lowest golf course—214 feet below sea level.

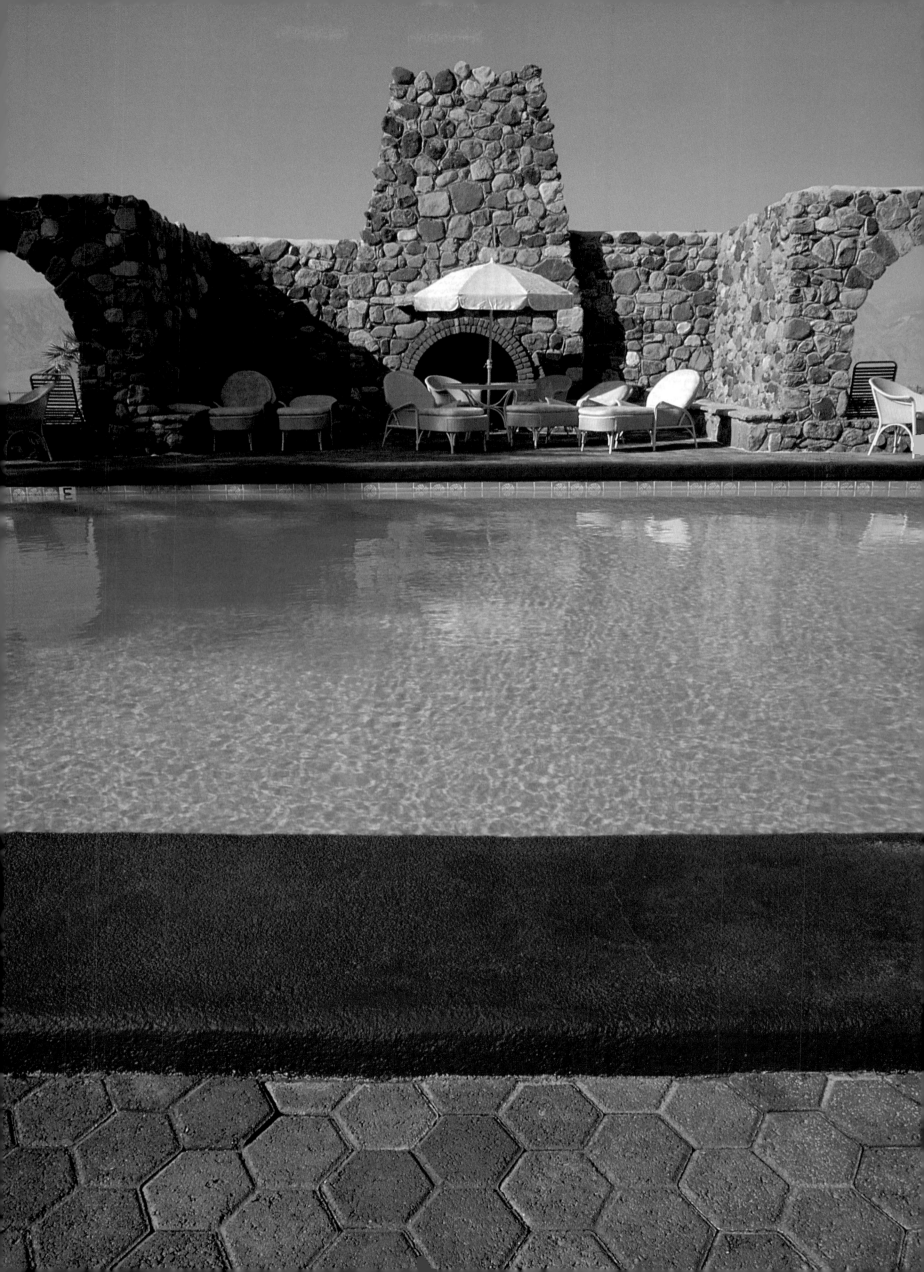

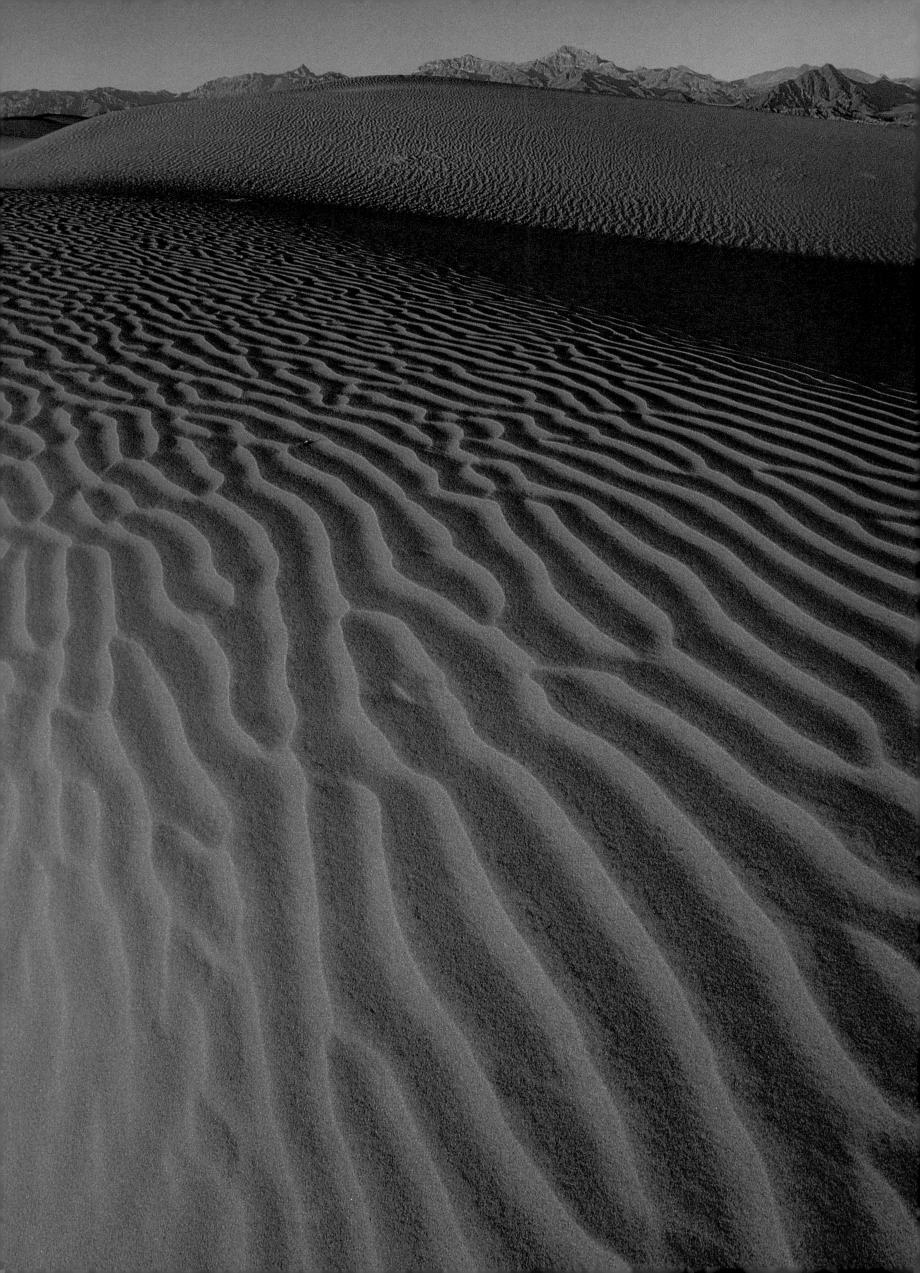

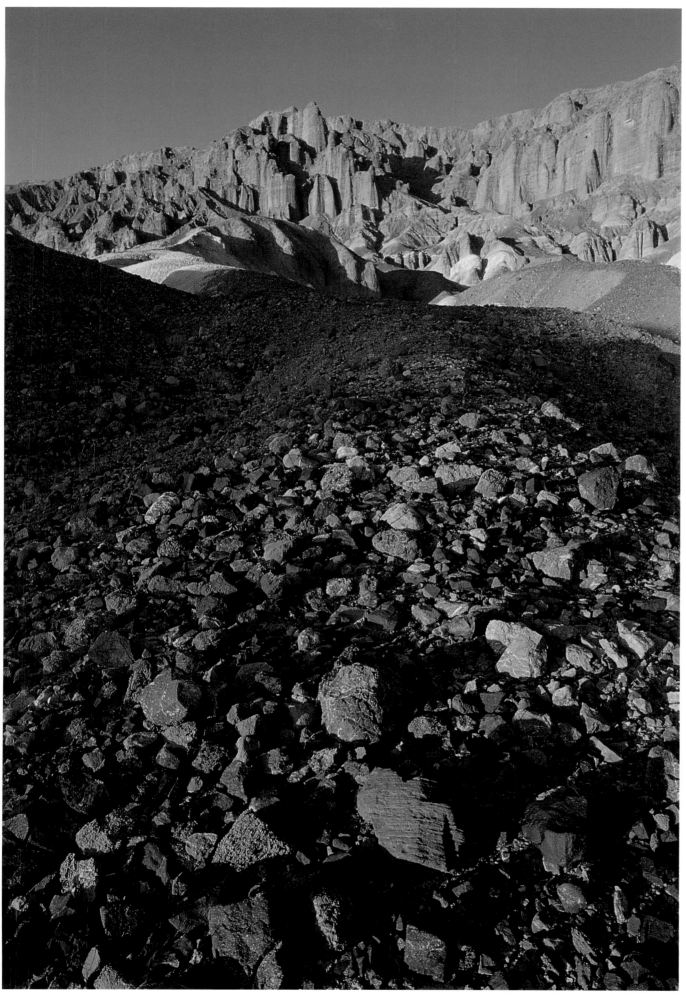

◄ Death Valley's main dunes lie at Mesquite Flat near Stovepipe Wells.
▲ Red Cathedral, in Death Valley's Golden Canyon, consists of gravel and boulders eroded from mountains. The color is from iron compounds.

▲ At Death Valley's Mosaic Canyon, periodic streams polish canyon walls.
► Golden Canyon, with Manly Beacon, is seen from Zabriskie Point.
► ► In 1976, a flash flood wiped out the road through Golden Canyon.

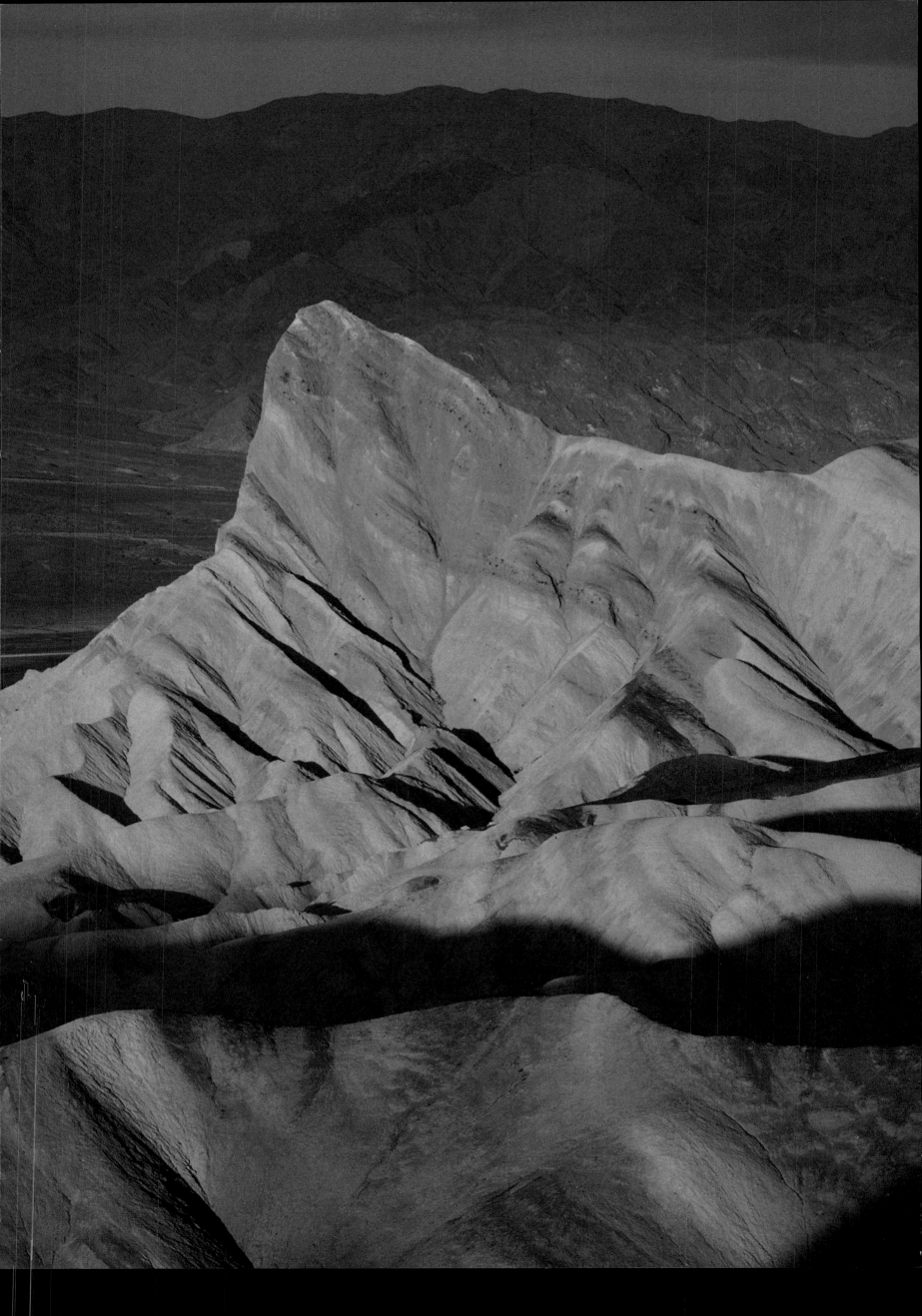

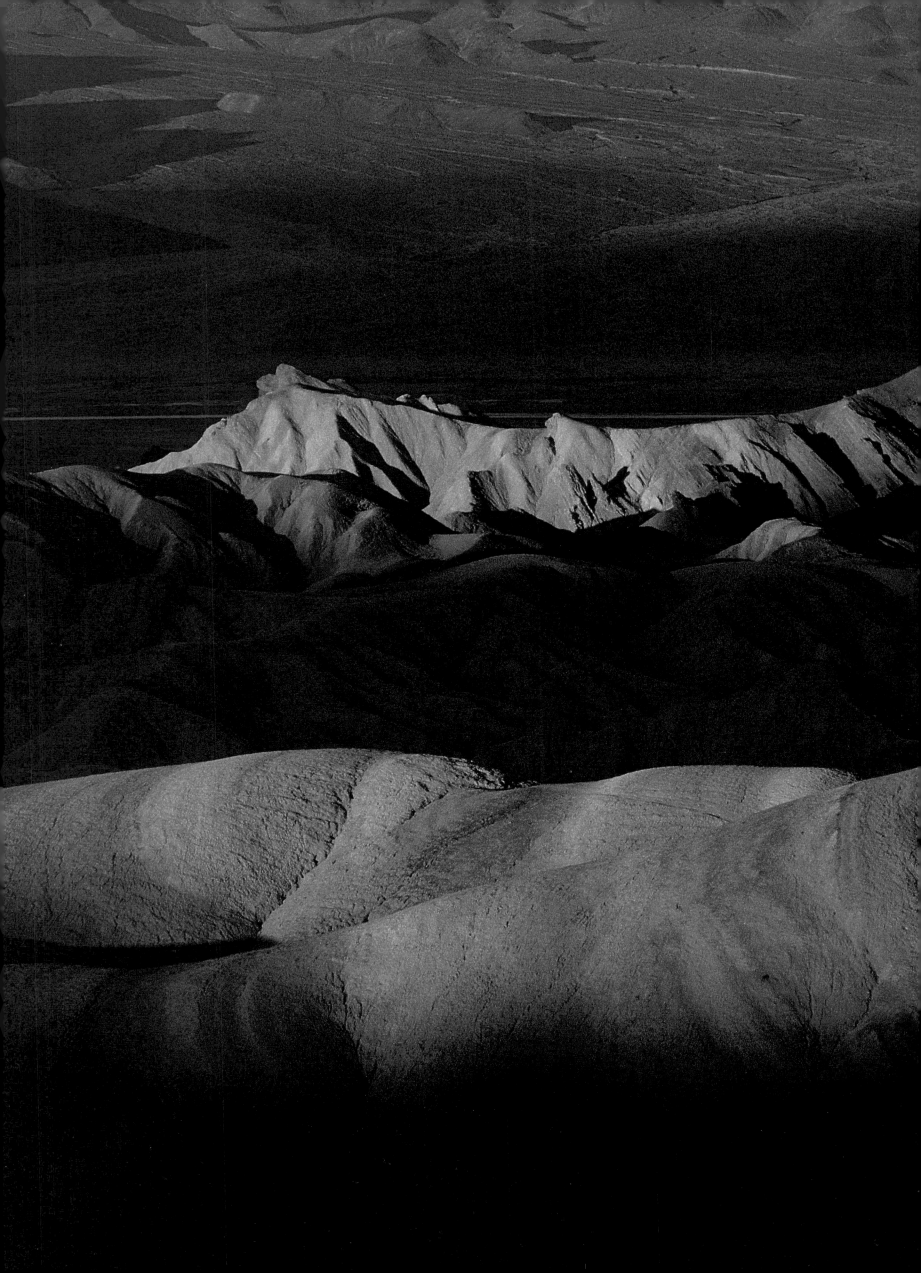

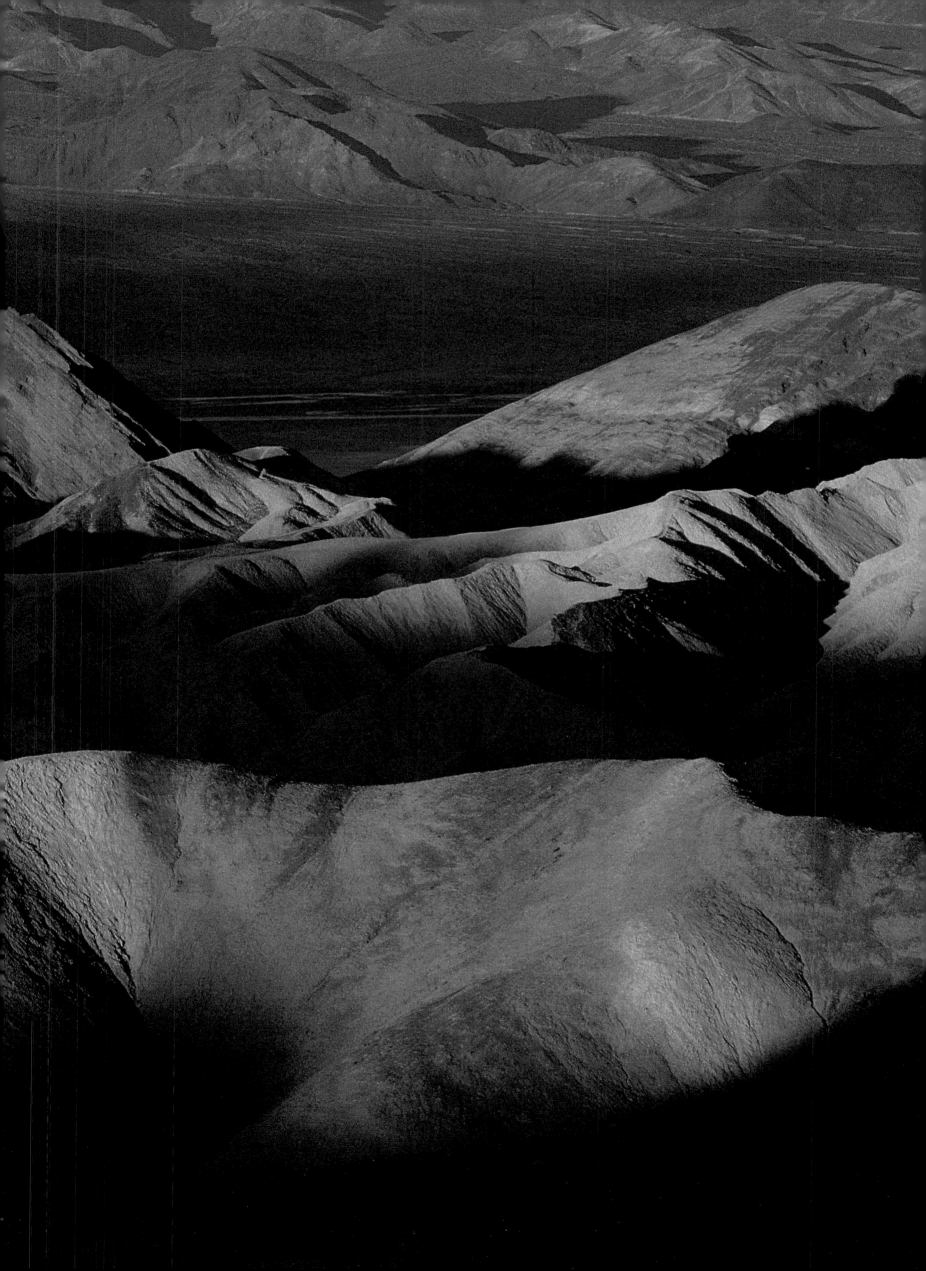

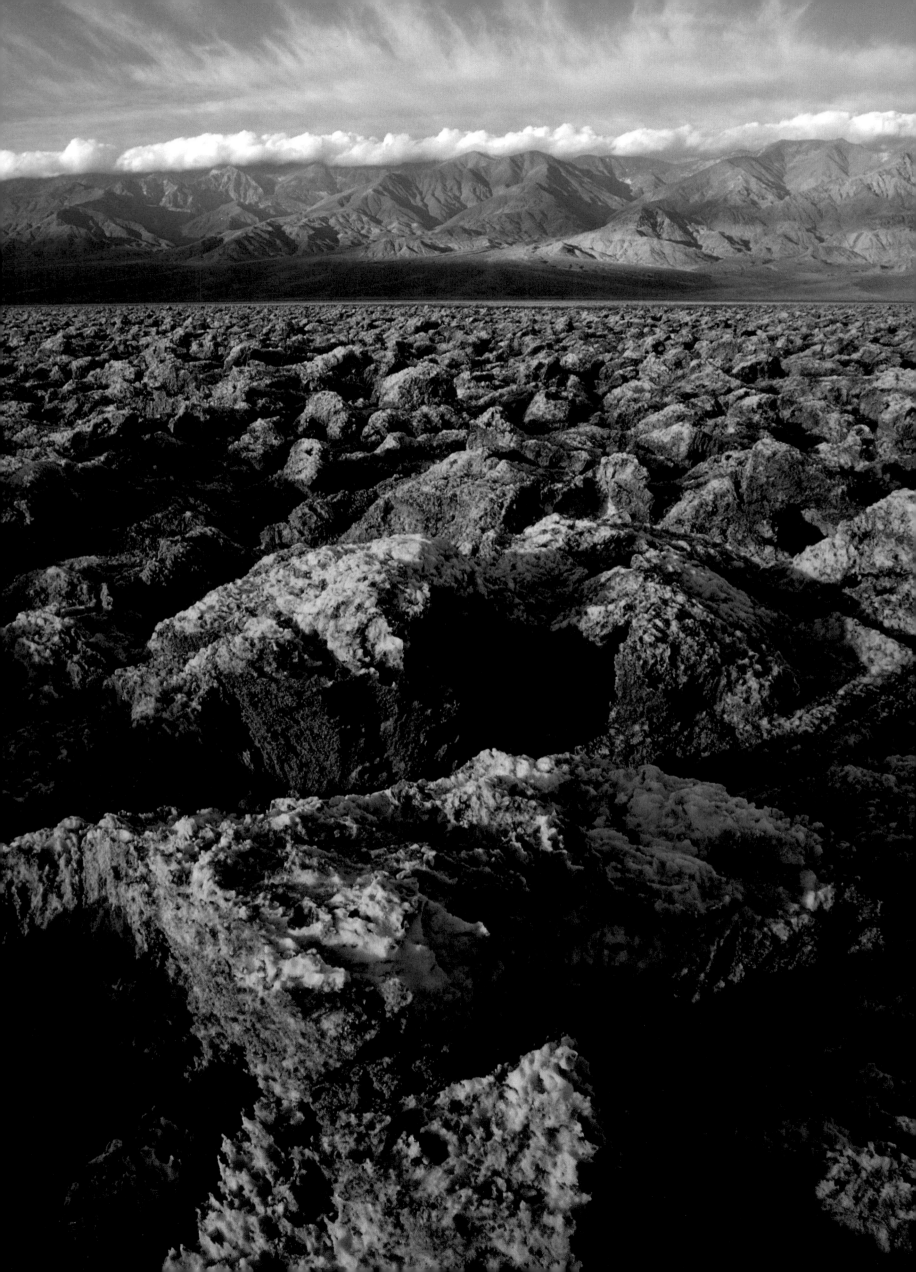

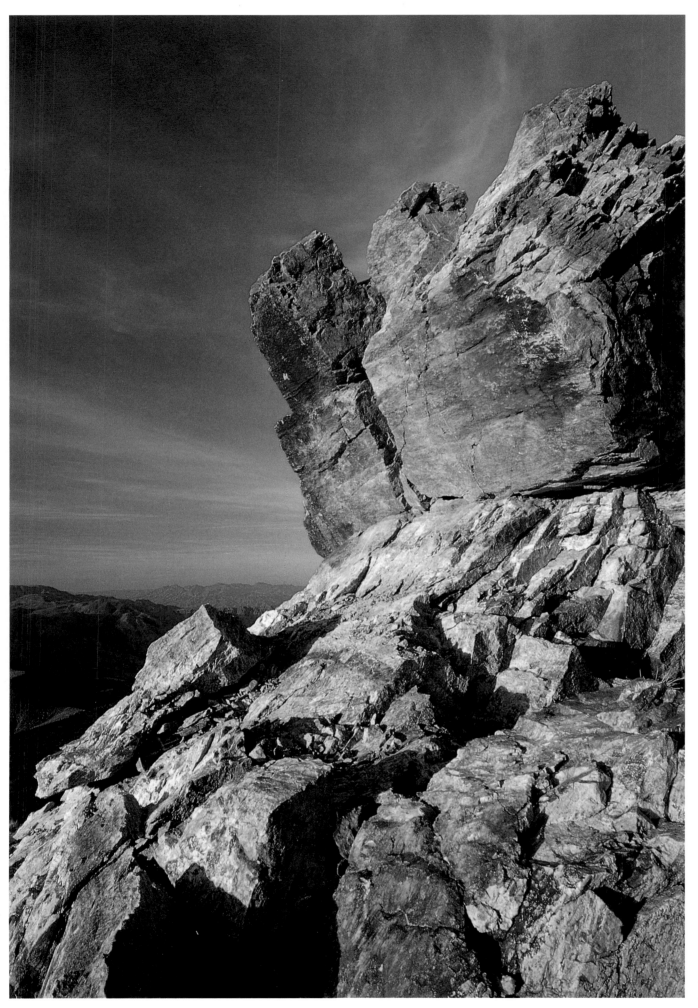

◄ The spikes of Devils Golf Course are made of almost pure table salt.

▲ Aguereberry Point is one of the features along Emigrant Canyon Road.

► ► This fourteen-square-mile dunescape stretches across Mesquite Flat.

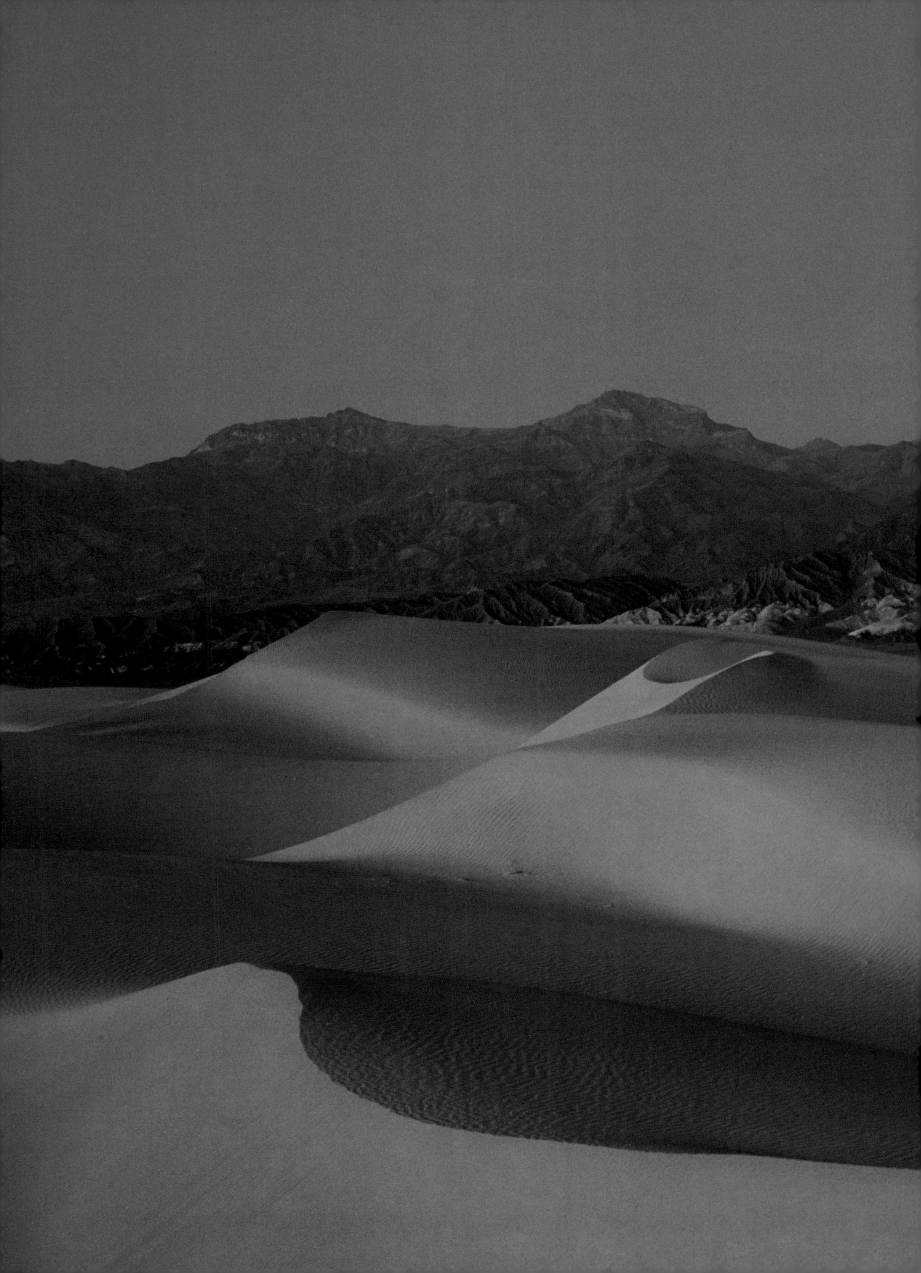

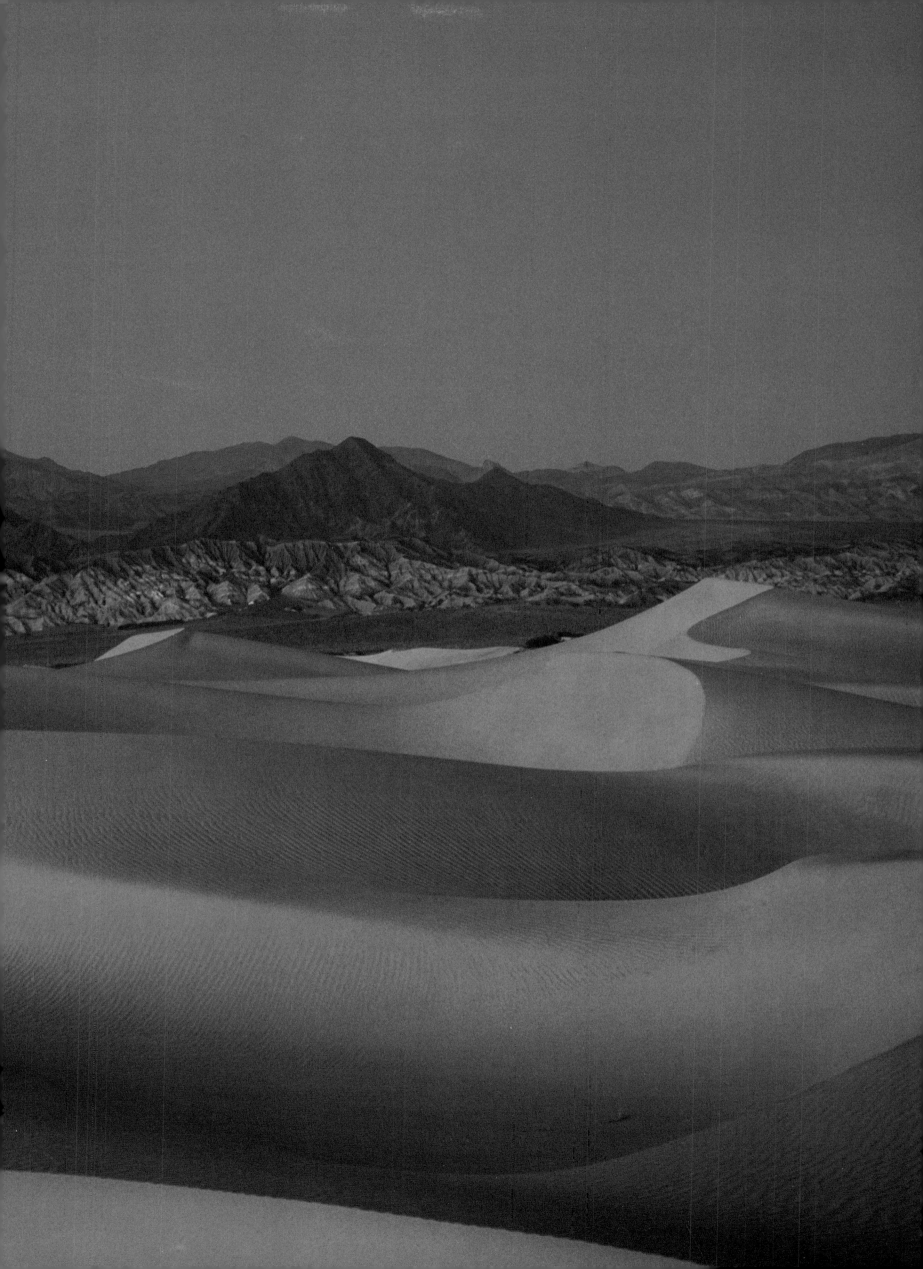

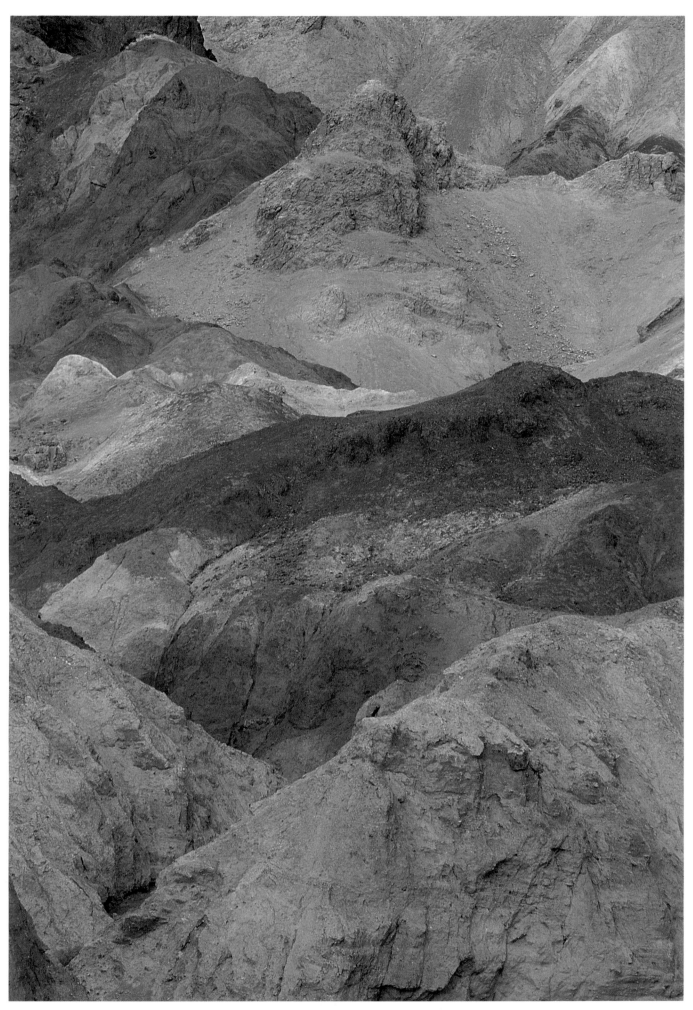

▲ The spilled-paint-box appearance of Artists Palette is the main stop along Artists Drive, which loops through the badlands of Death Valley. This desert-rainbow hillside is the colorful product of a variety of minerals.

▲ The twenty-mule-team wagon was made famous by the TV show, "Death Valley Days." In Furnace Creek, the Borax Museum and the Harmony Borax Works historic site explain the business of mining "white gold."

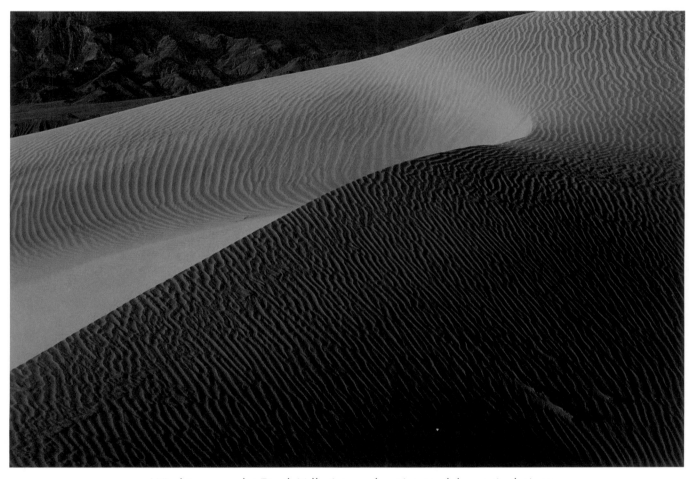

▲ Windstorms sculpt Death Valley's ever-changing sand dunes. And, since it blows from all directions, the wind helps keep things intact. The dunes attract energetic walkers armed with water, sunscreen, and brimmed hats.

▲ Built in the 1920s, a real-life mirage, Scotty's Castle, is at Death Valley's
northern end at a three-thousand-foot elevation. Also in the park's far north
is volcanic Ubehebe Crater—half a mile wide and five hundred feet deep.

▲ Scotty's Castle, tucked in remote Grapevine Canyon, was named for a flamboyant yarn-spinner, Walter E. Scott, though it was actually built by Chicago millionaire Albert Johnson. Scott was the colorful caretaker.

130

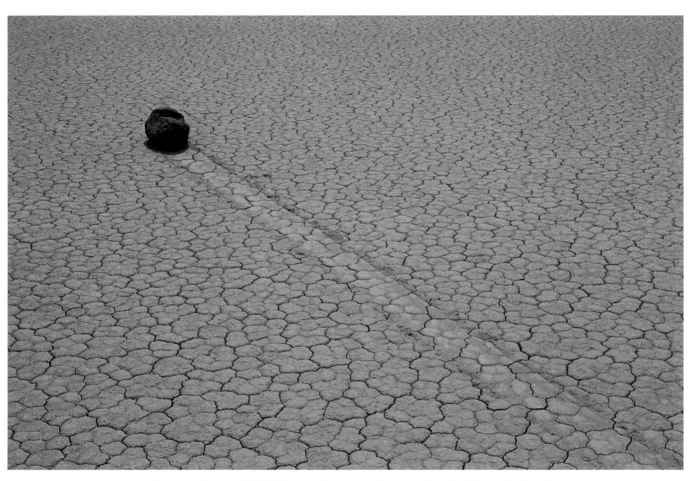

▲ "Moving" rocks highlight the Racetrack dry lake bed in Death Valley. It is thought that, following a rain, the wind propells the boulders along the slick surface. In some cases, the rocks' travels have left zigzag trails.
► ► The lowest point in North America—282 feet below sea level—is on the salt flats just beyond Badwater. The park's highest spot, 11,049-foot Telescope Peak, lies only fifteen miles away, across the Death Valley floor.

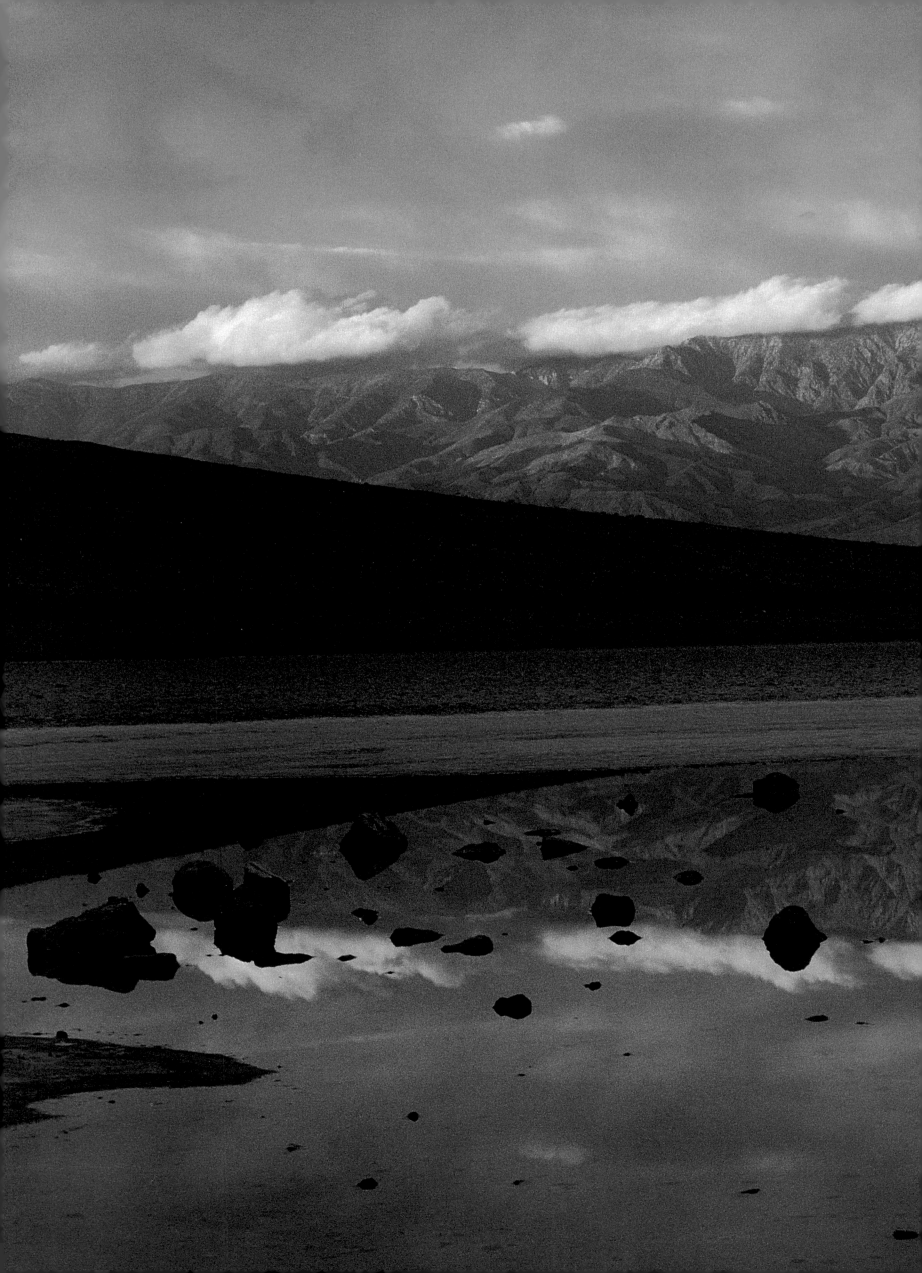

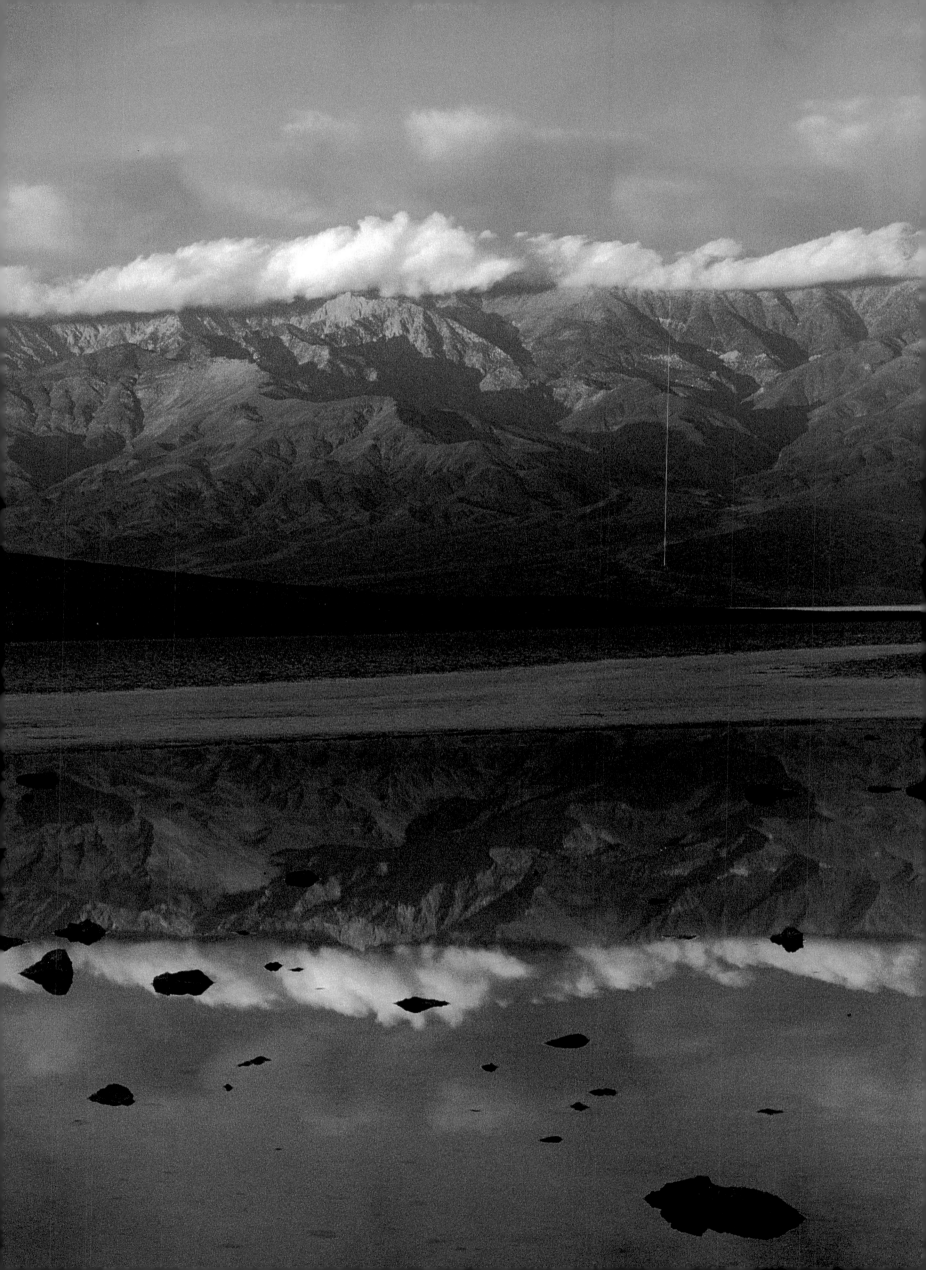

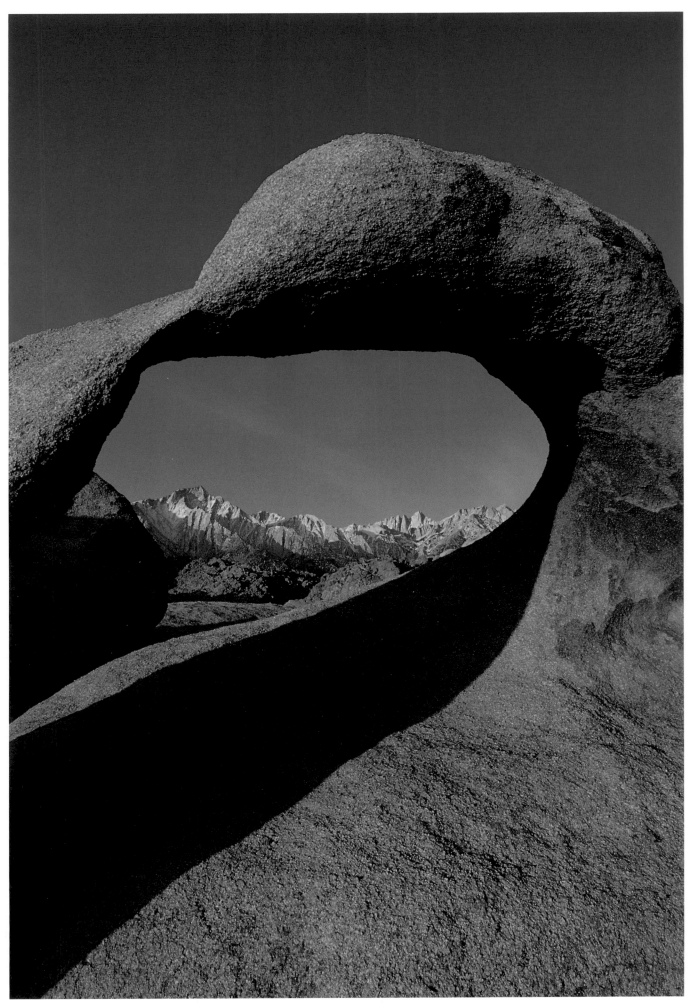

▲ Below the High Sierra along Highway 395, the Alabama Hills have been the frequent setting for movie and TV Westerns. Gateway to the Alabamas is Movie Road, where a plaque marks the area's Hollywood history.

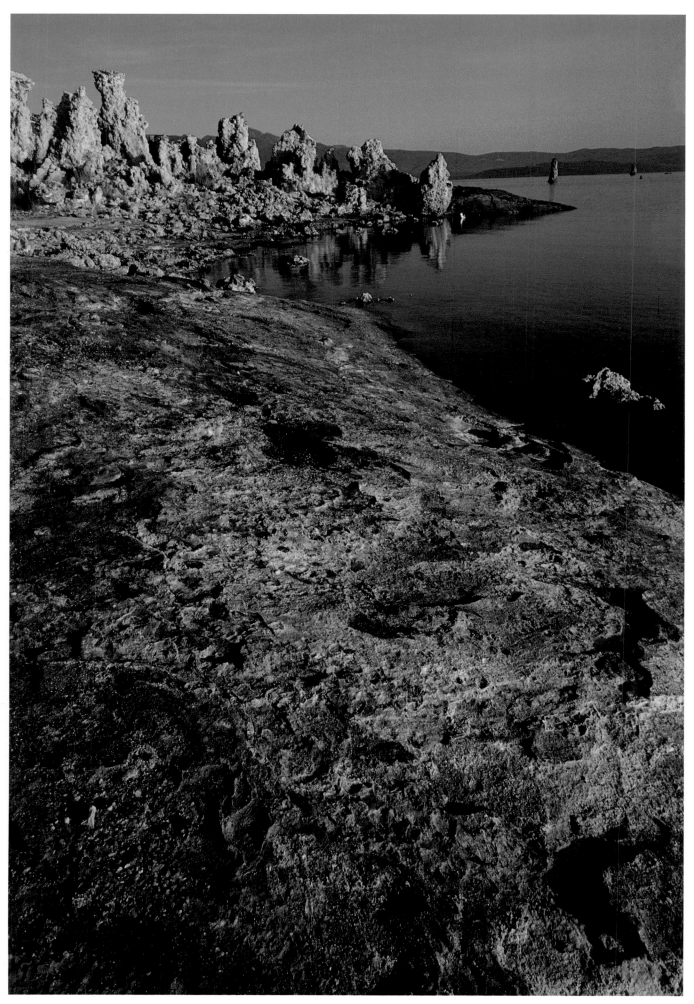

▲ A state reserve and national forest scenic area protect much of Mono Lake. Fresh and saltwater combined to form the strange tufa sculptures.

▶ ▶ Mono Lake, one of North America's oldest, is 700 thousand years old.

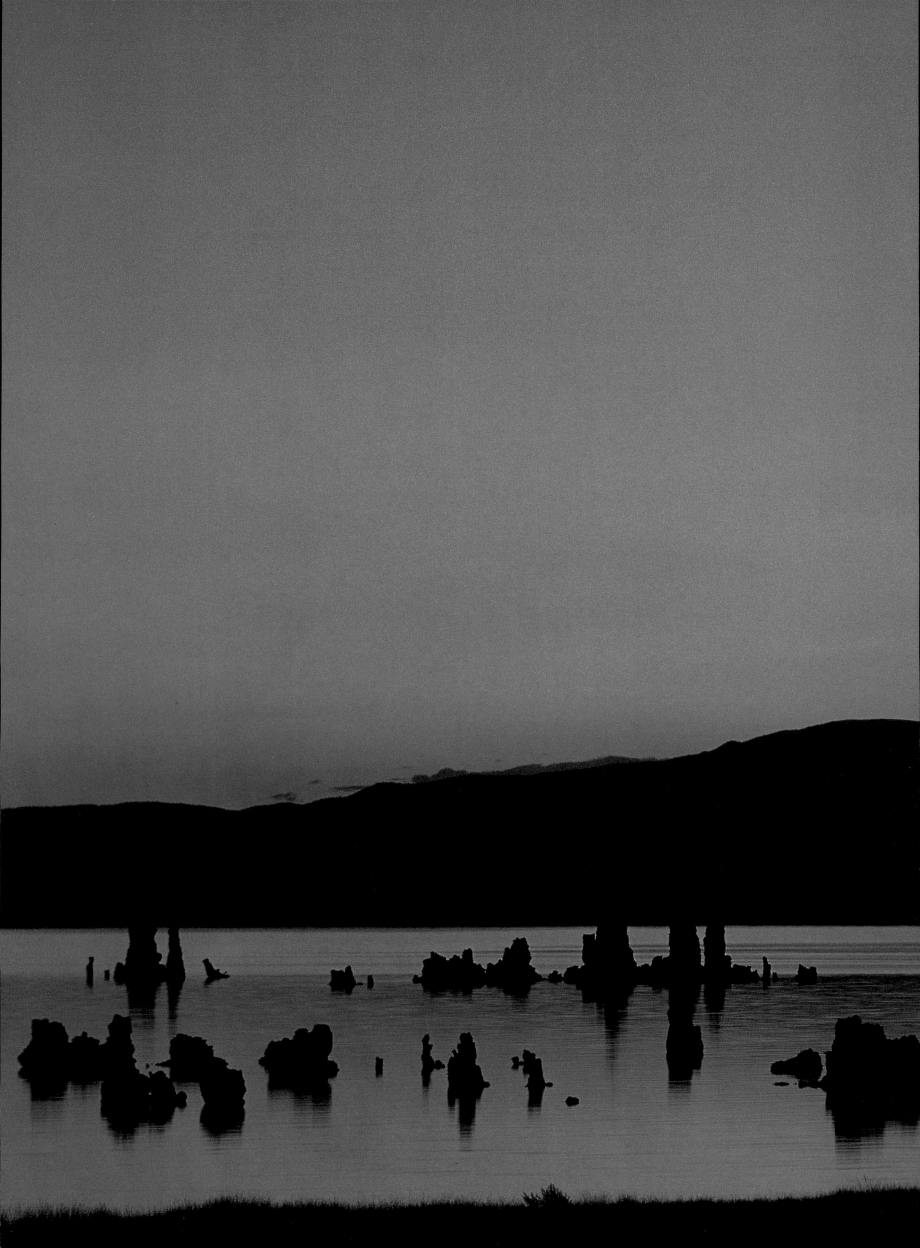

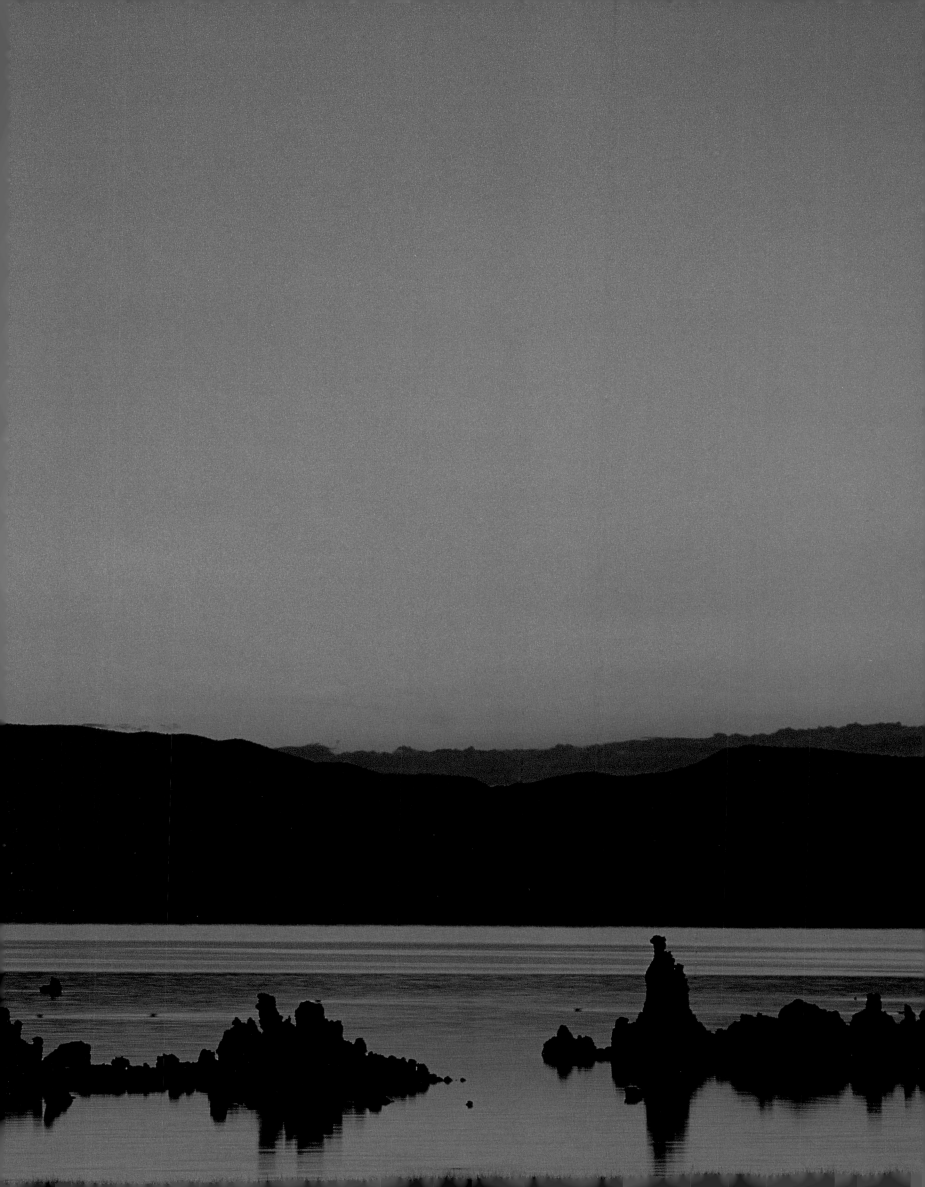

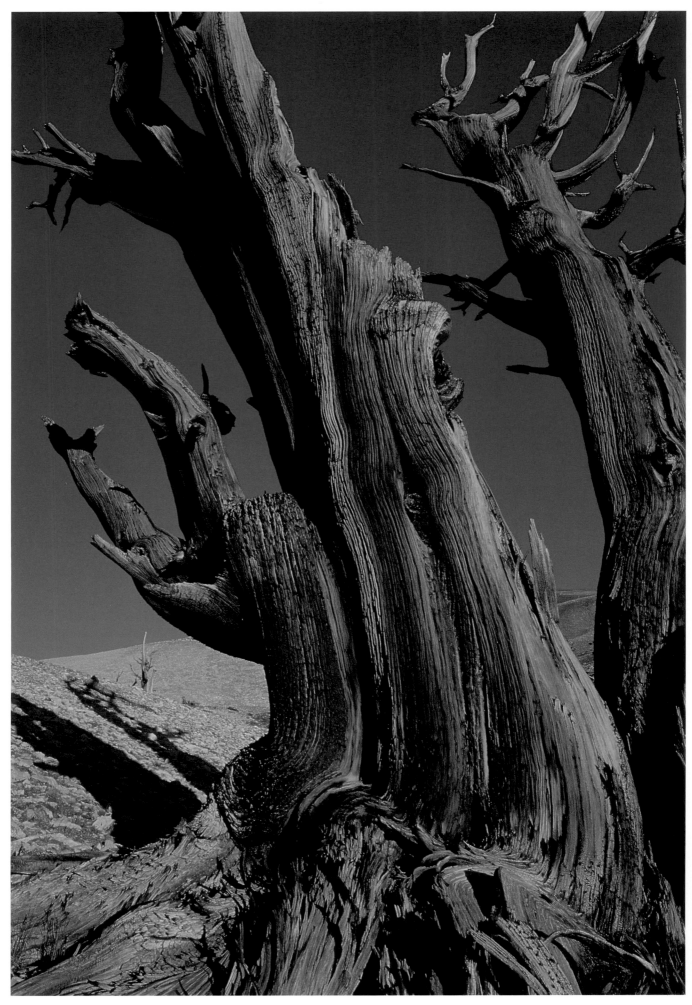

▲ Two groves of bristlecone pines line the barren upper slopes of the White Mountains, a Great Basin range. Some of the gnarled residents of the Ancient Bristlecone Pine Forest have survived more than forty centuries.

138

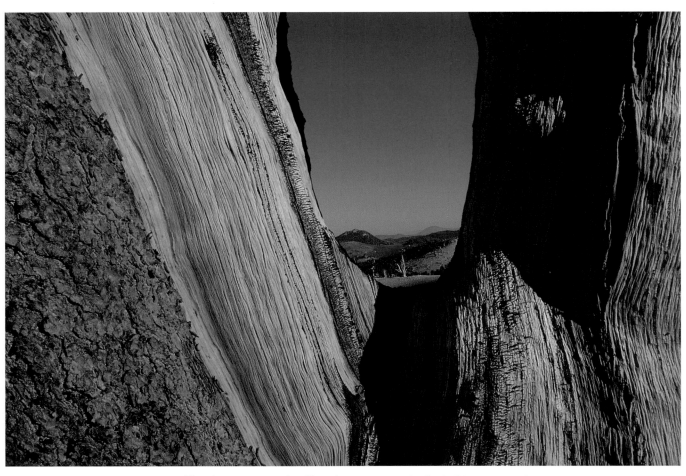

▲ A road leads to two stands of bristlecone pines in the White Mountains—Schulman Grove at ten thousand feet and Patriarch Grove at eleven thousand feet. Patriarch's stark scenery is the most dramatic of the two.

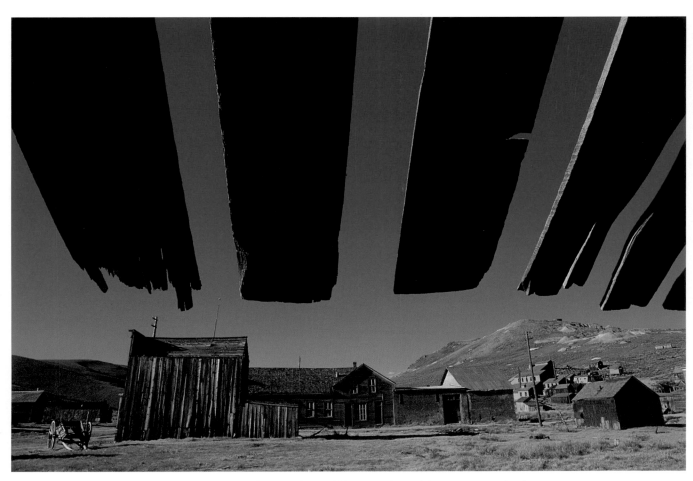

▲ A century ago, Bodie *was* the Wild West. The gold town sported saloons and a daily newspaper that ran a column titled "Last Night's Killings."
▶ A state historic park safeguards the surreal look of warping walls and sagging sidewalks that is Bodie. This gold mining ghost town occupies a desolate strip of high-desert countryside, at 8,375 feet, near Mono Lake.

◄ Bodie hit its heyday in the late 1870s—ten thousand residents, plus more than its share of stage holdups and street fights. The weathered remains of this town give a good idea of what life was like in a gold camp.
▲ Rain permitting, the pastoral Antelope Valley, west of Lancaster, comes alive in springtime with the state flower, the California poppy. The floral fireworks occur in and near Antelope Valley California Poppy Reserve.

Afterword

It has been a great privilege to photograph the California desert—its parks and resorts, flowers and fountains, sand dunes and golf courses, rock formations and ghost towns, palm groves and cactus gardens.

Of course, the desert's endless variety makes it impossible to include everything in a single book. But I trust that this collection of photos, combined with Sandra Keith's informative text, provides a good overview of the region and also a starting point for those readers who may wish to go out and make their own California desert discoveries.

However, any project of this size could not be accomplished without the help of many people. First, I am grateful to all those who granted permission to photograph their grounds—including the Agua Caliente Band of Cahuilla Indians, and the staffs of the Coachella Valley resort hotels and country clubs, the Living Desert, Palm Springs Desert Museum, Moorten's Botanical Garden, Furnace Creek Inn, the Eisenhower Medical Center, and Desert Hospital.

I would also like to thank the folks at the Palm Springs Historical Society and the Palm Springs Desert Resorts Convention & Visitors Bureau for their kind help; the staffs of Anza-Borrego, Death Valley, Joshua Tree, and the Bureau of Land Management for fact-checking various parts of the text; and the many park rangers for their friendly assistance.

Lastly, I extend special thanks to friends and family—among them Lewis Kemper for his valuable photographic advice; Marco Smolich and Julia Price for their encouragement; my parents, Richard and Helen Drager, and in-laws, Ralph and Nina Pile, for their support; and, especially, my wife, Mary, for her continued enthusiasm, despite my frequent absences.

A final note on the photography: No camera, darkroom or computer manipulations were used to alter any of the images. Most of the photos were recorded on Fujichrome Velvia slide film. Filters were used sparingly, and only then to narrow the slight gap between what the eye sees and what the film records.

KERRY DRAGER